MW00333994

Japanese Aest.
and Anime

DATE DUE		
APR 1 5 2014		

APR 0 3 2013

ALSO BY DANI CAVALLARO AND FROM MCFARLAND

Kyoto Animation: A Critical Study and Filmography (2012)

CLAMP in Context: A Critical Study of the Manga and Anime (2012)

Art in Anime (2012)

*The Fairy Tale and Anime: Traditional Themes, Images
and Symbols at Play on Screen* (2011)

The World of Angela Carter: A Critical Investigation (2011)

*Anime and the Art of Adaptation: Eight Famous
Works from Page to Screen* (2010)

*Anime and the Visual Novel: Narrative Structure, Design and
Play at the Crossroads of Animation and Computer Games* (2010)

Magic as Metaphor in Anime: A Critical Study (2010)

*The Mind of Italo Calvino: A Critical Exploration
of His Thought and Writings* (2010)

Anime and Memory: Aesthetic, Cultural and Thematic Perspectives (2009)

*The Art of Studio Gainax: Experimentation, Style and
Innovation at the Leading Edge of Anime* (2009)

Anime Intersections: Tradition and Innovation in Theme and Technique (2007)

The Animé Art of Hayao Miyazaki (2006)

The Cinema of Mamoru Oshii: Fantasy, Technology and Politics (2006)

Columbia College Library
600 South Michigan
Chicago, IL 60605

Japanese Aesthetics and Anime

The Influence of Tradition

DANI CAVALLARO

McFarland & Company, Inc., Publishers
Jefferson, North Carolina, and London

ISBN 978-0-7864-7151-5
softcover : acid free paper ∞

LIBRARY OF CONGRESS CATALOGUING DATA ARE AVAILABLE

BRITISH LIBRARY CATALOGUING DATA ARE AVAILABLE

© 2013 Dani Cavallaro. All rights reserved

*No part of this book may be reproduced or transmitted in any form
or by any means, electronic or mechanical, including photocopying
or recording, or by any information storage and retrieval system,
without permission in writing from the publisher.*

Cover art © 2013 Hemera Collection

Manufactured in the United States of America

*McFarland & Company, Inc., Publishers
Box 611, Jefferson, North Carolina 28640
www.mcfarlandpub.com*

*To Paddy, with infinite gratitude for his heroic devotion
and inspiring advice—without which I would never have
had either the motivation to write this book or the resolve to
see it through to completion—and for just about everything.*

*To Dr. Ian Cole of the Primrose Hill Surgery,
with deep appreciation for his ongoing
encouragement, patience and trust.*

*To Betsy, in recognition of her
mercurial efforts to do her best.*

Contents

The person who is a master in the art of living makes little distinction between their work and their play, their labor and their leisure, their mind and their body, their education and their recreation, their love and their religion. They hardly know which is which. They simply pursue their vision of excellence and grace in whatever they do, leaving others to decide whether they are working or playing. To them, they are always doing both. — Zen Poet

Preface

To the man who loves art for its own sake, it is frequently in its least important and lowliest manifestations that the keenest pleasure is to be derived. — Sir Arthur Conan Doyle

Imagination encircles the world. — Albert Einstein

This study engages with the relationship between Japanese aesthetics, a field of study steeped in philosophy and traditional knowledge, and anime, a prominent manifestation of contemporary popular culture, on the basis of three interdependent premises:

- the abstract concepts promoted by Japanese aesthetics find concrete expression at the most disparate levels of everyday life;
- the abstract and the concrete actively coalesce in the domain of visuality, attesting to the eminently visual nature of Japanese culture at large;
- as a major form of visual creation and expression, anime can help us appreciate many salient aspects of Japan's aesthetic legacy, in terms of both its theoretical propositions and its tangible aspects.

The legitimacy of proposing the existence of a bond between a time-honored discipline like aesthetics and a transient product of popular culture like anime is granted by the fact that over the centuries, Japanese culture has tended to apply its aesthetic precepts to all sorts of artistic and artisanal activities in a pointedly non-hierarchical fashion. It is therefore quite logical for those same ideas to reverberate in the context of a contemporary popular art form like anime. Given the supple adaptability of Japanese aesthetics

1

as a philosophical discipline, and the intrinsic vitality of anime as a product of popular culture, the relationship between the two can be viewed as a tantalizingly dynamic dialectical interaction.

Chapter 1, "Philosophical Perspectives," provides a survey of fundamental principles in Japanese aesthetics, laying the foundations for the theme-based chapters to follow. Chapter 2, "Creativity," engages with various manifestations of this phenomenon in traditional Japanese culture. Particular attention is devoted to the role played by the body in the process of creation, and to indigenous interpretations of the concept of mimesis. Chapter 3, "Nature," looks at diverse configurations of the natural and urban environments within Japanese society, with special emphasis on the interaction between human-made edifices and their surroundings. Cultural and philosophical positions are illustrated by means of detailed analyses of a range of contemporary anime. The chosen titles are informed by stylistic and thematic traits imbricated with native aesthetics, either literally or metaphorically. Although the book explores a few relevant pre–2000 anime titles for background purposes, the majority of the series and movies examined have been released over the past decade. The reason for prioritizing the post–2000 era is that this has witnessed the release of titles in which the conceptual and speculative dimensions play an unprecedentedly significant part. This is not entirely surprising when one considers that the cultural context in which they have emerged is characterized by generally more introspective and inquiring tendencies than earlier periods, arguably as a result of a unique concatenation of social, economic and environmental events of grave significance.

In evaluating the analysis conducted in this study, it is worth recalling that the available publications on the subject of Japanese aesthetics are binarily opposed into two neatly divided camps which never seem to make contact. On the one hand, there are numerous scholarly texts aimed at readers with more than a basic familiarity with philosophy — its history, terminology, discourse and specifically academic spectrum of influence. Such works barely venture into the practical/experiential arena and when they do so, they do not address popular culture to any appreciable degree. On the other hand, there is an abundance of books, guides, lush volumes and postcard-style collections devoted exclusively to the hands-on application to design of a few fundamental precepts drawn from Japanese aesthetics. These are destined essentially for Western readers keen on instilling

a touch of "Japanicity" into their homes or gardens. Clearly, such publications have precious little time for philosophical speculation. At times, in fact, they make no secret of their coffee-tablish nature. This book offers a fresh contribution to the area of philosophy-oriented scholarly writing on Japanese aesthetic thought, while also demonstrating the application of that traditional discipline in the particular context of a modern, vibrantly experimental, and internationally cherished sector of popular culture.

The timeline presented below may assist the reader.

- Paleolithic 35,000–14,000 B.C.
- Jōmon period 14,000–300 B.C.
- Yayoi period 300 B.C.–A.D. 250

- Yamato period 250–710
 Kofun period 250–538
 Asuka period 538–710
- Nara period 710–794

- Heian period 794–1185
- Kamakura period 1185–1333
- Muromachi period 1336–1573
 Nanboku-chō period 1336–1392
 Sengoku period 1467–1573
- Azuchi Momoyama period 1573–1603

- Edo period 1603–1868
- Meiji period 1868–1912
- Taishō period 1912–1926
- Shōwa period 1926–1989
- Heisei period 1989–Present

1

Philosophical Perspectives

To those who only wish for the cherries to bloom, / How I wish to show the spring / That gleams from a patch of green / In the midst of the snow-covered mountain village!— Fujiwara Iyetaka (1158–1237)

A special contribution of Zen to Western thought was its recognition of the mundane as of equal importance with the spiritual. It held that in the great relation of things there was no distinction of small and great, an atom possessing equal possibilities with the universe.— Kazuko Okakura

The Heterogeneity of Japanese Culture

The term "aesthetics" commonly designates the branch of philosophy concerned with the perception and appreciation of art, and of nature to the extent that nature can also be experienced as art. While this general definition is, by and large, as applicable to Japanese culture as it is to many other cultures, it is important to take into consideration, when dealing particularly with Japanese thought, the etymological root of "aesthetics" in the Greek word "*aesthesis*," i.e., sense experience. Indeed, in the context of Japanese aesthetics, the specifically sensory — and hence physical — dimension of both the object and the perceiver holds paramount importance. While mainstream Western philosophy has gone out of its way, at least since Plato, to efface the corporeal side of experience in the service of a supposedly incorporeal (or, at any rate, body-free) reason, Japanese thinking has consistently underscored the fundamentally material and embodied character of life at all levels. Shintō has fueled this proclivity as a tradition whose values are inseparable from the body and its natural

5

rhythms. Concepts such as beauty, elegance or taste — just to mention a few ideas stereotypically associated with aesthetics in everyday Western parlance — are pushed to the periphery of aesthetic reflection as the embodied sensorium is accorded prominence instead. As a result, Japanese aesthetics often has the refreshing effect of disengaging the reception of art and nature from arbitrary notions which, bolstered by convention and habit, have become so deeply embedded in the average mentality as to be upheld as proven and undisputable truths. As Helen J. Baroni suggests, Japan's "Zen monasteries" are themselves "places that engage the senses. The smell of incense pervades many halls.... Outside, one often encounters the scent of burning leaves as the novices clean the grounds in the afternoon. Colorful silk banners stream down pillars within graceful wooden structures with smooth polished floors and ornately carved rafters. One may glimpse the flashing eye of a painted dragon on the ceiling" (Baroni, p. ix).

According to Daisetz T. Suzuki, while "other schools of Buddhism have limited their sphere of influence almost entirely to the spiritual life of the Japanese people," this is not the case with Zen insofar as this belief system has actually penetrated "every phase of the cultural life of the people" (Suzuki 2010, p. 21). Japanese aesthetics is no exception since Zen has contributed vitally to the shaping of this body of ideas, while also playing an influential role in invigorating Japan's creative drives and artistic temperament. As Suzuki contends, a concatenation of historical developments can be invoked to explain this peculiar phenomenon. Sponsored by powerful patrons, who were often eager to receive their instruction and spiritual guidance, the ancient "Zen monasteries were almost exclusively the repositories of learning and art," and their "monks themselves were artists, scholars, and mystics." These eclectic communities were committed not only to the cultivation of skills drawn from established native customs, but also to enhancing their sensibilities and expertise through "contact with foreign cultures." In fact, "they were even encouraged by the political powers of the time to engage in commercial enterprises to bring foreign objects of art and industry to Japan (p. 28). In all areas of human creativity, Zen pursues an uncluttered state of mind graced with candid curiosity, playfulness, intrepidity and kindness. As Manu Bazzano suggests in *Zen Poems*, the art issuing from this commodious world view "ventures out through uncharted territory with courage, humor, and compassion, and in so doing

it forces us to reconsider our conditioned view of reality. It invites us to gaze with serenity and equanimity into the abyss, without having to resort to metaphysics, religion, science, or even poetics" (Bazzano, p. 10). It is by returning reality to "its natural fluidity" that this creative stance "questions the very ground on which we stand, undermining our fragile sense of solidity" (p. 12), and thus helping us learn how to relish the treasures of uncertainty. The same claim can be made, by implication, for any form of creativity animated by a keen desire to examine the world with eyes unclouded.

The attribution of unique importance to the sensory dimension of experience, highlighted earlier as one of the lynchpins of Japanese aesthetics, is itself a direct corollary of Zen's world view. Other manifestations of the interplay of Japanese aesthetics and that outlook will be pointed out as this discussion unfolds. However, although it is important to acknowledge the pervasive impact of Zen's lessons on traditional and modern Japanese culture, it would be preposterous to claim that they have infiltrated Japan's life so thoroughly as to have engendered a uniform culture in which all activities and values cohere harmoniously under the banner of Zen. Such a claim would amount to a spurious orientalist idealization of what is in fact a multilayered, and often discordant, cultural reality: a society in which the legacy of tradition coexists with a consuming apprehension of crisis. It is worth remembering, in this regard, that the process of modernization through which Japan incrementally opened its gates to Western influences was in itself far from smooth. Throughout the Edo Period (1603–1868), the Tokugawa regime had adopted a stringently isolationist policy which, while guaranteeing prolonged peace and stability through the maintenance of the ancient feudal system, had prohibited any significant interaction between Japan and the outside world. This period is conventionally referred to as *sakoku,* "closed country." As Masaru Katzumie observes, "the new government that overthrew the Tokugawa regime in 1868 (the year of the so-called Meiji Restoration) decided to reverse the existing policy of national isolation," and sought instead to "establish a modern state by introducing science and technology from advanced Western nations." Scholars and military experts from various Western countries were invited to Japan to abet the realization of this ambitious, albeit rushed, project. At the same time, grand edifices in the West's neoclassical style were erected, its vogues were superimposed onto traditional verstimentary

codes, its cuisine was incorporated into the national diet, and its artistic techniques were taught in many schools, sometimes to the disadvantage of time-honored indigenous methods. In implementing these radical changes, the government was effectively endeavoring to construct an alternate Japan conforming with its notion of what a properly industrialized nation should look like.

All the arts were affected significantly by the implementation of policies intended to abet rapid industrialization: the process which would enable Japan to catch up with the Western countries from which it had been cut off for so long. These developments were hailed in several camps as both politically necessary and culturally desirable, and hence regarded as tantalizing opportunities to explore novel avenues for creative expression. However, many resented the enforced governmental program, deeming it coterminous with the erosion of traditional values and practices, and their antipathy led to alternately violent and discreet forms of protest. Kazuko Okakura's *The Book of Tea* is a classic instance of scholarly opposition to rampant modernization, seeking to capture the essence of Japanese culture by using the tea ceremony as its ritualized emblem. In many people, the march toward modernization did not necessarily trigger either hostility or chagrin on a notable scale. Nevertheless, it did have a profound impact on the average cultural mentality to the extent that the endurance of long-established lifestyles, which could not simply be expected to disappear overnight, alongside the imported standards inevitably gave rise to what Katzumie terms "a kind of dichotomy": an internal contradiction as a result of which Japan has since operated "in a state of perpetual oscillation between the opposed phenomena of tradition and progress" (Katzumie, pp. 7–8).

Concurrently, it is crucial to recognize that even though diverse aspects of modern Japanese culture are indebted to ancient traditions steeped in native philosophy, many of these have progressively become entangled with Western influences without always merging with them in a cohesive fashion. The result has sometimes been a schizophrenic state of affairs in which both individuals and communities have found themselves torn between contrasting and even incompatible priorities. For instance, the injunction to succeed which underpins Japan's education system, and has often escalated to such frantic proportions as to lead to self-destruction, can on the one hand be traced back to the legacy of an archaic code of

honor associated with the "way of the warrior" (*bushidō*), and predicated on the supreme value of perseverance and on the commitment to doing one's best at any price. On the other hand, however, it would be hard to deny that such an imperative has also, over time, become imbricated with imported mentalities — after all, the Japanese educational structure is closely modeled on the American system — without these being comfortably integrated with native proclivities. It is not always possible, in such a context, for people to be incontrovertibly clear about the motivations and objectives sustaining their conduct. Another relevant example of cultural disjunction is provided by industry. No doubt, the Japanese penchant for miniaturization, for which the country's technological achievements are globally renowned, could be seen as a perpetuation of an aesthetic tendency which has been deeply ingrained for centuries in native philosophy, artistic creation, and agricultural practice. It is no coincidence, as Stephen Mansfield points out, that "tiny products, like large-scale integrated circuits in Japan are often called 'the rice of the high-tech world.'" Relatedly, it could be argued that the design principles underpinning Japan's technological output, and specifically the "economy of line and form" and "the elimination of non-performing space," indicate a "Zen aesthetic or orientation." This goes hand in hand with the "traditional, frugal approach" inherent in the ethos of *mottainai*, a feeling of regret toward materials which are wasted before their worth has been adequately recognized and employed (Mansfield).

Despite these lines of continuity between the traditional and the contemporary, it would be absurd to argue that the endurance of age-old principles somehow enables Japan's inventions to transcend today's economic realities. In fact, in Japan as elsewhere around the globe, the creation and incremental perfection of all manner of sophisticated technology has been channeled into the pursuit of economic goals dictated by Western-style capitalism, and ineluctably become embroiled in a reckless cycle of mass production, rapid consumption and no less rapid disposal. Moreover, the cultural tendencies enshrined in Japanese tradition do not monolithically equate to elevated notions of elegance and refinement. These are just the qualities which the West has often associated with Japanese art in its endeavor to *make sense* of Japan by aestheticizing it — i.e., by turning the country's culture into an art object unto itself, and containing it within a specious sanctum of exotic beauty. As it happens, tradition also carries an

inheritance which has little to do with rarefied sophistication, and bears witness instead to a deep-rooted passion for ephemeral gadgets, mechanical toys and gimmicks of all kinds. This proclivity is exemplified by the *utsushi-e*, the Edo-period Japanese equivalent of the Western Magic Lantern, and the *karakuri ningyou*, mechanical dolls popular from the seventeenth to the nineteenth century, and intended for a variety of both practical and entertainment purposes. Undeniably, the mechanisms and gizmos conceived by today's industry are executed to the highest of standards, as indeed were their mechanical ancestors, and thus denote a commitment to advanced aesthetic ideals. Yet, it is important to admit that they are also inevitably implicated with materialistic and consumerist agendas, while also being instrumental in stimulating an insatiable thirst for novelty.

In order to place the discussion to follow in its proper cultural perspective, it is likewise necessary to recognize that several pockets of contemporary Japanese society are afflicted by alienation, atomization and nihilism. These ordeals are again products of the dichotomy described earlier insofar as they have been largely triggered by an immersion into modernity and postmodernity which has not automatically brought undiluted pleasure or comfort, has suppressed many traditional values, and has thus left people with very little to hold onto. Florian Coulmas offers some enlightening comments on these issues, examining their significance as facets of a pervasive atmosphere of social and economic crisis which also carries troubling intimations of a widespread identity crisis. "Since the depressed 1990s," writes Coulmas, "economic insecurity has increased and the population reacts by expressing anxiety.... In recent years, educational standards have been on the decline. Extreme social withdrawal (*hikikomori*) of an unknown but large number of youths has become a recognized social problem that is indicative of a society with a less collectivist outlook than used to be the case. Crime rates have been rising generally, and, sad testimony to population ageing, among the elderly in particular.... Another worrisome characteristic of Japanese society in the twenty-first century is the growing incidence of clinical depression." These symptoms of pervasive discontent and uncertainty have identifiable political origins: "the neoliberal reforms of Japan's economy that were carried out in the name of the greatest happiness for the greatest number have lead to greater income disparities." Unsurprisingly, a major corollary of this state of affairs is the

"plummeting birth rate" and attendant "population decline" which characterize contemporary Japanese society, where longevity, by contrast, has reached record levels. This is most disturbing if set against the cult of ancestor worship — a vital component of the Shintō legacy, and hence one of the most inveterate elements of Japan's cultural identity. As Coulmas explains, "leaving descendants used to be one of the most important concerns linked to the family as the source and centre of happiness. Ancestor worship made the continuation of the family desirable, making it the locus of linking the past with the future.... This cultural tenet has evidently weakened." Contemporary Japanese life, in fact, appears less concerned with the future than with a fleeting "present where fulfilment and happiness is sought in consumption" (Coulmas).

The examples offered above suggest that Japan has had to accommodate cultural tensions and diremptions of a kind to which its people have not always found it possible to adjust smoothly. The sense of unease which they have generated must be acknowledged if one is to steer clear of a nostalgic distortion of Japan as a society homogeneously shaped by its own traditions, and to take stock of its complex, problematic, and at times downright painful historical actuality. Relatedly, in addressing the phenomenon of cultural schizoidism, one should not fail to recognize the coexistence, within the fabric of contemporary Japan, of seemingly incongruous scenarios: a substratum of enduring customs, on the one hand, and commercial ventures and products which have quite blatantly imitated preexisting Western models, on the other. Much of the time, if one seeks evidence for the endurance of traditional perspectives, one has to look for them in the interstices, the gaps, the lacunae: the very areas, as argued in some detail later in this chapter, to which Zen-inspired aesthetics ascribes special significance as the province of creativity and ingenuity. Donald Richie corroborates this suggestion, maintaining that "the Western visitor to Japan today who expects to find exquisite beauty wherever he looks is likely to be disappointed and even shocked by his first encounters with contemporary culture. He will notice Kentucky Fried Chicken establishments and other fast-food shops, the ugliness of commercial signs, the blank looks on the faces of people hurrying to places of business that more clearly resemble contemporary models in the West than anything traditional. But the past survives in aesthetic preferences that often find surprising outlets for expression — a box of sushi, a display of lacquered zori,

branches of artificial maple leaves along a commercial street" (Richie 2011, p. 40).

A grasp of the cultural tensions just outlined is essential in order to contextualize the arguments pursued in this book without indulging in facile glorifications which would only serve to distort the prismatic nature of contemporary Japanese society. However, the topics addressed in the immediately preceding paragraphs will not be developed further in any significant depth, since this study does not aim to offer either a sociological or an anthropological analysis of today's Japan. Its focus, in fact, is on the intersection of the art of anime and salient aspects of Japanese aesthetics as a cultural phenomenon sui generis, which can illuminate an interesting portion of popular culture but does not presume to posit itself as a metonym for an entire society.

The Legacy of Zen

Bearing in mind the provisos delineated above, it is nonetheless viable to argue that there is one factor which traditional and contemporary expressions of Japanese creativity persistently share: the principle that the term "art" should be equally applicable, in principle, to *any* human activity or practice. These include tasks which would not normally be considered "artistic" in a Western perspective. Concomitantly, no strict distinctions are held to obtain between arts and crafts. In fact, Japanese aesthetics accords artistic status to all sorts of pursuits embedded in everyday life, including garden design, flower arrangement, interior design, fashion design, the tea ceremony, and various culinary procedures, as well as both artisanal and industrial packaging. These practices and activities can involve just any individual who seeks to give form to a skill or vision, and not solely the so-called genius. The truly dedicated individual shuns ostentatiousness to the point that, ideally, the greater the exertion channeled into the productive task, the more spontaneous and effortless its products will seem. As Gian Carlo Calza maintains, in this context, "the apogee of culture is what can be recognized in a person, but is not put on display, ever. It is thus far removed from the world of the academy, which, in order to exist, has to demonstrate knowledge." The art of calligraphy upholds this aesthetic stance to the extent that "the apogee of writing is what hap-

pens when, however profound its contents, the text flows along without visible effort, as if the brush (or the pen) were not being held back and slowed down by the effort of thought and the muscular tension demanded by writing" (Calza, p. 66). This facet of Japanese aesthetics is redolent of the principle of *sprezzatura* fostered by Western aesthetics in the Renaissance.

In its commodious approach to art as a pointedly practical endeavor unfettered by hierarchical rules, Japan's aesthetic perspective is profoundly influenced by Zen. Tradition recounts that Zen (which translates literally as "meditation") was founded by the Indian monk Bodhidharma, and imported into China by this character in the fifth century. In fact, more accurate historical evidence indicates that Zen originated in the sixth and seventh centuries in China itself (where Indian Buddhism had been introduced in the first century), when Chinese scholars began to translate Buddhist texts and to blend their teachings with indigenous beliefs. By the eighth and ninth centuries, Zen had developed a distinct and unmistakable individuality. As Suzuki explains, Zen embodied from inception certain essential attributes of the "Chinese mind": namely, a "practical" concern with "worldly affairs" incongruous with the "transcendentalism or world-fleeing and life-denying tendencies" of Indian Buddhism (Suzuki 2010, p. 3). This pragmatically minded disposition instantly fashioned the life of Zen monasteries as communities devoted to "all the practical ways of life" and related activities more than to "offering prayers" or "practicing penance," and eager to pursue those tasks within an eminently democratic structure, so that both masters and pupils "were equally engaged in manual labor" (p. 4). In this perspective, enlightenment (*satori*) is not achieved by transcending the ordinary and the mundane but rather by discovering "a meaning hitherto hidden in our daily concrete particular experiences, such as eating, drinking, or business of all kinds" (p. 16). The "world of the senses" must be allowed to emerge "in all its multiplicities," and "free from intellectual complexities and moralistic attachments" (pp. 16–17). For art itself to thrive, morality must be put to one side, insofar as the creative urge is felt to be "more primitive or more innate" than moral dictates. While art is committed to creation, morality is only capable of disciplining what is already there: hence, "Zen finds its inevitable association with art but not with morality." If it has to choose between artistic impulses and moralistic regulations, it does not hesitate: it would rather be "unmoral" than "without art" (p. 27).

The concretization of thought and knowledge entails that learning is an entirely practical process. One learns "by doing," and lessons, accordingly, can only be taught "by action." It is necessary, therefore, to go "through a practical situation oneself without any outside aid" in a "spirit of self-reliance" (p. 9), which ultimately renders "verbal instruction" quite futile (p. 10). If all human activities can be potentially thought of as art, living itself is ultimately an art: the product of a creative effort through which a person may give shape to his or her life in much the same way as an artist gives shape to ink, clay or fabric. While the making of pictures and objects must at some stage be limited by an end point, however arbitrary this may be, the shaping of one's life as a creative work is a fluid and natural process: as Josef Albers reminds us, "learning never ends." The self-making process cannot be conclusively contained within either temporal or spatial boundaries, and forcing it into a mold would inevitably deprive it of the mobility and spontaneity necessary to its playful unfolding. "What Zen does," Suzuki poetically intones, "is to delineate itself on the infinite canvas of time and space the way the flying wild geese cast their shadow on the water below without any idea of doing so, while the water reflects the geese just as naturally and unintentionally" (p. 17).

Influenced by Zen's teachings, Japanese aesthetics posits the activity per se as valuable independently of its goals, and regards the creative process as infinitely more important than the product to which it is intended to be conducive. The practical and non-hierarchical proclivities promoted by this outlook entail that artists and artisans have traditionally evinced an attitude of profound respect toward their materials. Tools are the recipients of likewise reverential attention, as evinced by the custom whereby a tool which has outlived its usefulness is ritually thanked for its services and then buried. In Kyoto, for example, proper funerals are held for needles no longer considered serviceable. As Mira Locher explains, in this context, "the tool serves as an extension of the builder's body, allowing the hand to complete what is in the mind.... Each tool is carefully tuned to fit the craftsman's body, precisely adjusted to each day's atmospheric conditions and particular construction material, and meticulously maintained to assure its continued good use and long life" (Locher, p. 63). Thus, the degree of love and respect with which artisans treat their tools is comparable to that with which musicians might be expected to handle their instruments. According to Lenor Larsen, the material dimension is cardinal to

the creation of all conceivable artifacts within both traditional and contemporary Japanese culture. "Craftmakers working within Japan's ancient traditions," argues the critic, "respond to the generations of passed-on knowledge. This collective memory includes a deep respect for material and process, and respect too for the intended user" (Larsen, p. 12). Haruo Shirane corroborates this idea with specific reference to the classical Japanese poem (*waka*), where the concrete side of creativity was granted pride of place: "Japanese poetry" constitutes "a material object for which calligraphy, paper, and packaging were probably as important as the poem itself.... The type, color, and size of the paper were also important. The poet could also add a sketch, attach a flower or leaf, or add incense or perfume to the poetry sheet. The poem as material object was often a gift for the host, friend, or lover. Matching the poem or paper with the social occasion or season was a key factor in its effectiveness or performativity." *Waka*, the critic concludes, was "meant to be *seen* both as text and material object" (Shirane, pp. 223–224).

Japan's reverential treatment of the material dimension in virtually all its forms finds emblematic expression in the realm of sartorial fashion. This is demonstrated by the immense care with which textiles have been traditionally selected, treated, and manipulated in the execution of even the most modest of garments. The primary objective, in this context, has been to maximize the synaesthetic powers of different fabrics, and hence ensure that their visual appeal emerges in conjunction with other sensory and sensuous properties. While tactility has often been regarded as a material's most desirable quality, auditory, olfactory and even gustatory considerations have also come into play consistently, though perhaps less explicitly. The importance of fabric in the context of Japanese aesthetics (and culture generally) is confirmed by Yohji Yamamoto's comments on his creative labor. "In the final analysis," the stylist observes, "faced with fabric that is obviously going to be more beautiful the less one plays around with it, we designers are like swimmers wallowing in a tsunami or raging torrent" (cited in Fukai, p. 18). "It's like a current," Yamamoto continues, "it draws us in. But I didn't make anything, really. Not this time" (p. 25). The artifact, in this frame, is the product not of a human being's masterful control of nature's treasures but rather of a refreshingly collaborative effort between the enticing fabric and the designer's keen hand.

Given its pictographic roots, the indigenous writing system is itself

instrumental in affirming the material dimension of existence. Pictograms are relatively basic representations of objects in the actual world executed in a stylized fashion. Ideograms are also based on empirical referents but these are less immediately identifiable in ideograms than they are in pictograms. *Kanji* (and, by extension, the *hiragana* and *katakana* syllabaries issuing from them) participate in both the pictographic and the ideographic modalities, at times displaying intimate connections with real objects, and at others using extreme methods of stylization. Either way, the characters bear witness to the physical roots of language by preserving the material flavor of words in their visible shapes. Naturally, words do not solely describe material entities, and it might initially be hard to imagine how a sign meant to connote an abstract idea could retain a modicum of materiality. In fact, as the most fundamental level of familiarity with the Japanese language indicates, even *kanji* designating intangible experiences (thoughts, feelings, sensations, fantasies and dreams) come across as concrete images which have the power to suggest those experiences without becoming altogether incorporeal themselves. The status enjoyed by Japanese calligraphy (*shodō*) as a pictorial art in its own right is itself rendered possible, above all else, by the nature of native writing as a body of tactile signs. Like all systems of written signification, pictograms and ideograms pivot on the principle of metaphor: the forging of relationships between material and incorporeal entities. Western thought has traditionally attributed the capacity to establish such linkages to humanity's knack of logical abstraction, and to the attendant ability to dissociate the mind from the physical domain. In so doing, it has gone to considerable lengths to efface language's underlying materiality. Yet, as Ezra Pound suggests in the essay "The Chinese Character as a Medium For Poetry," initially penned by Ernest Fenollosa and then edited by Pound himself, the model at the basis of metaphoric association is in effect supplied by nature. Just as the correlations created by nature have concrete underpinnings, so do the metaphorical associations fashioned by human language. "Primitive metaphors," the essay proposes, "do not spring from arbitrary subjective processes. They are possible only because they follow objective lines of relations in nature herself. Relations are more real and more important than the things which they relate. The forces which produce the branch-angles of an oak lay potent in the acorn.... Nature furnishes her own clues. Had the world not been full of homologies, sympathies, and identities,

thought would have been starved and language chained to the obvious" (Pound). These material, and atavistically pictorial, associations are not unlike the "correspondences" sensed by Baudelaire: a vast interactive web in which all facets of the natural world constitute animate and sentient agencies capable of subjecting humans to their solemn gaze — even as we fallaciously presume to operate as their unchallenged observers.

As a keystone of Japanese aesthetics, the tendency to foreground a material's essence has also affected the native approach to artistic training. According to Sarah Lonsdale, "the traditional way of learning a craft has always been one of emulation: an apprentice observing a master, learning through osmosis as the student becomes familiar with the materials. Perfection for the master was traditionally more about enhancing the natural beauty of a material rather than asserting the individual ego" (Lonsdale, p. 147). Moreover, as Boyé Lafayette De Mente maintains, the approach to training based on the "*meisho* (master) and *deshi* (apprentice) approach to arts and crafts" has proved so influential over time as to affect virtually all levels of Japanese existence by "permeating the culture from top to bottom. The teachings of the masters incorporated philosophical and ethical factors as well as precise *kata*, or 'ways of doing things.' Masters in every art and craft used precise steps or processes in the training of their apprentices. Deviations from the *kata* were absolutely taboo" (De Mente, p. 22–23). The endurance of the traditional approach to training is paradigmatically exemplified by the formative experiences of one of the most widely acclaimed Japanese artists of recent decades, the architect Tadao Ando. Sunamita Lim's assessment of Ando's achievement upholds this contention, reminding us that "this introspective architect mastered the traditional art of Japanese wood designing and building first.... In the time-honored tradition of studying from the masters, he learned the precision techniques required in building with wood joinery, sans hardware" (Lim, p. 20). It is also noteworthy that the perpetuation of the *meisho-deshi* method has progressively contributed to the consolidation of the artistic imperative always to strive for perfection (*kaizen*): a goal which, in consonance with the lessons of Zen, is held to be forever incomplete, just as the learning process itself is deemed never-ending.

Another pivotal aspect of Japanese aesthetics which emanates directly from Zen's perspective is its tendency to value perception and intuition over logic and rationality. In the realm of Japan's traditional arts, the pri-

macy of intuition is epitomized by the *haiku* as a form of poetry which, particularly in its perception of nature, aims to offer a glimpse of the intuition itself, and not an interpretation of the intuition, thereby prioritizing sensory immediacy to rational explication or logical definition. *Hosomi*, the distinctive kind of emotional delicacy enabling the reader or listener to relate to the *haiku*'s images, likewise pivots on intuition, not on interpretive ingenuity. As Lucien Stryk points out with specific reference to the *haiku* composed by the seventeenth-century poet Matsuo Bashō, the secret to the effectiveness of this poetic form is "*karumi* (lightness)," the quality which Bashō himself urged his colleagues to cultivate as the key to freeing "their minds of superficiality." This attribute constitutes "the artistic expression of non-attachment, the result of calm realization of profoundly felt truths" (Stryk, p. 10). *Karumi* enables a person to glide over things and appreciate them nonjudgmentally, only ever touching them in a totally unacquisitive manner. In the mindful ethos of *karumi*, there is no desire for analytical plodding and cerebral overcomplication, and no urge to possess the aesthetic experience and thus turn it into a private asset. The stance fostered by *karumi* echoes Zen's aversion to intellectualization as a process likely to quash the energy of the present moment by translating it into something cold and inert. In Zen, this position manifests itself most audaciously as an explosion of linguistic conventions through the insistent use of absurd statements, rampant nonsense and risible paradoxes. The lessons delivered by Zen elders in the traditional context of the monastic brotherhood were not sermons in the obvious sense of the term but rather brief and cryptic utterances, often riddled with incongruities, and complemented by actions which were by no means connected with the words in a self-evident logical fashion. As Suzuki maintains, Zen's use of language is meant to disrupt the power of "conceptualization," which inevitably causes words to become detached from reality as such, and thus to deal with "the thing itself and not an empty abstraction" (Suzuki 2010, p. 5).

Of course, Zen is well aware that words are bound to be arbitrary substitutes for the things they supposedly name, and that language can never therefore be expected to capture reality in an immediate and transparent way. Nevertheless, it seeks to retain a hold on the concrete even in the proverbially abstract province of language by treating words *as though* they themselves were things, material entities of sorts. According to Suzuki, in handling words like physical entities, "Zen verbalism has its own fea-

tures, which violate all the rules of the science of linguistics. In Zen, experience and expression are one. Zen verbalism expresses the most concrete experience" (p. 6). While Zen's philosophical perspective emanates from its idiosyncratic approach to language, it never takes the shape of explanations or rationalizations. In fact, brainteasers and nonsensical utterances are allowed to remain just what they were when they were first voiced: their significance does not lie with a hidden meaning or essence but simply with their tangible and fleeting occurrence, and with the unnamable "something" which that occurrence might evoke in the listener. The moment that "something" is subject to linguistic dissection, it ineluctably vanishes. The mobility allowed by this semiotic stance entails that a word, if left to itself, is perfectly capable of embracing logically contradictory realities. Evoking a universe reminiscent of quantum physics, Zen intimates that "a staff is a staff and at the same time not a staff, or that a staff is a staff just because it is not a staff" (p. 7).

This outlook finds a parallel in the eschewal of purity which Japanese culture has characteristically evinced for time immemorial. Embracing a resourcefully eclectic outlook, Japan has shown scarce interest in the accomplishment of homogeneous cultural patterns, seeking instead to cultivate inclusiveness by frankly admitting to the existence in its midst of divergences, ambiguities and ironies. Seen from the perspective of Zen, these should be perceived as inevitable components of the world's rhythms — as no less natural, in fact, than breathing or than life's inherent absurdity. Japan's fascination with diversity manifests itself as a sustained integration of local and global styles, Eastern and Western motifs, tradition and innovation. By and large, foreign vogues are keenly adopted, assimilated and integrated, yet reinterpreted and restyled so as to carry a distinctively Japanese flavor. For example, even during periods in which Japan's political system and cultural output were deeply influenced by Chinese models, such as the era spanning the late seventh century to early eighth century, native art was averse to the robotic parroting of Chinese styles and techniques. A major moment in Japanese art's self-emancipation from Chinese antecedents in the specifically visual domain coincides with the Heian era. At this point, Chinese-style painting (*kara-e*) was gradually superseded by a distinctively indigenous style (*yamato-e*) in which themes and settings of Chinese origin gave way to subjects of clearly native orientation, especially in the portrayal of the natural world throughout the

seasons, and of famous Japanese locations close to the artists' hearts. As Tsuneko S. Sadao and Stephanie Wada point out, "the transformation of culture and art" marking this phase of Japanese history went hand in hand with a "new desire to make a clear distinction between Japanese and Chinese style," which had a substantial impact on "narrative painting and calligraphy. In a secular context, both of these art forms were closely connected to developments in literature," and particularly drawn to the interpretation of "episodes from romantic prose stories like Lady Murasaki's *The Tale of Genji*" (Sadao and Wada, p. 92).

The Lessons of Nature

Over the centuries, Japanese artisans and artists have endeavored to follow nature (*shizen*), and made their formal and compositional decisions on the basis of the essential qualities (*honshitsu*) of each material. In the context of contemporary culture, nature's fundamental properties have often been obfuscated or masked by the superimposition of flimsy veneers upon their pristine forms in the pursuit of pretentious effects. The architect Kengo Kuma laments this development, contending that "a culture of ornamentation dominates the present-day world" whose aim is "to show 'nature' as a symbol," rather than a breathing reality, by exploiting natural materials as purely ancillary decorations. "Wood, for example, is used merely as one kind of ornamental material," as indicated by the practice of "fastening thin wood sheets over structures made of concrete and steel," while "thin stone" is utilized as the emblem of "authority and wealth." Not even the most modern styles are exempted, since "aluminum and glass" are themselves "affixed" as supplements, not treated as a building's essential substance. "Global capitalism," Kuma declares, "has fostered this 'era of skin.'" In the face of this pervasive trend, the artist encourages us to "search once more for the essence behind the skin" (Kuma, p. 8) — to rekindle the desire ingrained in Japan's traditional aesthetics to let nature's intrinsic attributes govern the execution of every art. The garden landscaper, for instance, must learn from the innate qualities of stones, shrubs and water how best to organize his or her materials into a satisfyingly coherent whole. Yuriko Saito vividly illustrates this proposition with reference to the eleventh-century treatise *Book on Garden Making*: "the scenic effect of a

landscape," she maintains, is best achieved "by observing one principle of design': 'obeying ... the request' of an object." Thus, "the gardener 'should first install one main stone, and then place other stones, in necessary numbers, in such a way as to satisfy the request ... of the main stone' ... The whole art ... requires the artist to work closely with, rather than in spite of or irrespective of, the material's natural endowments" (Saito, p. 86). Stones and rocks, in this scenario, are believed to possess distinctive personalities which manifest themselves in their unique shapes, sizes and marks. Hence, as David A. Slawson avers, these natural and architectural entities have received an astounding variety of designations over the centuries in consonance with "scenic," "sensory" and "cultural" connotations. The "Hovering Mist Rock" and the "Water-channeling Rock," for instance, receive their names in accordance with the scenic impressions they evoke, whereas the "Erect & Recumbent Rocks" owe their denomination to their sensory properties, and the "Master Rock" and "Attendant Rock" are so labeled on the basis of their culturally defined "aesthetic roles" (Slawson, p. 134).

Gardeners are by no means alone in approaching the materials at their disposal as wise and sensitive entities. Package designers, for instance, also allow the inherent attributes of paper, wood and numerous vegetable fibers to tell them what shapes and sizes are most apposite to the demands of a particular type of wrapper or container, while chefs allow the unique flavors, colors and fragrances of various food items to tell them how to prepare a dish so as to maximize its gustatory and visual potential. Among Japan's time-honored materials, wood (*ki*) constitutes a particularly interesting case: traditionally, the supreme objective of artists engaged with this substance has been to ensure that all naked portions thereof would appear attractive per se, regardless of their practical functions. This priority has been sustained by the desire to allow the wood's fundamental properties to reveal themselves. It has not, however, been considered sufficient to let them shine forth unimpeded. For this goal to be achieved, Japan's traditional artificers have also deemed it necessary to select pieces of wood endowed with individual essences borne out by their unique grain patterns, fissures, knots and other textural peculiarities (so-called flaws included). The most popular and iconic of Japan's wood treasures is undoubtedly bamboo (*take*), a family boasting over six-hundred varieties that has found so many applications in both traditional and contemporary Japanese cul-

ture as to constitute the potential candidate for an entire work on aesthetic matters. Its combination of strength and flexibility, and its symbolic association with long life and contentment impart bamboo with ubiquitous resonance. As Koichi Kawana emphasizes, the pine also constitutes a "major basic structural tree" emblematic of "longevity and happiness." A distinction is made between the "black and red pines" as symbolic, respectively, of the "positive and negative forces" at work throughout the cosmos. Japan's most meaningful trees come together in the "combinations of pine, bamboo, and plum" which are customarily employed to welcome "the New Year and the most auspicious occasions." The virtues of "vigor and patience," associated with the plum on account of its being "the first to bloom after a severe winter," complement perfectly the auspicious properties of both pine and bamboo (Kawana).

Relatedly, the Japanese have given meticulous attention to the selection and arrangement of stones (*ishi*) for use in both outdoor and indoor settings, on the premise that the affects they emanate have the power to connect humans with the earth, and the body with the mind. Paper (*washi*) stands out as another major cultural presence, as borne out by the almost infinite range of applications it has found (and still finds) in practically all sectors of Japanese life, and the likewise impressive variety of artistic effects to which it has been put. As De Mente remarks, "in earlier eras — and also today — the texture of Japan's handmade paper might suggest anything from the grain of wood to the pattern and feel of an exceptionally beautiful leaf.... This same mind-set and talent has been applied to the creation of 'modern' paper, especially paper used for wrapping gifts and other things" (De Mente, p. 109). While the importance of wood, stone and paper cannot be overestimated, no account of Japanese culture's devotion to materials could ever be complete without a recognition of the importance of straw (*wara*). Indeed, this substance has yielded a profound effect on the development of Japan's distinctive approach to interior design, providing the basis for the *tatami* kind of flooring which has been in existence since the Heian era, and is still used today even in Western-style residences, and has traditionally been held capable of communicating a deep sense of both physical and mental comfort.

Japan's respectful attitude to materials is no less manifest in its approach to food. According to Kenji Ekuan, in the gastronomic sphere, the processing and arrangement of different ingredients is informed by the

desire to let their fundamental natures manifest themselves unimpeded. The preparation of the classic Japanese lunchbox (*bento*), for instance, is underpinned by one vital objective: to collect "normal, familiar, everyday things from nature, according to season" and maximize "their inherent appeal" so as "bring each to full life" (Ekuan, p. 6). Fish will thus be made "more fishlike" and rice "more ricelike" (p. 77), and the undiluted essence (*seizui*) of each will hence be free to release its power. The long-established tendency to match specific dishes and both their chromatic and formal properties to particular seasons consolidates Japanese cuisine's allegiance to nature. A simple cup of green tea accompanied by a tiny sweet in the shape of a maple leaf, for example, are felt to sum up the mood of an autumnal garden view. This ethos is also confirmed by the traditional cutting of vegetables so as to make them resemble flowers, meant to remind the diner of the ingredients' material roots in nature. It should also be noted, on this point, that Japanese cuisine has traditionally treasured the value of visual appeal, and hence given painstaking attention not only to the processing of food but also to the formal arrangement of modest portions of food for the purpose of maximizing the synesthetic interaction of color, texture and shape within the overall design. The selection of suitably molded and decorated vessels is thus posited as a major priority for the accomplished chef. The eminent position held by the culinary arts in the context of Japanese culture is further confirmed by the richness of the native language of gustation. As Richie remarks, Japanese people recognize categories of taste which lack exact correlatives in other cultures, including "*awai* (delicacy), *umami* (deliciousness), and *shibui* (astringency) ... *Nigai* is used for 'bitter' and *egui* for 'acridity.' English does not differentiate between acridity and bitterness" (Richie 2007, p. 23).

It is crucial to appreciate, however, that in advocating the imperative to follow nature, Japanese aesthetics does not actually encourage artists to feel enslaved to nature's lessons, and thus emulate its forms in a passive fashion. In fact, following nature, in this perspective, means penetrating the criteria and processes which characterize nature's modus operandi in all possible contexts through attentive observation of all entities and through intuitive participation in their being, and then taking them apart in order to reconstitute them by one's own conscious effort. Though seemingly laborious, this task can be infinitely rewarding as a productive gesture in its own right, contributing to the formation not only of the art object

per se but also of the creating self. This idea is exemplified by the anecdote surrounding a young monk and his spiritual leader. Having meticulously cleared a path within the temple compound by removing every single leaf, the youth eagerly anticipates his mentor's praise. The older man in fact responds by shaking the branch of a nearby tree, thus causing a fresh cascade of leaves to descend upon the same path, and then instructing his pupil to rearrange the leaves in precisely the same pattern in which nature itself had originally caused them to collect. Garden art offers a paradigmatic example of Japan's distinctive attitude to nature by punctuating its nature-dominated components with discreet reminders of human creativity, and of the physical effects which such creativity alone is able to achieve. Locher illustrates this idea as follows: "although the primary focal points in traditional Japanese gardens are naturalistic features created by plantings, compositions of large rocks, and flat expanses of white gravel, there are other smaller elements that are shown intentionally to show the hand of man. Also constructed using natural materials like stone, wood, and bamboo, these elements serve to heighten the sensory experience and create small moments of pause or surprise within the garden" (Locher, p. 202). Such elements include *ishidōrō* (stone lanterns), *chōzubachi* and *tsukubai* (bowls and basins containing purifying water), and *shishi-odoshi* (deer scarers).

In order to grasp Japanese art's relationship with nature, it is also necessary to consider its stance on two alternate ways of approaching the creative act. These are tersely outlined in the writings of the Japanese seventeenth-century thinker Tosa Mitsuoki. "If ... there is a painting that is lifelike and that is good for that reason," the philosopher reflects, "that work has followed the laws of life. If there is a painting which is not lifelike and which is good for that reason, then that work has followed the laws of painting" (cited in Richie 2011, p. 88). By drawing a distinction between the kind of work which follows the laws of life, and the kind of work which follows the laws of painting, Mitsuoki is effectively differentiating between two ways of ideating reality, not only on paper but also in one's mind. At its most vibrant, Japanese art cultivates an aesthetic in which the two options outlined by Mitsuoki are commodiously integrated. As Makoto Ueda emphasizes, Mitsuoki himself "conceives of the laws of nature and art not as mutually exclusive or contradictory, but as complementary. The artist must first observe the laws of nature before he comes

to cope with the laws of art; otherwise his work would not resemble life but become lifeless" (Ueda, M., p. 131). Artists gain the freedom to follow art's own rules to the extent that they have explored nature with scrupulous care, yet also know how and where to depart from nature for the sake of art itself. Without a sensitive grasp of their initial matrix, they could never determine where nature ends and their art begins. Yet, without a thorough understanding of their art, they would be powerless to translate their experience of nature into an artifact endowed with energy and the semblance of life.

The Poetics of Space

In its approach to space, Japanese aesthetics relies on concepts which Western philosophy has conventionally regarded as synonymous with negativity: incompleteness, emptiness, absence, nothingness. As Michele Marra points out in relation to the writings of the Japanese philosopher Nishida Kitarō, the extent to which the West finds the notion of nothingness hard to countenance finds clear expression in the religious context. By contrast with the positive appreciation of this notion promulgated by many strands of Eastern thought, "the Western idea of nothingness is still marred by the resilience of the concept of presence that simply refuses to die. The God of the Judeo-Christian tradition is still profoundly anchored by a strong concept of personhood, whose perfection requires the presence of a free will that works within a structure of self-conscious self-determination. As soon as the concept of nothingness is introduced in the West in the description of the idea of transcendence, the West celebrates its death by personalizing it into a concrete essence" (Marra, p. 172). "Westerners," argues Richie with specific reference to spatiality, "believe in the integral site, the whole thing, the big picture." Japanese culture, by contrast, seems to work on the premise that "things in their fullness are not necessary, and that a frame need not insist upon fullness.... It was this way of framing that so excited French painters [such as Degas] when they first saw it" (Richie 2011, p. 80). Relatedly, while Western thinking commonly assumes that "space is empty," and therefore "exists only in order to be filled" (p. 76), Japanese thought embraces the principle of meaningful emptiness, proposing that space does not need to be "filled in because it is already filled in with itself" (p. 46). More specifically, space is supposed

to be filled with "*ma*, an aesthetic term, originally Buddhist ... meaning something like 'empty' or 'space' or even 'gap.'" (This intriguing term will be revisited later in the discussion.) We are here presented with an intriguing irony: the *stuff* which supposedly *fills* space is itself an absence. It is on this basis that "the Taoist philosopher Lao Tse could write confidently that thirty spokes might meet at the hub but the empty space between them was the essence of the wheel" (pp. 76–77). The irony becomes even more trenchant as one begins to discover that "emptiness ... has its own weight, its own specific gravity, its own presence" (p. 46).

In an article on Zen architecture's approach to space, Antariksa elaborates this point with close reference to traditional Buddhist texts, explaining that the term "emptiness" corresponds to "the Sanskrit word *sunyata* [or *shunyata*], which means 'everything is no–substantial,'" and that its Japanese equivalent is "*kū*, which also means 'sky.'" Drawing on Stewart W. Holmes' writings on Zen meditation, the critic goes on to explain that "*sunyata* is an Emptiness so full of potentiality that all emerges from it, all is reabsorbed in it. In Emptiness, forms are born. When one becomes empty of the assumptions, inferences, and judgments he has acquired over the years, he comes close to the original nature and is capable of conceiving original ideas and reacting freshly" (Antariksa, p. 77; Holmes, p. 66). (Please note that the concept of *shunyata* will be revisited in Chapter 2.) In Japanese culture, this outlook does not remain confined to the realm of abstract conceptualization. In fact, in keeping with Zen's dislike of any kind of intellectual labor that is totally divorced from practical activity, it gives material expression to the idea of creative emptiness in its organization of lived space. Hence, the idea that empty space is actually meaningful and productive can be seen to underpin both garden design and the interior architecture of the traditional Japanese house. The stone garden of the Ryōan-ji (a.k.a. Temple of the Dragon at Peace) in Northwest Kyoto epitomizes that spatial sensibility with its considerate use of empty areas: these allude to a world in which the absence of tangible forms is not synonymous with amorphousness but rather with a fluid wave field inhabited by an infinite range of potential or implied forms. In domestic architecture, the idea that emptiness is creative asserts itself in spatial arrangements that are meant to provide the context for an ongoing process of creation — a process in which the human dweller is both the artist and the artwork. A "room in the Japanese residence," writes Antariksa with reference to Heinrich

Engel, "becomes human only through man's presence." Yet, if this presence is to come to life, the person must not simply occupy the room, let alone try to control it. In fact, "the empty room" should be approached as the blank page, canvas or stage wherein "man's spirit can more freely and where his thoughts can reach the very limits of their potential" (Antariksa, p. 82; Engel).

In order to grasp this conception of space, it is vital to recognize that Zen's nothingness, as Andrew Juniper argues, is not tantamount to "nonexistence … but rather the passing through to that which lies beyond the dualism of existence and nonexistence" (Juniper, p. 115). This notion finds visible expression in a profound "reverence for space and the feeling it can instill," as typified to by the "open expanses of the gardens," the "unused areas of monochrome painting," and the "complete lack of adornment in the tearoom." Allowing the spirit of space to "play an active role," artistic practices inspired by this viewpoint seek to open up not only "the space into which an object is placed, but also the space within it. There is a need to provide visual space so the nonmaterial aspect of the work can interact with and balance its material counterpart" (p. 116). The position underpinning this aesthetic gesture is that all things either grow from or melt into nothingness, with nothingness (*mu*) designating not a negation or barren absence but rather a space of potentiality. Gaps, in this scenario, are the precondition of creativity — invitations to use our imagination to plug them, albeit provisionally. Gaps are sparkling providers of opportunities which do not foreclose any outcomes. This perspective mirrors the teachings of Zen: the "Zen *koan*," according to Richie, is precisely "a riddle constructed to be empty," and it is up to the listener or reader "to fill it" (Richie 2011, p. 47). As Makoto Ueda evocatively reminds us, the gap is the cradle of inventiveness insofar as it holds the potential to "present the indescribable essence of the universe by means of suggestion." Art which is inspired by this conception of emptiness thrives on allusiveness and subtle elision, while shunning ostentatious elaboration in all its guises. "It is in blank space that suggestive power reaches its maximum," argues the critic, "void is fullness" (Ueda, M., p. 223). Just as emptiness, far from being tantamount to bleakness and despair, constitutes the receptacle of infinite potentiality, so "*not knowing*," as Manu Bazzano suggests, is posited as a constructive state, "far removed from the ignorance of small-mindedness as it is from the parochial arrogance of those who think they do know" (Bazzano, p. 10).

In Japanese aesthetics, space often proves inseparable from time. This idea is eloquently demonstrated by the aforecited concept of *ma*. As explained in an article from *Things Asian*, even though the term "is generally translated as 'space' ... it can also mean 'time,'" insofar as it can be seen to allude to "the space between events, as it is being perceived by someone, as well as being expressed by an artist." This is not a space-time established through cold mathematical calculation but actually a "sensory" or even "a 'sensually' perceived space. For musicians and actors, *ma* refers to the expressive space between musical events; it becomes in this sense a measure of artistic expression. For art lovers, it is that space between oneself while perceiving, and what is being perceived in the flow of time. This space is sensory because it determines how our senses are solicited and it is ... 'sensual' because of how our minds will respond to what is aesthetically being perceived or expressed by artists.... The *ma* is thus the perceptual space as our eyes notice things that entice our minds to wander and wonder upon each of these items." Arata Isozaki reinforces the role of *ma* as a defining trait of Japan's spatial sensibility, suggesting that it expresses itself in an avoidance of "three-dimensional, solid spatial composition," and an attendant tendency to "sever time into instances and space into floor areas, and to organize these fragments with intervals ... among them" (Isozaki 1996, p. 41). In the sartorial domain, *ma* designates the spare space between the body and its clothes. This interstitial area is not traditionally conceived of as a dull vacuum but rather as a site endowed with infinite energy and hence incalculable creative potentialities. Contemporary Japanese fashion designers have perpetuated this lesson in several of their most stunning creations.

The supple dimension charted by *ma* finds an apt correlative in the fluid conception of time encapsulated by the principle of *naru*. This is essentially "a becoming ... in which all events of life flow progressively from one to another ... a creative process controlled by a vital energy called *musubi* (literally meaning the spirit of fecundity), which propels the events of life from one state to another through time. In this line of thought, time is viewed as a natural process through which life evolves.... It is a time impregnated with all that it brings to life" ("Aesthetics in Japanese Art"). In this perspective, existence is coterminous with incompleteness, things only are to the extent that they are always in the process of dissolving and transforming, and any manifestation of presence is therefore shot

through with reminders of its underlying or impending absence. In Japanese art, these perceptions have time and again found expression in a deep sensitivity to the fragile yet awesome beauty of the changing seasons. In everyday existence, this life-giving force is honored throughout the year by recourse to seasonal objects and ornaments intended to bolster humanity's bond with nature and its cyclical rhythms. Moreover, the construction of Japan's gardens has been traditionally governed by a desire to incorporate their seasonal changes into their design as major components of their beauty, particular attention being paid to the varying qualities of particular plants.

All in all, Japan's traditional approach to space could therefore be said to be pervaded by the playful spirit of paradox: emptiness is full, presence is absent, revelation is hidden. These aporias coalesce in the quintessentially paradoxical concept of *seijaku*: the capacity to evoke a feeling of energized stillness. According to Patrick Lennox Tierney, *seijaku* is typified by "the calming influence one feels on entering a Japanese Garden.... Silence and tranquillity prevail and all sense of disturbance is absent. Reflections on water often express this principle. Its opposite is noise and disturbance. An old proverb says stillness is activity, therefore *seijaku* is thought of as an active state though its effect is one of calm and unruffled solitude. Its timely and seasonal character has to do with late autumn or early spring, and it is evident at dawn and dusk, in the moonlight and in snow-covered gardens" (Tierney). The affects described by Tierney are distinctive of the particular strand of Zen which encourages the individual to cultivate the arts of introspection, reflection, solitary effort and personal responsibility. At the same time, the symbolic connection between gardens and an atmosphere of vibrant serenity and stillness is consonant with the idea that such spaces ought to embody a utopian haven. As Slawson explains, the "early gardens" indeed served as "perfect receptacles for the foreign religious symbolology — such as Buddhist and Taoist images of paradise — that the Japanese were increasingly importing from the mainland." It is important to recognize, however, that once they had touched Japanese soil, these ideas were not unthinkingly parroted by local designers and artists: in fact, they were processed and reimagined in light of indigenous beliefs. Shintō, in particular, played a major role in "helping these foreign influences to take root in the Japanese garden," since its belief in "the immanence of divine spirit in trees, mountains, rocks, and other nat-

ural phenomena" found an ideal home in a lovingly tended garden where the aliveness of each element could be honored and nourished (Slawson, p. 57).

At the same time as it honors lacunae and paradoxes where the West treasures plenitude, Japan's conception of space evinces a preference for flatness which is starkly at odds with the Western passion for three-dimensionality — and concomitant pursuit of technical rules intended to generate the illusion of depth. In addition, the Western notion of symmetry as formal proportion is quite irrelevant to the Japanese approach to space. As Kawana explains, the importance of asymmetry in Japanese thinking is eloquently attested to by Zen garden design. "Asymmetry involving a preference for the imperfect over the perfect form and shape and a preference for odd rather than even numbers," argues the scholar, is a fundamental characteristic of the art, and "symmetry in shapes or forms" is accordingly "avoided whenever possible" (Kawana). This idea is reinforced by the article "Asymmetry and emptiness: lessons from the tearoom" with close reference to the aforementioned seminal text *The Book of Tea*. Penned by Okakura over a century ago, *The Book of Tea* argues that "uniformity of design" is bound to be "fatal to the freshness of imagination." This proposition is a direct corollary of Zen's "conception of perfection," which cherishes "the process 'through which perfection is sought rather than perfection itself.' True beauty, then, 'could be discovered only by one who mentally completed the incomplete.' Designs which are asymmetrical are more dynamic, active, and invite the viewer in to participate. An asymmetrical design will lead the eye more and stimulates the viewer to explore and interpret the content" ("Asymmetry and emptiness: lessons from the tearoom").

Concurrently, the Japanese approach to spatial harmony is vitally dependent on a distinctive, even idiosyncratic, conception of symmetry which does not pivot, as Mitsukuni Yoshida emphasizes, "on precise geometrical values" in the way Western symmetry of Classical orientation tends to do. On the contrary, it strives to "achieve a balance based on inner meaning rather than shape: in a pair of folding screens, the left-hand screen might represent autumn by a maple tree and the right-hand screen, spring, by a cherry tree. To Japanese eyes such a composition seems symmetrical and well balanced, in spite of the fact that cherry trees and maples are not at all symmetrical as shapes" (Yoshida 1980, p. 18). Spatial orchestrations predicated on the avoidance of symmetry often exude an impression of

irregularity. In fact, asymmetry and irregularity have traditionally come together in the aesthetic dyad of *fukinsei*. This concept bears persuasive witness to the impact yielded by Zen on the development and formulation of Japan's aesthetic principles, since the idea that a sense of overall balance may be achieved by recourse to asymmetrical and irregular forms is axial to the Zen world view at large. This is borne out by the depiction of the *enso* ("Zen circle") in traditional ink wash painting as an incomplete circle. Intended to symbolize life's inevitable imperfection, this evocative shape exploits the sense of imbalance implied by its denial of plenitude in an eminently ironical fashion to convey an alternative idea of harmony. This is a feeling of equilibrium and poise which has nothing to do with the neatly proportioned arrangements required by Classical Western art but actually ensues from vibrant — and potentially incessant — dynamism. The respect for imperfection is confirmed by the fact that Japanese art does not endeavor to efface the process of creation in the way classical Western art has been inclined to do. It is often possible, therefore, to observe traces of the corrections and transformations to which a work has been subjected, to appreciate their value as signs contributing to the work's overall meaning, and to savor the raw markers of productivity as aesthetic attributes in their own right. As Joan Stanley-Baker remarks, "the human qualities of imperfection" are deeply "built into the artwork" (Stanley-Baker, p. 11), frequently in the guise of "rough edges, fingerprints or chisel marks" (p. 13).

The Idioms of Chroma

If Japan's sense of space is an axial component of its traditional outlook, its highly developed and unique chromatic language deserves parallel recognition. The richness of this aesthetic realm is tersely underlined by Kunio Fukuda in the both highly informative and sensually enticing volume *The Colors of Japan*, where he maintains that "many Japanese colors have poetic names, and these poetic associations tend to be more sophisticated than our own rather descriptive 'sky blue,' 'mint green,' or 'blood red.' For the visitor or student of culture, the notions of 'appropriateness' that color associations have in Japan might seem in some occasions like a minefield to be traversed with delicacy. Knowing that white is a funereal color, for instance, might make a guest think twice before offering a bou-

quet of white chrysanthemums" (Fukuda and Hibi, p. 6). Relatedly, it is crucial to remember, as Ikko Tanaka emphasizes, that in Japan, hues "are identified not so much on the basis of reflected light or shadow, but in terms of the meaning or feeling associated with them," which inevitably entails that "the value of colors is determined by their context." Red, for example, may signify "ostentation and vulgarity" but may also be associated with "unexpected beauty," depending on the contingent circumstances of its occurrence (Tanaka).

Color possesses matchless affective powers which are not lessened by knowledge of its scientific triggers. The cultural specificity of color categories and names adds to its magic. One does not need to look as far as the Land of the Rising Sun to glean evidence of this fascinating phenomenon. The Swiss linguist Ferdinand de Saussure (1857–1913) corroborated his contention that language does not describe reality but rather shapes it, and that different languages accordingly develop different versions of reality, by stressing that though colors are conventionally regarded as natural phenomena, they are actually culturally constructed concepts without precise equivalents as one translates from one language to another. Thus, "Russian does not have a term for blue. The words *poluboi* and *sinij*, which are usually translated as 'light blue' and 'dark blue,' refer to what are in Russian distinct colors, not different shades of the same color. The English word 'brown' has no equivalent in French. It is translated into *brun, marron,* or even *jeune* depending on the context. In Welsh, the color *glas*, though often translated as 'blue,' contains elements that English would identify as 'green' or 'grey.' Because the boundaries are placed differently in the two languages the Welsh equivalent of the English 'grey' might be *glas* or *llwyd*" ("Ferdinand de Saussure). In the specific case of Japan, as Fukuda indicates, a good example of the country's culture-bound grasp of colors is "the fact that what an English speaker would call a 'green' traffic light is generally referred to in Japanese as *ao* [blue]" (Fukuda and Hibi, p. 97). Yet, this apparent tendency to see blue and green as "overlapping" concepts does not entail that the colors themselves are treated indiscriminately, since they are in fact understood as distinct fields bridged by a virtually limitless range of blue-green nuances.

The symbolic connotations which are attached to different colors and define their cultural specificity go back to ancient times, and have been handed down with great care from generation to generation as though

32

they were highly valuable possessions exceeding in significance even a costly material artifact. However, these connotations have not proved immutable over the centuries. For example, while polychromatic architectural structures were considered the apotheosis of tasteful magnificence in the seventh century, monochromatic restraint epitomized by the hues of natural wood has been Japan's aesthetic preference for so long that the very thought of colorful architecture is now unpalatable for most people. Japan's approach to color was initially influenced by Chinese art and philosophy — especially by the theory of the Five Elements or Five Movements (*Wu Xing*), and by Chinese artists' figurative construal of that theory. As Yoshida points out, contemporary Japanese culture is still indebted to China's ancient color scheme, consisting of "blue, red, yellow, white and black," and to their association with the elements of "wood, fire, earth, metal and water" which *Wu Xing* posits as the fundamental ingredients of the entire universe (Yoshida 1980, p. 19). In spite of China's pervasive influence, Japan's own color sensibility has evolved in an autonomous fashion. Indeed, in developing their chromatic register, the Japanese have been primarily inspired by the indigenous landscape and, more specifically, by an intuitive sensitivity to the nature of colors as living entities which alter, much as breathing organisms do, in accordance with nature's cycles. Various colors have been inspired by seasonal changes, and carefully matched to the requirements of different times of the year and related climatic features. This tendency is exemplified by the custom of using cool hues in the design of summer clothing and accessories to counterbalance the more disagreeable effects of heat and humidity. As Tohru Haga maintains, "when wearing a *yukata* on a hot summer evening, one could not be without an *uchiwa*, or round fan, both to stir the breezes and banish the persistent mosquitoes. These bamboo frame fans covered with paper were usually printed with designs using *ai* blue [indigo] as the main color in order to accentuate the image of coolness." The use of *ai* in the production of "mosquito nests," likewise, "was an attempt to create at least the illusion of coolness" (Haga).

Nowhere are seasonal changes recorded more palpably than in the local vegetation, as attested to by the iconic significance of cherry blossom and red leaves across Japanese culture. It is not surprising, therefore, to find that color terms have often alluded to plants and flowers. As Fukuda explains, "literary terms for colors that derive from seasonal plants and flowers, along with the names of colors created with vegetable dyes, account

for an overwhelming proportion of the traditional color vocabulary." So dominant is the vegetable kingdom in Japan's color system as to push the mineral and animal realms to the outermost periphery. Hence, "the only color-name one finds that is related to precious stones is *kohaku-iro* (amber), while names derived from the color of the fur of mammals are limited ... to *kitsune-iro* ('fox-color') and *nezumi-iro* ('mouse-color,' gray)." Several of the terms "adopted for dyes," conversely, are inspired by "birds" but these are "limited to common species," such as ducks and sparrows" (Fukuda, p. 98). Japan's elemental chromatic register encompasses red, blue, brown, green, purple, white, black, gold, and silver. In Japan, as in countless other cultures, red derives unique symbolic power from its association with the forces of "blood and fire." In addition, it is honored as "the color of the sacred" (p. 8), as vividly borne out by the employment of vermilion red in the creation of the classic *torii*: the Shintō gateway leading to a shrine, and hence a pivotal component of the indigenous religion and attendant world view. Concurrently, red has served for long as a signifier of authority: an attribute it derives from its use in official seals over the centuries. The vermilion seal is still used nowadays as a regular equivalent of a person's signature in all areas of everyday life.

Blue, like red, carries universal resonance among humans, feasibly because of its association with the life-giving power of water and the transcendental marvel of a cloudless sky. Yet, also like red, it holds special significance in Japanese history, its pervasiveness in myriad facets of native art, everyday accessories and apparel being unequaled by any other hue. Lafcadio Hearn (1850–1904) was among the first to comment on this interesting chromatic phenomenon in his copious writings on Japan, highlighting "among his first impressions" of the country the ubiquity of blue in disparate items and settings: e.g., "the indigo *noren* (short divided curtains) hanging over shop entrances, the tall indigo banners serving as advertisements, the predominant blue of people's dress, fields of indigo in the low foothills, and indigo-dyed cloth hung out to dry in front of private homes" (p. 28). Even people with the most cursory knowledge of Japanese art will plausibly have taken cognizance of its iconic blue-and-white pottery and porcelain. As a matter of fact, this same color combination is still popular to this day in the realms of fine art and mass production alike.

Although, as noted, ancient Buddhist architecture influenced by Chinese models employed lavish polychromatic ornamentation, Japan's own

chromatic sensibility has traditionally favored the natural hues of unpainted wooden surfaces. This preference is entirely congruous with the ethos of simplicity, modesty and restraint which, as will be argued in some detail at a later stage in the discussion, could be regarded as the quintessence of Japanese aesthetics, and has found expression in a variety of indigenous arts and customs. It is not surprising, in light of these proclivities, that what we call brown should have featured pervasively in Japanese culture for time immemorial. What is, however, intriguing is the fact that "it is doubtful whether the Japanese have thought consciously of it as a color in its own right. In the languages of Europe, equivalents of the English 'brown' ... have existed since ancient times as color-names.... But *chairo* ('tea color'), the normal name for the same color in Japanese, is relatively new, not having appeared until, in the Edo period (1600–1867), the custom of drinking tea became widespread" (p. 38). This suggests a *spontaneous* sympathy with the color, consonant with Japan's likewise uncalculated attraction to the beauty of simplicity. Like brown, green stands for nature at its most unadulterated and productive. The Japanese term *midori*, translatable as both "green" and "greenery," symbolizes youthfulness, freshness, rejuvenation and rebirth. Evergreens, and specifically the pine, appear regularly as both actual trees (full-size or miniaturized) and motifs in interior decoration, while moss plays a key role in garden art as the favorite signifier of the "pleasing patina of age" (p. 46): an aesthetic attribute which, alongside simplicity, sustains the edifice of Japanese aesthetics as an indispensable pillar.

Though commonly rendered in English as "purple," the Japanese color term *murasaki* in fact embraces a wide scale of variations which include our lilac, violet, amethyst, magenta, mauve, periwinkle, mulberry, plum and wine (and this list is not exhaustive). Idealized as the supreme emblem of dignity and aesthetic refinement since ancient times, purple is still regarded today as the archetypical signifier of nobility and sanctity. An especially inspiring use of this color term can be found in *The Tale of Genji*: as Fukuda emphasizes, "the woman of infinite physical and mental charm who was the hero's best beloved companion throughout his life is given the name Murasaki, signifying a paragon among her sex" (p. 60). White carries mystical connotations as a symbol of absolute purity, as demonstrated by the use of "white pebbles or white sand" to mark "places associated with the gods" (p. 70). In addition, as Yoshida observes, "delicate

white symbols made of the bleached fiber of the bark of the paper mulberry or other trees" have been traditionally employed as a means of communicating with the divine. "Such symbols, called *yushide*, were affixed to the ever-greens or other trees that were considered to possess the spirit of the divine" (Yoshida 1985, p. 26). At the same time, birds "with pure white wings, like the crane (*tsuru*) and the snowy heron (*sagi*) seemed half-mystical.... The rooster that crows at dawn, for example, was thought to drive away the evil deities of darkness, and herald the return of the deities of light and goodness" (p. 74). In spite of its widespread association with the spiritual domain, when white is combined with red, it acquires novel connotations: in this instance, as Tanaka points out, "it is instantly transported to the realm of the mundane and the human," functioning as "*yang*" in contrast with "red as *yin*" (Tanaka). As the natural counterpart of white in the ideal vision of cosmic harmony, black is considered one of the most venerable hues, and declares its special authority in two major expressions of Japan's creative output: "the beauty of black lacquer with its burnished, mirror-like surface," which "exerts the same fascination over us today as it did over the nobles of the Heian period," and "ink painting," where black is held capable of evoking "all other colors" and, by implication, "all the phenomena of the universe" (Fukuda, p. 72). In combination with red, however, black undergoes a radical metamorphosis, as the two hues work together to evoke a compelling current of "sexuality," red playing the part of *yang* and black that of *yin* (Tanaka). Gold has featured prominently in Japanese culture as a prime attribute of Buddhist art, and particularly of its visions of paradise, in both architecture and interior design, as well as in the decorative arts. Silver, conversely, is used sparingly, and "always in a supplementary role to gold." What deserves special attention, from an aesthetic viewpoint, is the stance to both hues fostered by traditional Japanese culture. Indeed, since "the Japanese are not particularly interested in private possession of precious metals as symbols of wealth or authority," gold and silver have generally been used "for special, or non-practical purposes" (Fukuda, p. 86).

Ultimately, the uniqueness of the Japan's color ethos does not lie so much with any one hue or set of hue as with its spontaneous attraction to what Yoshida terms "the beauty of the intermediate shades that lie between the five colours." This preference has traditionally resulted in a deep appreciation of "the aesthetic value of the harmonious mixture that results when

they are combined with one another." Appreciably contributing to "the emergence of a feeling for elegance and grace," this aesthetic was first cultivated by "the ladies of the Heian period ... who were the first to discover and develop an appreciation of the beauty of these blended colours" (Yoshida 1980, p. 19). In Heian culture, and particularly in the sartorial realm, color asserted itself as both a pivotal marker of social identity, and a work of art of independent value, as exquisitely demonstrated by the season-coded chromatic gradations evinced by the *jūnihitoe* ("twelve-layer robe"). As Fukuda observes, "the courtly poetry and prose of the Heian period" fostered an analogous disposition, as borne out by their inclusion of "countless elegant names for colors and color combinations derived from associations with the seasonally changing colors of the natural scene" (Fukuda, p. 98). The proclivity to create chromatic ensembles capable of both mirroring and honoring nature's rhythms still characterizes the traditional kimono, where both patterns and colors themselves change with the season or even the month. The essay "Japanese Traditional and Ceremonial Colors" elucidates this idea by enumerating the principal hues at play in the refined game of layering:

- **January** *Pine:* sprout green and deep purple
- **February** *Redblossom plum:* crimson and purple
- **March** *Peach:* peach and khaki
- **April** *Cherry:* white and burgundy
- **May** *Orange Flower:* deadleaf yellow and purple
- **June** *Artemesia:* sprout green and yellow
- **July** *Lily:* red and deadleaf yellow
- **August** *Cicada wing:* cedar bark and sky blue
- **September** *Aster:* lavender and burgundy
- **October** *Bush Clover:* rose and slate blue
- **November** *Maple:* vermilion and grey-green
- **December** *Chrysanthemum:* lavender and deep blue ["Japanese Traditional and Ceremonial Colors"].

Over the centuries, the aesthetic preference for intermediate nuances and subtle blends over undiluted hues has resulted in the conception of a variety of neutral shades combining several colors. Some of the available mixes are so understated as to seem infinitesimal or even pointless to Western eyes unaccustomed to their subtlety—a case in point is "the color

moegi, a neutral tint corresponding to the green tinged with yellow color of onion tops as they sprout, and slightly darkened by the addition of gray so that it is more like strong green tea." At the same time, one and the same fundamental color can be endowed with a broad range of poetic associations depending on its context. A paradigmatic example is provided by the names employed in different seasons or times of the day to describe the color of the morning glory (*asagao*), a flower which countless artists and poets have adopted as the supreme symbol of artless beauty. "Among the many colors of the morning glory," Haga explains, "perhaps the most closely associated with this flower is the color *ai* or indigo blue ... it is the color of water that, cascading down a mountain over jagged rocks, eddies gently in a deep pool." This lyrical chromatism is not, however, stable insofar as seasonal transitions call different hues into play. Thus, "when the indigo blue or deep blue of the morning glory is somewhat paler, it is known as *ao* (blue) or *mizuiro* (sky blue). It is the color of an early summer or early autumn sky or of shallow lakes or rivers that mirror such skies." By contrast, "when blue is dark, it is known as *kon* (dark or navy blue). In some case, when all strong light is eliminated and a shade of purple added, it is *shikon* or purplish blue." The intriguing case of the *asagao* shows that even a single specimen of nature's infinite treasures may disclose a broad variety of shades and, by implication, of metaphorical extrapolations — in this specific instance, these range "from a bright blue, clear mid-summer sky dotted with puffy white clouds and the billowing ocean that reflects it to the towering gray-blue silhouette of Mt. Fuji viewed from the adjacent seacoast, to the purplish blue of the delicate *nasu*, the small Japanese eggplant. All these hues may be found in the morning glory as well" (Haga).

Key Concepts in Japanese Aesthetics

Before embarking on a survey of the principal ideas which have come to define the field of Japanese aesthetics, it is necessary to acknowledge that all of these notions are rooted in a shared aesthetic attitude: a sensibility which appears to have coursed Japanese society over many centuries of change as an enlivening lymph, tenaciously withstanding the injuries of time, and influencing profoundly its perception of life. As to the precise

reasons for which such a sensibility should have emerged, these remain largely a matter of conjecture. An intriguing interpretation, advanced by Shūichi Katō, deserves attention as an exemplary argument — not because it is conclusively reliable or convincing but rather because its admirable boldness endows it with the power to challenge us to ponder further the possible causes of Japan's aesthetic disposition. In Shūichi's opinion, it was the country's seclusion which caused Japanese culture to become intensely focused on its internal artistic values: "Japanese culture became structured with its aesthetic values at its center. Aesthetic concerns prevailed even over religious beliefs and duties." Buddhist sculpture of the Heian age supplies a vivid example of this evolving trend, being a case not of an art "illustrating a religion" but rather of "a religion becoming an art." The metamorphosis of religion into art is further documented by the "gradual dissolution" of the "originally mystic discipline" of Zen "into poetry, theater, painting, the aesthetics of tea ... in one word, into art" (cited in Richie 2007, p. 68).

One of Japan's most renowned aesthetic concepts is undoubtedly that of *mono no aware*: loosely translatable as the "sadness of things," this describes the pathos associated with a person's sensitivity to the ephemerality of beauty and pleasure. Although this translation is widely accepted, it is important, given the term's multiaccentuality and semantic evolution, to look at its actual roots in indigenous usage. As William Theodore de Bary explains, "in old texts we find it first used as an exclamation of surprise or delight, man's natural reaction to what an early Western critic of Japanese literature called the 'ahness' of things, but gradually it came to be used adjectivally, usually to mean 'pleasant' or 'interesting.'" Over time, however, the phrase acquired more somber affective connotations and to be therefore "tinged with sadness.... By the time of *The Tale of Genji* [eleventh century] ... it bespoke the sensitive poet's awareness of a sight or a sound, of its beauty and its perishability." The eighteenth-century scholar Motoori Norinaga associated *mono no aware* specifically with the atmosphere which pervades *The Tale of Genji* from start to finish, using the term in a fashion which renders it equivalent to either the "sadness of things" or "sensitivity to things" (de Bary, p. 44). It could in fact be argued that the Heian Period as a whole (794–1185) enthroned *mono no aware* as an aesthetic dominant and, by extension, a cultural definer of its identity as a distinctive culture. The feeling of *aware* is characteristically associated

with the transient glory of cherry blossom and autumn leaves, as well as mournful bird song or the call of wild animals at dusk. When the concept of *mono no aware* is expanded to encompass the emotive dimension of life at large, one often discovers that it is through ostensibly inert objects that the world's pathos is most effectively conveyed. Quite a different aesthetic interpretation of transience is the one typically associated with the Edo Period (1603–1868). This was an era characterized by tantalizing, and often deep, internal contractions: not least, as de Bary emphasizes, its simultaneous adherence to "strict Confucian principles" and "devotion to sensual pleasures." The key aesthetic concept which acquired special significance in the Genroku era (1688–1703), "the most brilliant part" of the Edo Period, was that of *ukiyo*. "In Heian literature," the critic explains, "the word was used to mean 'sorrowful world,' and was a typical Buddhist description of the world of dust and grief. However, about 1680 the same sounds acquired a new meaning, by making a pun between *uki* meaning 'sorrowful' and *uki* meaning 'floating,' The new term. the 'floating world,' was quickly taken up, probably because it gave so vivid a picture of the unstable volatile society which had succeeded the medieval world of sorrow and gloom" (pp. 69–70). The most illustrious embodiment of this principle no doubt consists of the woodblock prints known as *ukiyo-e*, i.e., "pictures of a floating world," which often depicted figures and locales readily identifiable as symbols of intense yet fleeting pleasure: courtesans, Kabuki actors, sumo wrestlers, redlight districts, festivals and parties, alongside exquisite landscapes which many people have often considered emblematic of Japanese art in its entirety.

Transience is also central to the notions of *kire* ("cut") and *kire tsuzuki* ("cut continuity"), concepts indebted to Zen's contention that if the self is to experience the world unshackled from contingent desires, it must let go of its hold on the here-and-now, harmonize its actions and affects with the impermanence of the world at large (*mujō*), and ultimately accept that the self itself is essentially nothing. The intuition of beauty in both nature and art pivots on an aesthetic stance resulting from this vision of the self. According to Steve Odin, "the traditional Japanese sense of beauty" indeed posits this quality "as a function of an aesthetic attitude of disinterested contemplation through insertion of psychic distance" (Odin, p. 19). This aptitude for detached and impartial observation is a direct upshot of the Zen world view, and specifically of its cultivation of "the egoless state of

'no-mind' (*mushin*) or 'no-self' (*muga*)" (p. 155). Such an attitude is ultimately a prerequisite for the proper appreciation of any aesthetic quality. Nō theater paradigmatically exemplifies the importance of aesthetic detachment to the extent that its aesthetic and dramatic effectiveness is conditional on the propensity for unbiased, selfless contemplation: "it is the shift away from the personal standpoint of *gaken* or 'ego perception' to the transpersonal standpoint of *riken no ken* or 'the seeing of detached perception,' which enables both actor and audience to fuse together into an undivided aesthetic continuum of heightened artistic awareness" (p. 115). In the ethos promoted by *kire*, organic and inorganic creatures alike partake of the same existential condition: rootlessness. Portraying life as it truly is, therefore, means exposing its lack of definitive anchors. The time-honored native art of floral arrangement, "*ikebana*," reflects this stance insofar as it is precisely by severing the living flower from its roots in the earth that the designer reveals its genuine nature as a fleeting entity. As Makoto Ueda observes, *ikebana*'s "ultimate aim" is "to represent nature in its innermost essence" (Ueda, M., p. 86). The word indeed translates as "make flowers live" since it originates in the combination of *ikeru* ("to live") and *hana/bana* ("flower"). The pointedly stylized fashion in which performers move in classic Nō theater further exemplifies the principle of *kire*. The actor typically shifts the foot along the floor with the toes lifted and then abruptly interrupts the motion by dropping the toes to the floor. The instant the toes touch the stage, the other foot starts performing the very same movement in its turn. This dramatic convention underscores the intrinsically discontinuous character of all life. Moreover, the cut is the axial mechanism regulating the rhythm of classic Zen meditation itself (*zazen*). The pause placed between exhalation and inhalation is intentionally more protracted than the interval separating inhalation from exhalation, which intimates in symbolic form the idea that life could be dissolved at any point.

The breakdown of Heian culture was marked by horrific wars and natural disasters, which some interpreted as inevitable corollaries of the state of moral degeneracy into which the once dazzling society had precipitated in the course of its sunset years. Surprisingly, this radical disruption of Japan's fabric did not lead to a correspondingly drastic redefinition of its aesthetic principles. Even though the warrior who ultimately unified the country's opposed factions, Hideyoshi Toyotomi, was a man of very

humble origin (his father was a peasant foot soldier), neither he nor his followers sought to dismantle the courtly ideals of Heian society in favor of values more consonant with the lower classes. In fact, "the new aesthetic standards in literature and art which eventually emerged did not represent a sharp break with the past, but were instead an intensifying and darkening of the Heian ideals" (p. 50). Of all the principles current in the period stretching from the twelfth to the seventeenth century, the most prominent was *yūgen*. Etymological analysis of this concept indicates that it comprises two interrelated ideas. As Makoto Ueda explains, "*yū* means deep, dim, or difficult to see," while "*gen*, originally describing the dark, profound, tranquil color of the universe, refers to the Taoist concept of truth" (Ueda, M., p. 60). *Yūgen* epitomizes a ubiquitous preference in Japanese art: namely, its tendency to give precedence to suggestion over direct statement, to haziness over distinctness, to inconclusiveness over finiteness, and to evocative shadows over revelatory light. *Yūgen*, specifically, promulgates the deliberate avoidance of the obvious and the explicit in favor of the allusive and the veiled. Seeking to discern "the subtleties of nature," as Tierney explains, *yūgen* valorizes "the suggested rather than the totally revealed aspects of it. It involves partly hidden views of indistinct areas sometimes relative to shadows, partial reflections and darkly revealed forms. *Yūgen* hints at extra layers of meaning which are not at first obvious to the casual viewer" (Tierney). Leon corroborates this view, maintaining that in the logic of *yūgen*, "real beauty exists when ... only a few words, or few brush strokes, can suggest what has not been said or shown, and hence awaken many inner thoughts and feelings" (Leon).

Yūgen will shortly be returned to. It should first be noted, however, that the preference for suggestiveness is intrinsic to several of the aesthetic principles which have shaped Japanese culture over the centuries. A good example is *miegakure*, which De Mente portrays as "the effect, the power, of getting only tantalizing glimpses of something, such as the moon alternately being obscured by clouds, or seeing a woman's leg in the slit of an ankle-length gown" (De Mente, p. 78). Another notable instance is *iki*: a word which, in its contemporary usage, is practically synonymous with "trendy" or "cool." These modern attributes are themselves suggestive rather than descriptive since they lend themselves to contrasting interpretations. Accordingly, the qualities which they are supposed to connote are more a matter of hypothesis than one of truth, and can therefore only be

glimpsed or imaginatively intuited. In the past, as Makoto Ueda indicates, the concept of *iki* encompassed an even greater range of allusions which comprise ethical as well as strictly aesthetic properties: "aesthetically it points toward an urbane, chic, bourgeois type of beauty with undertones of sensuality. Morally it envisions the tasteful life of a person who was wealthy but not attached to money, who enjoyed sensual pleasure but was never carried away by carnal desire" (*Kodansha Encyclopedia of Japan*). As Odin points out, "the aesthetic ideal of *iki* arose in the government-regulated centers for prostitution in Edo-period Japan that have come to be referred to poetically as the 'floating world' (*ukiyo*)" (Odin, p. 158). A particularly interesting interpretation of the concept of *iki* can be found in the writings of the modern philosopher Shūzō Kuki, who, as Stephen Light explains, "sets forth a decadent aestheticism based on the high-fashion ideal of *iki*, or 'stylishness,' wherein erotic feelings and other sensual pleasures are sublimated into highly refined sensations by the aesthete, dandy, or connoisseur (*tsūjin*)." It is typical of such a character to evince an "impartial attitude of disinterested contemplation" (p. 157). In Kuki's view, the concurrently "moral and aesthetic" ideal of *iki* is personified by the figure of the floating-world courtesan, the geisha, as "a harmonious union of voluptuousness and nobility" (Light, p. 87). According to Odin, the "moral-aesthetic ideal of *iki*" elaborated by Kuki "reveals a paradoxical union of contradictory tendencies such as the sensual and the noble to be found in both the artistic sensibility cultivated in Edo-period bordello life and French decadent aestheticism" (Odin, p. 159). Kuki indeed maintains that "sensual pleasure animated by a noble spirit is testament to a great idealist civilization," bolstering this bold contention with the assertion that this is "the reason why Baudelaire, for example, has so many admirers in Japan" (Light, p. 88).

Returning now to *yūgen*, it is noteworthy that this term, as de Bary points out, was traditionally "used to describe the profound, remote, and mysterious, those things which cannot easily be grasped or expressed in words." While *yūgen* may be grasped on an intuitive level, it defies rationalization: in this respect, it is faithful to Zen's disregard for conceptualization as a process inimical to true understanding. It is in Nō drama that *yūgen* finds its most consummate expression insofar as in this context, each of an actor's movements is intended to allude to a semiotic *excess*—an undefinable element which both surpasses physical motion and verbal

expression per se. As de Bary observes, "when a Nō actor slowly raises his hand in a play, it corresponds not only to the text which he is performing, but must also suggest something behind the mere representation, something eternal — in T. S. Eliot's words, a 'moment in and out of time' ['Choruses from *The Rock*']. The gesture of the actor is beautiful in itself ... but at the same time it is the gateway to something else ... a symbol not of any one thing, but of an eternal region, of an eternal silence" (p. 51). The aesthetic preference for approximation, adumbration and inconclusiveness springs largely from a desire to foreground the unfathomable dimension of creativity as instrumental in the evocation of beauty. As Nancy G. Hume evocatively puts it, "when looking at autumn mountains through mist, the view may be indistinct yet have great depth. Although few autumn leaves may be visible through the mist, the view is alluring. The limitless vista created in imagination far surpasses anything one can see more clearly" (Hume, pp. 253–254). Bashō's *haiku* embody this vision with unique incisiveness: "Spring / A hill without a name / Veiled in morning mist" (cited in Bazzano, p. 46). Another memorable depiction of the special charm of the vague and the ineffable is offered by the thirteenth-century writer Kamo no Choumei: "it is like an autumn evening under a colorless expanse of silent sky. Somehow, as if for some reason that we should be able to recall, tears well up uncontrollably" (cited in "Japanese Aesthetics"). The works of the Edo-period poet Fukuda Chiyo-ni (a.k.a. Kaga no Chiyo) convey a related mood through images which, ironically, come across as palpable by remaining undefined: "green grass — between, between the blades / the color of water" (cited in Bazzano, p. 62).

No less axial to Japan's aesthetic inheritance than the aforementioned concepts are the mutually related tenets of *wabi* and *sabi*. According to Suzuki, the former can be translated as "poverty" (Suzuki 2010, p. 23) and, if described with reference to ordinary existence, can be regarded as an appreciation of the special beauty inherent in simple things, modest achievements, and unassuming attitudes. It is the beauty of a small and sparsely adorned room, of a basic meal consisting of freshly picked and ungarnished ingredients, of listening to rain tapping on the window. According to Haga Kōshirō, as an aesthetic ideal which values the modest, the imperfect and the unadorned, *wabi* embodies "a beauty of great depth which finds its expression in simple and unpretentious terms,"

thus offering "an aesthetic of unequal composition in which the most important component lies within that which is being overtly expressed.... It is a beauty ... that detests excess of expression and loves reticence, that hates arrogance and respects the poverty that is humility" (Kōshirō, p. 247). The related principle of *sabi*, as David Pascal explains, designates "pleasure in that which is old, faded, lonely ... a love of imperfection" (Pascal). According to Kōshirō, "*sabi* was a very old word, found as far back as the *Manyōshū* [a.k.a. 'Collection of Ten Thousand Leaves," c. 759 A.D.], where it has the meaning of 'to be desolate.' It later acquired the meaning of 'to grow old' and it is related to the word 'to grow rusty.'" By the thirteenth century, it had come to designate "not only 'old' but the taking pleasure in that which was old, faded, and lonely" (p. 53). Being seen not as ends in themselves but rather as emblematic of "remoter eternities," these qualities are deemed "capable in themselves of giving deep pleasure" (p. 54).

According to Juniper, artistic practices inspired by the principles of *wabi* and *sabi* mirror the lifestyle of Zen monks in that they aim primarily "to try and express, in a physical form, their love of life balanced against the sense of serene sadness that is life's inevitable passing." In so doing, they convey an all-embracing feeling of "simplicity" emanating from a consummate grasp of the values of "humility, restraint, naturalness, joy, and melancholy as well as the defining element of impermanence," and thus encourage us to "rediscover the intimate beauty to be found in the smallest details of nature's artistry" (Juniper, p. ix). In De Mente's opinion, this world view originated in the earliest manifestations of Shintō as a form of "nature worship that included paying extreme attention to the details making up things in nature." With the introduction of Zen Buddhism to Japan, the attraction to details gained fresh impetus in accordance with the Zen proposition that "the form or shape of something is not correct until it has been paired down to its essence" (De Mente, p. 67). Concurrently, the passion for smallness — still notable toady at practically every level of Japanese art and design — strikes its roots in "reverence for the finest details of nature" (p. 69). Central to the principles of *wabi* and *sabi*, this philosophical attitude also underpins the Zen idea of *kanso* ("simple," "plain"): an aesthetic ideal which often manifests itself as a desire to condense things down to their quintessence.

Neither the stark humility of *wabi* nor the subdued maturity of *sabi*

should be confused with crudeness or artlessness since the achievement of the distinctive kinds of beauty they communicate, both individually and as a pair, actually result from attentive dedication to their tiniest details. However unpretentious their objects might seem, great care is lavished on the evocation of their inner qualities. Thomas Hoover upholds this contention with particular reference to Zen ceramic art: "making a bowl with *wabi* is considerably more difficult than making a smooth, symmetrical, perfectly glazed piece. The creation of contrived 'accidents,' on which much of the illusion of artlessness depends, is particularly difficult. Everywhere there are scars, contaminants, spotty glaze — all as deliberate as the decoration on a Dresden plate.... The same skill goes to make a piece look old, the essential quality of *sabi*. By suggesting long years of use, the bowls acquire humility and richness.... The potter's genius has gone to create the sense of *wear*, a quality considerably more difficult to realize than an aura of newness" (Hoover, pp. 197–198). This creative attitude imbues the art object with a deep sense of awe as both an intimation and an echo of nature's inexhaustible splendor. At the same time, insofar as its intuitions find form in deftly balanced constellations of diverse or even incongruous elements, they rarely fail to emanate an aura of sedate elegance. Ultimately, awe and elegance meet in simplicity because simplicity is the hardest thing to accomplish, but when it is realized — intuitively, modestly, and patiently — then it has the power to yield both the most sublime and the most graceful of perceptions. Bashō's poetry captures the mood of both *wabi* and *sabi* with arresting freshness — for example: "Solitary now / Standing amidst the blossoms / Is a cypress tree" (cited in "Japanese Aesthetics"); and: "What fun, / it may change into snow — / the winter rain" (Bashō; cited in Bazzano, p. 18).

The preference for simple forms is corroborated by Japan's pictorial tradition. In this realm, simplicity is epitomized by a representational style in which the very soul of Zen finds paradigmatic expression: the so-called "one-corner" approach. Simplicity is here married to another quintessentially Japanese value which is still prominent in contemporary design: compactness. As Suzuki explains, the one-corner method revolves around one essential criterion: the employment of "the least possible number of lines or strokes which go to represent form." A classic example of such simplicity is the picture of "a simple fishing boat in the midst of the rippling waters," executed with the most economical handling of both lines and shades.

Though disarmingly basic, the same image is also able to capture the idea of the sublime as an intimation of the infinite, of the unquantifiable, of the unrepresentable and, above all, of the coexistence in life of apparently incompatible realities. Hence, the little boat "is enough to awaken in the mind of the beholder a sense of the vastness of the sea and at the same time of peace and contentment — the Zen sense of the Alone" (Suzuki 2010, p. 22). Within this ironical outlook, the boat's exposure to a potentially crushing environment functions at once as a sobering reminder of humanity's vulnerability, and as a heartening marker of the resilience and pluck which even the puniest of creatures may evince in the face of the overwhelming. Bashō's *haiku* convey a similar intuition of the "Zen sense of the Alone," often infused with touches of *yūgen*. As Stryk comments, in these poems, "the poet presents an observation of a natural, often commonplace event, in plainest diction, without verbal trickery. The effect is one of sparseness, yet the reader is aware of a microcosm related to transcendent unity. A moment, crystallized, distilled, snatched from time's flow, and that is enough. All suggestion and implication, the *haiku* event is held precious because, in part, it demands the reader's participation" (Stryk, p. 12).

While the Japanese language has indubitably abounded for centuries with subtly nuanced aesthetic terms, it has also no less persistently shown a liking for formulae meant to define and differentiate in relational terms certain key ideas considered applicable to a great variety of contexts. As Richie indicates, one such structure is "the three-part formula" commonly known as "*shin-gyō-sō*. The first term, *shin*, indicates things formal, slow, symmetrical, imposing. The third is *sō* and is applied to things informal, fast, asymmetrical, relaxed. The second is *gyō* and it describes everything in between the extremes of the other two…. A *shin* garden, for example, is usually both public and grand…. A garden deemed *gyō* is both formal in some aspects and informal in others…. The *sō* garden is decidedly informal" (Richie 2007, p. 59). The same basic formula can be invoked to define tonal differences "in terms of strength and warmth." Richie bolsters this contention by recourse to an amusing range of seemingly random but in fact wonderfully apposite examples: "thus cats are *shin* but dogs are *sō*. In the same way Sean Penn is very *shin* though Brad Pitt is quite *sō*. Or Mozart is a very engaging aspect of *sō* tempered with *shin*, while in Beethoven we have *shin* tempered with *sō*, and Brahms is all *gyō*" (p. 63).

Anime Examples

Several of the principles, and related philosophical perspectives, discussed in this chapter find vibrant exemplification in some of the most renowned anime classics. Countless anime engage visually and symbolically with *mono no aware* in their depictions of nature. This key concept is often captured through sequences dominated by cascading *sakura*, or cherry blossom: a natural entity that is traditionally celebrated not only as a generalized harbinger of spring but also as a marker of moments of rebirth charged with mythological implications. This is borne out, for example, by Rintaro's movie *X* (1996), where ethereal *sakura* bless the otherwise spine-schilling sequence in which the hero's mother extracts a portentous sword from her very body. *Sakura* may also be deployed to signify fresh beginnings. School-based yarns, in particular, capitalize on the fact that the Japanese school year begins in April, and use cherry blossom as the protagonist of enchanting sceneries intended to evoke an atmosphere of promise and hope. The opening of Tatsuya Ishihara's TV series *Clannad* (2007) typifies this idea with arresting grace. While symbolizing regeneration and the stirrings of first love, *sakura* are also inevitably associated with the ephemerality and fragility of both beauty and love — as well as, ultimately, of life itself. The cinematic employment of cherry blossom specifically as a shorthand for transience is epitomized by Makoto Shinkai's movie *Five Centimeters Per Second*, here also addressed in Chapter 3: a touching tale of deferred desire whose very title alludes to the speed at which the petals make their earthward descent upon leaving the bough. It is also worth observing, given the Japanese penchant for ambiguities, that *sakura* are sometimes associated with death. A truly sensational evocation of this idea is offered by Shunsuke Tada's OVA *Tsubasa: Spring Thunder* (2009), where the heroine's demise is marked by her body's dissolution into a deluge of pink petals. Another outstanding example of symbol-laden cherry blossom is offered by Nagisa Miyazaki's TV series *D. C.— Da Capo* (dir., 2003), where the magic of the setting, the crescent-shaped island of Hatsune Jima, is evoked precisely by the omnipresence of cherry trees which flower all year long. These are simply a handful of examples of a widespread proclivity to sprinkle anime's landscapes with images of *sakura* petals gliding on the breeze, bathing the world in a pink mist, summoning students to the beginning of a new school year, or metaphorically

alluding to ancient Japan's rich mythology. Relatedly, anime abounds with scenes recording a major *sakura*-related custom, the *hanami*: a party traditionally devoted to the viewing of the blossom under the blooming trees but commonly used as a pretext for jolly picnics replete with inebriating beverages. Exemplary representations of this event can be found in Junichi Satō's TV series *Sailor Moon* (1992–1993) and in Kazuo Yamazaki's movie *Lum the Forever* (1986). Yutaka Izubuki's TV series *RahXephon* (2002), finally, yields a tantalizing variation on the *sakura* theme with its use of trees whose flowers display blue petals as a means of capturing one of the anime's major thematic premises in a visually concise symbolic fashion.

If *mono no aware* makes frequent appearances in anime, finding a natural objective correlative in cherry blossom, the related concepts of *wabi* and *sabi* are also accorded significant roles. Especially memorable dramatizations of these principles are offered by the representations of rural living found in the films *My Neighbour Totoro* (dir. Hayao Miyazaki, 1988) and *Only Yesterday* (dir. Isao Takahata, 1991)—both of them fruits of Studio Ghibli's globally acclaimed genius. In *My Neighbour Totoro*, the dwelling to which the protagonists move upon leaving the city, and which they instantly proceed to explore with great alacrity, is closely modeled on traditional indigenous country houses. Its creaky floorboards and rattling window panes, sooty attic and clanking pipes, combined with the painstakingly rendered feel of wood, stone and straw, incarnate the spirit of *wabi* and *sabi* with incomparable beauty, attesting to the unparalleled lyricism of all objects that have been caressed by time. *Only Yesterday* likewise encapsulates the ethos of *wabi* and *sabi* with its rural buildings and attendant accessories. At the same time, however, it also endeavors to embody those ideals in its visual style, opting throughout for muted and faded palettes, mellow lighting, and delicate contours. Both movies, moreover, punctuate their interpretations of *wabi* and *sabi* with poetic allusions to *yūgen*. In *My Neighbour Totoro*, these find expression in the sequences featuring the titular creature and its companions, and are characteristically tinged with folkloric and mythical connotations. In *Only Yesterday*, by contrast, they emanate from a fundamentally realistic take on native traditions, as shown most spectacularly by the atmosphere of ceremonial awe which bathes the sequence set in a safflower (*benibana*) field at dawn. A no less notable, albeit very different, interpretation of the principle of *yūgen* is supplied by Hideaki Anno's epoch-making OVA *Gunbuster* (1988)

through its deft manipulation of palettes. As argued in detail earlier in this chapter, color is one of the most remarkable aspects of Japanese culture, and is indeed internationally recognized as one of its most distinctive qualities. Yet, Japanese artists have often opted for monochrome techniques in order to convey their visions most incisively, and to honor the Zen-inspired aesthetic lessons which place inconspicuous beauty above all else. *Gunbuster* reflects this proclivity in its closing episodes, filmed entirely in black and white. The somber mood evoked by this technique is heightened, in the final installment, by a palpable sense of the unfathomable sublimity of space reminiscent of *yūgen* at its purest. Within the realm of anime, *yūgen* reaches its apotheosis with yet another Miyazaki masterpiece: *Princess Mononoke* (1997). Informed by the teachings of Shintō, this film relies on the subtle power of suggestion to impart an awesome aura of vitality, sentience and will on every aspect of the natural environment, down to the humblest of pebbles and the frailest of rain-battered leaves.

The distinctive stance to nature's lessons inscribed in traditional Japanese aesthetics, with its emphasis on close observation and creative reinvention, is stunningly exemplified by Mamoru Oshii's film *Ghost in the Shell 2: Innocence* (2004). While playing an important role throughout the movie as a whole, this aesthetic attitude is declared most resonantly by its credit sequence. Focusing on the genesis of a cybernetic organism, the sequence portrays this intrinsically artificial process as a fluid, natural and organic phenomenon. Hence, it implicitly proposes that artists can only successfully emulate nature's principles if they are able to study their environment with studious and loving dedication, and then filter their perceptions through their art's distinctive laws and medium-specific objectives. In addition, *Ghost in the Shell 2: Innocence* delivers a sumptuous gallery of settings in which the aesthetic preference for irregularity and asymmetry reigns supreme. Filled to the brim with stylistic details and ornamental fixtures, these architectural feats include the villain Kim's metamorphic mansion, a majestic cathedral stylistically reminiscent of the Milanese Duomo, and the setting of a carnival parade packed with opulent floats. Ironically, despite their repleteness, all of these locations lay emphasis on emptiness, absence and lack as the ultimate essence of space. They do so by drawing attention to their constructedness in a self-reflexive fashion, reminding us that without their makers' creative intervention, the spaces which we see on the screen and experience as full (or even swarming with

details at times) would be entirely vacuous and amorphous expanses. In this way, Oshii's settings allude to the nature of space in its entirety as a tapestry of gaps for the imagination to fill. Finally, any viewer seeking a comprehensive visual repository of virtually all of the key aesthetic ideas examined above is unlikely to encounter a more satisfying answer than the anime gem *The Tale of Genji* (2009). The issue of Osamu Dezaki's inspired vision, this TV series offers an utterly unique adaptation of the first portion of Lady Murasaki Shikibu's eleventh-century masterwork, thereby bringing Japan's aesthetic precepts to life in the chronicling of its protagonist's unquenchable and soul-destroying passion. In offering a diligently detailed reconstruction of the Heian era, the series is able to locate all of the relevant principles in a tangible context, and to enflesh them in specific artistic pursuits, customs and rituals which endow them with unmatched documentary validity.

Japanese Aesthetics and the West: Areas for Further Thought

A comprehensive historical grasp of Japanese aesthetics cannot fail to acknowledge its profound influence on Western art and specifically on the output of the modernist avant-gardes of the late nineteenth and early twentieth centuries, including Impressionism, Post-Impressionism and Cubism. This contention is borne out by the output of painters as diverse as Manet, Monet, Degas, Gaugin, Cézanne, Toulouse-Lautrec, Van Gogh, Whistler, Picasso and Bonnard (among many others). As Natalie Avella observes, "many academics and art historians" go so far as to assert that "Western modernism would not have happened were it not for the Japanese influence" (Avella, p. 11). Japanese art and aesthetics also served as major sources of inspiration for Art Nouveau, particularly in the depiction of shapes and motifs drawn from nature. No less vitally, as Calza observes, "architects like Bruno Taut, Richard Neutra, Mies van der Rohe, Frank Lloyd Wright, Le Corbusier and Walter Gropius adapted and reinterpreted concepts of space, such as organicity, modularity and fusion with nature, that are characteristic of the Japanese architectural tradition" (Calza, p. 11). Western painters and architects keen to disengage their visions from the constraints of rigorous representationalism have found Japanese art most appealing, feeling par-

ticularly drawn to its use of neat silhouettes, essential shapes, delicate lines, bold colors and airy spaces, as well as to its daring approach to both structure and perspective. Japan's influence on Western productivity also extends to the realm of music, as memorably demonstrated by Debussy's fascination with Japanese art, and particularly with the aforementioned woodblock prints known as *ukiyo-e*. In the symphony *La Mer*, for example, Debussy's endeavor to evoke a visual image of the sea in the Impressionist style was deeply inspired by Katsushika Hokusai's *The Great Wave off Kanagawa*. In recent decades, the impact of Japanese culture on Western creativity has further expanded, and accordingly manifested itself with varying degrees of overtness in numerous fields, including the graphic arts (e.g., printmaking, serigraphy, calligraphy, typography and photography), architectural design, interior design, garden landscaping, fashion, website design and advertising.

At the same time, Japanese aesthetics evinces salient affinities with aspects of modernist and poststructuralist aesthetics which have emerged in the West between the late nineteenth century and the late twentieth century. The suggestion of a linkage between a distinctive facet of Japan's culture and philosophical developments in Western thought might at fist look like a colonizing move meant to reconfigure that culture in the West's own image, and thus deprive it of its purity. It becomes quite justifiable, however, when one takes into account the intrinsically hybrid character of Japanese culture (as discussed earlier). Its purity, ironically, is inseparable from its heterogeneity, insofar as its very distinctiveness depends vitally on its composite identity. In the present context, three particular concepts deserve mention due to their overarching relevance to the book as a whole. The relationship between these concepts and Japanese aesthetics is analogous to that between parallel mirrors. The first is that of "quiddity," an idea accorded vital significance by the aesthetics of modernism, and used to designate an entity's ultimate essence: the very quality which, as shown, Japanese art seeks to capture in all of its materials. The second is the poststructuralist concept of the "absent center," an image meant to epitomize the lack of a definite organizing point in any system, and hence throw into relief the system's inherent instability, fluidity and unpredictability. In positing absence as a facet of existence without which, strictly speaking, no human structure could operate, this idea bears important points of contact with the Japanese conception of space as a site of meaningful

emptiness. Moreover, the emphasis placed by the idea of the absent center on incessant mobility echoes the Zen notion of impermanence. The third, and arguably most critical, idea consists of the "engineer/bricoleur" pair, a distinction first put forward by the structuralist anthropologist Claude Lévi-Strauss to differentiate between two types of mentality: the one which strives to create specialized instruments for specific purposes (the engineer), and the one which deploys any number of non-specialist tools at its disposal in a jack-of-all-trades fashion in consonance with the task in hand (the bricoleur). While the Western obsession with specialization and compartmentalization is comparable to the engineer typology, the penchant for eclecticism embedded in Japanese art makes its exploits akin to those of the bricoleur. These Western developments, although they cannot be explored in this context, attest to the far-reaching significance of Japanese aesthetics over time.

MARK WHEELER MacWILLIAMS ON JAPANESE VISUAL CULTURE

Modern Japan is what Michel de Certeau describes as a "recited society" where people walk "all day long through a forest of narratives from journalism, advertising, and television, narratives that still find time as people are getting ready for bed to slip a few final messages under the portals of sleep...." Japan is also what Susan Sontag refers to as an "image world," since much of Japanese mass media is involved in producing and consuming images, at a time when they have "extraordinary powers to determine [people's] demands on reality and are themselves coveted substitutes for firsthand experience...." ... The animated images that flicker across the screen and all the pages of comic magazines and books are a major source of the stories that not only Japanese, but also an increasingly global audience, consume today. — MacWilliams, p. 3

2

Creativity

Geidō ... is an interesting principle in that it does not specifically speak of a visual aesthetic—but rather a way of working and a way of treating everyday actions as an art form. Every art form—from painting, sculpture, dance, tea ceremonies to Kabuki—all of these not only have an end result but they also have a process/method in which they are created. Geidō is a celebration of the discipline involved in the process of the art form.—Leon

Creativity is more than just being different. Anybody can plan weird; that's easy. What's hard is to be as simple as Bach. Making the simple, awesomely simple, that's creativity.—Charles Mingus

One. Cultural Background

The Creative Body: Spiritual Influences

Japan's understanding of creative endeavor, as argued in the foregoing chapter, pivots on the attribution of incomparable value to its corporeal components: the materials intrinsic in each art form, the tools designed to harness their energies into shapes, and the creator's very body and patterns of motion. As Gian Carlo Calza observes, "gesture" is "fundamental," and the "body is considered to be a direct manifestation of consciousness, able to transmit inner states often far more clearly than words" (Calza, p. 15). This perspective can be seen as a reflection of aesthetic leanings pivotal to indigenous thought as a whole. Indeed, as Graham Parkes reminds us, "Japanese philosophy tends to concentrate on concrete things and relations

54

within the world rather than on abstractions beyond it" (Parkes, p. 79). This does not de facto make it a pragmatic, hard-nosed or unimaginative world view: in fact, it allows plenty of room for dimensions which the West would regard (and possibly dismiss) as mystical, preternatural and mysterious, but posits these realities as immanent in the world we inhabit, not as transcendental in either a Christian or a Buddhist sense. To this extent, materiality is granted precedence in matters not only physical but also spiritual. In addition, it is worth recalling that in "East-Asian thought" generally, "the body has consistently been a focus of philosophical reflection, whether by virtue of the emphasis on ritual performance in the teachings of Confucius, the development of breathing and concentration techniques or physical skills in Taoism, or the practice of meditation in sitting, walking, and other physical activity in Zen Buddhism" (p. 81).

In order to grasp the precise bearing of Parkes' assertion, it is necessary to appreciate, albeit cursorily, the part played by each of the systems to which the scholar refers in the broader context of Japanese culture. The impact of Zen on the entire fabric of Japanese culture has already been explored in some detail, and will be returned to later in this discussion. Other philosophical influences deserve consideration at this stage for the purpose of contextual accuracy. In the case of Taoism, what we are confronted with is a galaxy of rituals and beliefs (including the renowned doctrine of *yin* and *yang*) which often bear affinities with the lessons of Zen. While the legacy of Taoism is perceptible in various areas of Japanese culture, its influence makes itself felt primarily in the ambit of esoteric practices pivoting on the performance of divinatory and apotropaic rituals. Confucianism, conversely, has proved more pervasively influential. First introduced into Japan as early as the third century, Confucianism began to acquire special distinction in the seventh century, initially providing a model on which structures of governance and social organization could be based. Gradually, Confucian precepts prescribing ideal standards of conduct at both the individual and the collective levels gained such authority as to yield a profound effect on the evolution of Japan's customs and mores. Most prominent among them were an emphasis on the hierarchical character of all human relations, loyalty to one's leaders and to the state, a steadfast commitment to the pursuit of learning, and the imperative to cultivate one's moral integrity as the prime human requirement. As Parkes remarks, "for Confucius, the major task was to cultivate oneself as a human

being in society by engaging in the ritual practices handed down from the ancestors." This objective entailed that age-old tenets, and the standards of behavior they subsumed, could be invested with an eminently corporeal density: that "tradition" itself, in other words, could be posited as "literally *embodied.*" Far from being regarded as an undesirable trapping, as the prison of the soul, or at best as a shell housing a privileged consciousness, the body was emplaced as a fundamental vehicle for the perfection, enactment and transmission of the most admirable human qualities. "By disciplining the movements and postures of the body through ritual practice," Parkes explains "one could refine the faculties and capacities of the whole human being." The impact of this legacy cannot be overestimated when one considers that its stance "was maintained in the Taoist tradition that developed after Confucius — and thus was incorporated into Chinese Buddhism as well as the Japanese forms of Buddhism that were descended from it. This is why the ideas of Zen have traditionally embodied themselves in such activities as archery, sword play, tea ceremony, Nō drama, painting, and calligraphy" (p. 82).

A further major force determining the attribution of centrality to the body is the indigenous religion of Shintō. Shintō's belief system does not feature a comprehensive theory of the body. Yet, it asserts its centrality not only to human life but to the genesis and workings of the cosmos itself in more overt, colorful and visceral terms than any of the aforementioned doctrines. As an online article on the subject explains, "according to ancient mythology, the Japanese islands themselves were created by the sexual activities of anthropomorphic creation deities. In these myths the deities' sexuality was the creative power of nature.... A common metaphor for nature's generative forces was the sexual body" ("Shintō"). With this mythological legacy, the Shintō tradition offers an undeniably lusty exaltation of the corporeal side of existence. Boyé Lafayette De Mente reinforces this point, arguing that "Japanese culture owes its unabashed sensuality, which is both stated and unstated, to Shintō, which is based on sexual reproduction and growth. Unlike religions based on suppressing and limiting human sexuality, Shintō celebrates it." Over the centuries, Shintō's "sensual orientation" has not merely extended its sphere of influence to native mythology and lore but has actually impacted pervasively on "virtually every aspect of Japanese life, including design. The *nikukanteki*, or sensual, qualities of Japanese arts, crafts, and modern com-

mercial products are very subtle, but their subliminal influence on viewers is real — and is now beginning to be emphasized more and more by Western designers" (De Mente, pp. 56–57).

It is necessary to acknowledge, for the sake of historical accuracy, that in the late nineteenth century, the kind of body promoted by traditional Shintō was deemed ill-suited to the advancement of the Meiji state's ideology, whose primary aim was to inculcate ethical values drawn largely from Confucianism in matters both personal and political. Hence, Shintō was conveniently restyled in order to abet the process of nation-building, which involved turning the Emperor into an object of worship by proclaiming his divine lineage, but its emphasis on the flesh (and, by implication, on the possibility of individual pleasure) felt incompatible with the "general policy of policing morality." As a result, "the leaders of modern Japan sought to suppress the overtly sexual symbolism of Shintō. Instead of the sexual body, modern Japan's state Shintō stressed *kokutai*, the 'national body' (often translated 'national polity') — a vague but potent concept of Japanese essence embodied in an allegedly unbroken lineage of emperors descending from the solar deity (Amaterasu). What began in ancient Japan as worship of the sexual body, ended in modern Japan (until 1946) as worship of the national body" ("Shintō"). It is ironical that the essence of a belief system initially entrusted to provide a reliable account of Japan's origins should come to be considered improper by the very guardians of national identity — agencies which, in principle, should have aimed to preserve the country's elemental heritage in as authentic a form as possible.

In the Judeo-Christian tradition, the divine is considered external to both time and space. In Shintō, by contrast, spiritual forces (*kami*) are held to fill the entire universe in an eminently corporeal guise by inhabiting mountains and trees, rivers and waterfalls, rocks and stones, as well as human beings and other animals. As Percival Lowell tersely puts it, in Shintō, "everything, from gods to granite, has its god-spirit" (Lowell, p. 28). Relatedly, while in the Judeo-Christian tradition, only the transcendental deity is accorded the power to secure the triumph of good over evil, in Shintō, *any* being is held to harbor, at least in principle, the potential to reshape reality. Tempting though it is, dwelling on the painful aporias at the heart of the Judeo-Christian attitude to good and evil is clearly beyond this book's remit. What requires emphasis, in the present context,

is Shintō's contention that spiritual energies pervade the fabric of the cosmos down to its humblest manifestations. The reverence for materials and tools evinced by Japanese artisans and artists over the centuries — which, as we have seen, constitutes an axial aspect of native aesthetics — emanates directly from this belief. The respectful recognition of materiality goes hand in hand with a frank — and, ideally at least, unruffled — acceptance of transience. This attitude has traditionally played a pivotal role in Japanese culture by stimulating a deep-seated desire to preserve the material world's purity against defilement and corruption. The centrality of this goal is attested to by fact that the Great Shrine at Ise, the holy place dedicated to the supreme Sun goddess Amaterasu, and hence Shintō's chief place of worship, is rebuilt from scratch every twenty years. This practice typifies a whole way of thinking about life, and ultimately the universe itself, which Donald Richie perceptively describes as "an alternative to the Pyramid — a simpler answer to the claims of immortality. Rebuild precisely and time is obliterated. Ise embodies the recipe for infinity: one hundred cubits and two decades. We see what is there and behind it we glimpse a principle" (Richie 2011, p. 18).

In Shintō's world picture, all kinds of physical entities, and especially natural or quasi natural objects, are conceived of as the repositories of specific *kami*, and hence deemed capable of affecting people's existence in both predictable and bewildering ways. Concurrently, the souls of the deceased are honored as ever-present and highly influential forces. Over the centuries, Japanese art has untiringly endeavored to communicate these lessons with beguiling gracefulness in the portrayal of diverse facets of the natural environment. At the same time, traditional architecture and interior design have consistently treated both entire edifices and individual items of household decor as virtually animate entities with an inherent capacity to radiate potent spiritual energies. Importantly, this power is not believed to be confined to the sphere of religious constructions intended to host solemn ceremonies and services: in fact, it is also attributed, with no less zeal, to the buildings and items punctuating people's everyday existence. As Michael Ashkenazi remarks, there is "no effective limit to the number of *kami*" one may encounter — and interact with — in any of these areas of human endeavor. Hence, there is "no clear division between the mundane and the *kami* worlds" (Ashkenazi, p. 27). This non-hierarchical stance implies that otherworldly and mortal creatures evince the same basic con-

stitution: a tripartite ensemble consisting of a body, a spirit and a soul. Since the terms "spirit" and "soul" are often used interchangeably in Western discourse, it is here worth explaining that in Shintō, as Lowell explains, the spirit is a less refined aspect of a creature's being than the soul, and gradually "clarifies" until "it approaches soul and finally becomes it" (Lowell, p. 27).

In his exhaustive discussion of Shintō's interpretation of the concept of "spirit," Lowell also underlines that the ubiquity of life forces throughout the universe means that "spirit never dies, it only circulates. When a man or animal or plant dies its body duly decays, but its spirit either lives on alone or returns to those two great reservoirs of spirit, the gods *Takami-musubi-no-kami* and *Kami-musubi-no-kami*. From them a continual circulation of spirit is kept up through the universe" (Lowell, p. 28). The chief goal of Shintō's esoteric practices is precisely to encourage the spirit to travel freely. Rituals aiming at self-purification are held in particularly high esteem, in this respect, insofar as they are believed to clear the body of all polluting adjuncts, and hence open it up to possession by the spirit of a different body. This allows the initial self to be discarded or exorcised, albeit provisionally. "This shift in spirit," Lowell maintains, "may take place between any two bodies in nature." While supernatural possessions of "things" are traditionally described as "miracles," possessions of "people" are known as "incarnations" (p. 30). Incarnations are frequently regarded as possessions by spectral visitors from the spirit-world, and are therefore prized as "practical mediums of exchange between the human spirit and the divine" (p. 98). Furthermore, as Ashkenazi points out, many of Shintō's mystical procedures come across primarily as magical rites of "propitiation and divination," several of which evince a consummately playful approach to life in their tendency to accommodate "some form of entertainment, whether dance, a magical play, or some music" (Ashkenazi, p. 31).

Commenting specifically on the thaumaturgic practices distinctive of Shintō shamans, the *kannushi* (male practitioners) and the *miko* (their female counterparts), the essay "The Shintō Tradition" explains that "Shintō magic originates in the relationship between the practitioner and the *kami*," and "primarily concerns itself with ensuring that the practitioner acts in harmony with the *kami* spirits, with magic being a natural extension of this harmony." Unsurprisingly, the phantasmagoric variety and profusion

of *kami* throughout the cosmos poses a steep challenge for even the most experienced of practitioners. Indeed, *kami* "come in all varieties, from elemental spirits to the ghosts of ancestors to strange and wonderful animals. They are so numerous that they are commonly referred to as the 'Eight Million Kami.' Some are kindly and helpful, while others are mischievous or selfish. Shintō *kannushi* use many ritual tools in their magic, including *haraigushi*, a wand covered in paper streamers used to purify an area, and *ofuda*, paper prayer strips used for good luck or to deal with malicious spirits" ("The Shintō Tradition," p. 41). In the logic of Shintō, magic issues from the natural environment itself as the *kami*'s principal abode: this makes it, at least in theory, a power achievable by anyone curious and playful enough to go looking for it. This is one of Shintō's most distinctive features, as well as further evidence for its non-hierarchical disposition, since many other forms of native magic in fact regard the mage as a trained specialist. A case in point is the tradition of witchcraft originating in the principles of the Tao, which relies on rigorously tutored practitioners committed to the comprehension and mystical management of the five elements: earth, water, air, fire and the void. Confucian conjurers, in turn, specialize in the interpretation of the *I Ching* (the most venerable of China's ancient texts) for the purposes of divination.

Not only do benevolent and pernicious *kami* coexist and overlap at all times: *kami* are also held to accommodate conflicting powers within their very nature. Shintō's aversion to monolithic, let alone monotheistic, interpretations of the natural world is paralleled by the plurality and multifacetedness of its conception of the essence of each spiritual entity as a tripartite affair. Indeed, as Ashkenazi explains, each *kami* is supposed to host "three *mitama* (souls or natures): *aramitama* (rough and wild), *nigimitama* (gentle and life-supporting), and *sakimitama* (nurturing). ... one or another of these natures might predominate in any particular myth" (Ashkenazi, p. 31). What is most vital, in the present context, is the extent to which the principles of diversity and many-sidedness ascribed by Shintō to its *kami* find direct correlatives in the realms of traditional Japanese art and aesthetics, where they express themselves as a deeply ingrained belief in the inextricability of peace from turbulence, and of harmony from dissonance. Sustained not only by Shintō but also by Buddhist teachings, this belief finds an especially vibrant application in the evocation of motion out of inert matter — an aesthetic goal of

prime importance to Japan's creative endeavor since time immemorial which anime has inherited with relish. It is through their tantalizing expression of suffused feelings of serenity and balance through tension, irregularity, asymmetry and even conflict that both traditional indigenous art and anime succeed in communicating the underlying aliveness of even ostensibly inanimate forms. At the same time, the kinetic qualities of space are brilliantly conveyed, as the image consistently allows the eye to roam past the boundaries imposed by a frame or other physical means of containment.

The aesthetic significance of Shintō's emphasis on the bodily dimension is bolstered by its ethical outlook: a commodious perspective wherein natural proclivities are valued over and above socially acquired codes and conventions. As H. Paul Varley explains, in this respect, "although Shintō may be said to lack a code of personal ethics, it has always been associated with an idea, *makoto* or sincerity, that has been probably the most important guide to behavior in Japanese history" (Varley, p. 11). The attribution of "high value to sincerity (*makoto*) as the ethic of the emotions" reflects a deeply ingrained cultural perception, insofar as "there has run through history the idea that the Japanese are, in terms of their original nature (that is, their nature before the introduction from outside of such systems of thought and religion as Confucianism and Buddhism), essentially an emotional people" (p. 61). According to De Mente, this natural disposition manifests itself consistently in Japanese culture: "in both a social and a business sense," argues the scholar, "*makoto* ... means fulfilling all of the obligations that make up the foundation of Japanese relationships, including maintaining harmony at all costs.... This gets right down to the heart of the traditional Japanese way of using highly stylized etiquette, avoiding direct speech, masking one's real intentions until a consensus gradually evolves" (De Mente, pp. 74–75). Some people might consider this attitude the very antithesis of sincerity to the extent that it seems to obfuscate a person's true intent under a cloak of socially sanctioned mannerisms and mores. It is, however, sincere if what is understood by sincerity — which appears to be the case in Japanese culture — is loyalty to one's most inveterate proclivities: in this instance, a desire for harmony which requires the individual to do anything in his or her capacity not to offend and inadvertently sow the seeds of possible discord in an otherwise cordial relationship.

The Zen Arts I: Nō Theater and the Tea Ceremony

In assessing the body's centrality to the phenomenon of creativity, the legacy of Zen must once again be acknowledged as a major shaping force in Japanese culture at large. Indeed, this culture's emphasis on the material side of life is in a sense a direct corollary of what H. Gene Blocker and Christopher L. Starling have described as "all that is most distinctive about Japanese Buddhism": namely, Zen's resolutely "antimetaphysical, antitranscendental stance, its stress upon an immediate, aesthetic point of view celebrating the wonder and richness of ordinary commonsense reality." In this scenario, "there is no Reality behind this world that it could take thousands of lives to figure out; there is just this world, which one must see directly, immediately, from a heightened aesthetic perspective" (Blocker and Starling, p. 61). Rupert A. Cox has further expounded Zen's approach to the concept of embodiment with specific reference to the notion of mimesis. In the Western conception of mimesis, the body is granted no clear role: "when we talk in theoretical terms of a correspondence, through imitation, between an act and its representative value, we do not know what kind of correspondence it is. Is it a sensory or a non-sensory correspondence? There is no space in Aristotle's theory of mimesis for acknowledging or exploring this area of embodied experience" (Cox, p. 107). Zen offers a radical alternative to the Aristotelian perspective by investing the body with expressive capacities *sui generis*: capacities which, ironically, tend to emerge most effectively when the individual responsible for their expression appears wholly compliant with a code which, in principle, would seem to foreclose the very possibility of unfettered expression. Cox offers an intriguing explanation for this ironical state of affairs by throwing into relief the body's cruciality to its functioning. "If we view the Zen arts as systems of mimetic action," argues the scholar, "then we can see participants as intending, by their 'somatic attitude,' to produce an aesthetic world *in such a way* that it will be perceived by both them and others as a specific world.... Explained as mimetic acts, the Zen arts on the one hand generate a pressure to conform, disciplining, structuring and restraining the body, while on the other they allow it individual expression. The Zen arts make available fixed, standardised forms of how to act and at the same time supply interpretations and representations of what one can be and become in action" (p. 109). It could be argued that in the

passage just cited, the key words are "specific," "individual" and "action." The ritualized, formulaic and repetitive patterns of motion one finds in the Zen arts are not mimetic in the sense that they are supposed to reflect, mirror or imitate immutable realities. What matters most is the performer's ability to construe, and internally process, those patterns as vehicles for the communication of something personal. Concomitantly, both the practitioner and the audience must feel engaged in the enactment of a particular embodied event. The overall significance of such an experience is clearly inseparable from its dynamic and corporeal qualities. These ideas are epitomized by both Nō theater and the tea ceremony. Let us consider each of these major Zen-inspired arts in some detail.

The aesthetician, actor and playwright Motokiyo Zeami (1363–1443), the first systematic theorizer of Nō theater, ascribes great significance to the principle of imitation in the context of this Zen art. Imitation as conceived by Zeami does not constitute a reflective, or mirroring, activity, as has traditionally been the case in Western thinking. In fact, as Makoto Ueda explains, "to imitate an object," for Zeami, entails "that the actor becomes identical with that thing, that he dissolves himself into nothing so that the qualities inherent in the object would be gradually manifested. Zeami's way of saying this is that the actor 'grows into the object' ... The actor's self, in other words, should be completely absorbed by the object of his imitation. If this is successfully done, the actor will have no awareness that he is imitating an object outside of himself, for he is at one with it" (Ueda, M., p. 57). The ethereal subtlety with which Nō theater articulates its distinctive take on imitation owes much to its unique use of masks. As Calza maintains, in the West's dramatic tradition, the mask's main purpose is "to conceal, to hide behind another element ... something that is not meant to be seen." Nō theater, conversely, does not call attention to the mask's disguising capacity but rather to its power "to evoke, to suggest, even to the point of violently expressing ... specific conditions, both human and divine" (Calza, p. 93). Another notable difference resides with the divergent perceptions of a mask's symbolic meaning in the two traditions. Western cultures are by and large dominated by a binary mentality inclined to make sense of reality according to mutually incompatible categories. Hence, they tend to impart masks with figurative attributes which epitomize clear-cut principles. Japanese culture, by contrast, is not averse to the coexistence of antithetical ideas, but is in fact willing to accommodate

them in the guises of ambiguity, irony and paradox. Nō masks (*nohmen*) mirror this propensity with their unique dramatic versatility, capturing diverse feelings simultaneously, and letting their energies merge, collide and crisscross in often unforeseeable ways.

Performers can convey disparate moods by simply angling their masks so that they will express flawless transitions between contrasting emotions. Moreover, the play of light on a mask's surface, and resulting reflections, refractions and shadowings, is in itself a source of infinite emotional effects. These are enhanced by the barely perceptible furrows and indentations placed on the mask's surface by its maker as a means of producing delicate expression lines. Unsurprisingly, the manufacture of a Nō mask is an extremely difficult art guided by strict and jealously guarded technical rules. The actor's body language has the ability to boost with each motion the mask's emotional import insofar as even the least obvious turn or tilt of the head will cause the object's vacuous orbs to brim with pathos, euphoria or sadness. Concomitantly, a *nohmen*'s meaning can change significantly in tandem with the merest shift of its position on the player's face. Therefore, in spite of its aptitude to embody fairly stable values, the mask's ultimate power as a corporeal entity lies with its adaptability to the communication of wavering affects, and hence with its ability to remind us that no indisputable truths are ever on offer — on the stage or beyond it. The only truth we can hope for is as vague and mercurial an event as the slightest shift of a mask on an actor's face, or of light on a mask's surface. By implication, spectators are invited to embrace their own personal contradictions, inconsistencies and caprices as inescapable elements of humanness.

In examining the most salient aesthetic features of the tea ceremony (*chanoyu*), it is first worth noting, as *The Japanese Tea Ceremony* informs us, that the "drinking of green tea was known in China from the fourth century. Tea plants didn't grow in Japan until the first seeds were brought from China during the Tang dynasty (China 618–907), when relations and cultural exchanges between the two countries reached a peak" ("History of the Japanese Tea Ceremony"). It was not until the sixteenth century, however, that tea experts, and especially Sen no Rikyuū (1522–1591), formulated a set of rules underpinning the formal procedure destined to become the tea ceremony as such. The tea cottage and garden were thereafter conceived to accommodate the event. To access the tea room itself

(*chashitsu*), the participants pass though the *roji* (literally, "dewy ground"), a garden designed to induce an ambience of hushed stillness that will help them appreciate the ceremony's deeper meanings. In order to abet the gradual and unforced absorption of this somewhat magical atmosphere, the *roji* tends to be divided into an outer and an inner garden with a *machiai*, a sheltered bench where guests await the start of the ceremony, normally announced by a bell or by the sound of fresh water being poured into a stone basin. Traditional garden accessories found in the *roji* include charming wicket gates, stone basins and lanterns, and studiously placed stepping stones (*tobi-ishi*) which guide the transition from everyday reality to the rarefied realm of the tea room. Colorful flowers and artificially shaped trees and bushes are typically avoided in favor of inconspicuous plants left in their natural state, including moss, ferns, evergreens, plum trees and maples. As Makoto Ueda emphasizes, Rikyuū saw the "tea room" as "a world completely cut off from everyday life," and unencumbered by "social class distinctions," with the power to release its guests not merely from the pressure of "what they possess" but also from that of "what they yearn after in their trivial daily existence" (Ueda, M., pp. 89–90).

In the tea ceremony, ritual gestures carry pivotal importance both as expressive tools and as symbols of autonomous worth. The actions performed in the context of the *chanoyu* are not only instrumental in the communication of emblematic messages: they also stand out as independent symbols themselves. The body, and hence the material dimension of creativity, are enthroned as the fundamental underpinnings of creation — as producers of meaning whose impact is capable of surpassing that of all immaterial sign systems and attendant concepts. At the same time, in making the creative gesture an artwork unto itself, the *chanoyu* declares its freedom from the notions of causality and teleology which have shackled much mainstream Western art for centuries. In this respect, it tersely reminds us that Japanese aesthetics is not, as a rule, haunted by an obsessive focus on either outcomes or goals. Calza underlines this idea as follows: "the tea ceremony ... requires the practitioner ... to be aware of the human value of what he or she is doing and not excessively attached to results." Thus, "the art of tea must be practised with devotion, but also with detachment." Like archery, another major Zen art, the art of tea "must be 'aimless,'" since "ingesting the tea," like "hitting the target," does not actually constitute the "purpose of the exercise." What is paramount is "the purity of

the act itself" as a graceful expression of "total, absolute naturalness"—
which is ironical (also in keeping with Zen's temperament) when one con-
siders the strictly ritualized and stylized nature of the act. "Every moment
of the tea ceremony," Calza continues, "is ... under the tightest possible
control. But we are not talking about a recitation to a watching audience,
or about a simple gestural form in the sense that the gesture itself expresses
a particular spiritual value. The tea ceremony is the symbol, and at the
same time the vehicle, for the man who rises above the frenetic struggle
for survival to an awareness that every action is an expression of himself,
evidence that he is approaching his ideal world or conversely, regressing
to the brute state" (Calza, p. 15). It is through this spiritual process that
the ostensibly trifling act of drinking a cup of tea can rise to the status of
a powerful aesthetic experience—"a kind of pleasure," as Makoto Ueda
puts it, "not obtainable in ordinary life." The tea garden and room, in this
respect, have the capacity to make their visitors the "temporary inhabitants
of a different world" (Ueda, M., p. 88).

Daisetz Suzuki has provided one of he most comprehensive accounts
of the tea ceremony's aesthetic import in the context of his seminal writings
on Zen's ubiquitous influence on Japanese culture. "The art of tea," the
philosopher maintains, "is the aestheticism of primitive simplicity. Its
ideal, to come closer to Nature, is realized by sheltering oneself under a
thatched roof in a room which is hardly ten feet square but which must
be artistically constructed and furnished" (Suzuki 2010, p. 271). The pivotal
aesthetic principles governing this thoroughly ritualized event are "'har-
mony' (*wa*), 'reverence' (*ki*), 'purity' (*sei*), and 'tranquillity' (*jaku*). These
four elements are needed to bring the art to a successful end" (p. 273). It
is particularly noteworthy, in this context, that "the character for 'harmony'
also reads 'gentleness of spirit' (*yawaragi*)," and that in Suzuki's personal
opinion, "'gentleness of spirit' seems to describe better the spirit governing
the whole procedure of the art of tea. The general atmosphere of the tea-
room tends to create this kind of gentleness all around—gentleness of
touch, gentleness of odor, gentleness of light, and gentleness of sound."
Every minute facet of the *chanoyu*'s ambience, architecture and decor con-
tributes uniquely to the generation of this intensely synesthetic experience
"You take teacup," Suzuki poetically intones, "handmade and irregularly
shaped, the glaze probably not uniformly overlaid, but in spite of this
primitiveness the little utensil has a peculiar charm of gentleness, quietness,

and unobtrusiveness. The incense burning is never strong and stimulating, but gentle and pervading. The windows and screens are another source of a gentle prevailing charm, for the light admitted into the room is always soft and restful and conducive to a meditative mood" (p. 274). All in all, therefore, it would be oafish to assume that the tea ceremony is the direct equivalent of the Anglo-Saxon habit of having a good old cuppa to relax or warm up. In fact, as Suzuki emphasizes, it "is not just drinking tea, but involves all the activities leading to it, all the utensils used in it, the entire atmosphere surrounding the procedure, and, last of all, what is really the most important phase, the frame of mind or spirit which mysteriously grows out of the combination of all these factors. The tea-drinking, there-fore, is ... the art of cultivating what might be called 'psychosphere,' or the psychic atmosphere, or the inner field of consciousness" (p. 295).

The Zen Arts II: The Way of the Warrior and the Way of the Brush

While Nō theater and the tea ceremony are regarded by many as the quintessential Zen arts, it is important not to neglect *bushidō* (the way of the warrior), as another Zen-inspired practice which accords the body a critical role. As Parkes points out, *bushidō*— i.e., the epitome of the samurai class' ethical system— "stresses the discipline of the whole person, the train-ing of the psychological and spiritual aspects of the warrior as well as the physical. The idea is that once one has undergone the requisite self-disci-pline and trained the body to its utmost limits, the appropriate activity will flow effortlessly" (Parkes, p. 87). One may be surprised to discover that Zen, as a school of Buddhism, and hence a peaceful and meditative discipline committed to respect for life in all its forms, should be somehow associated with the martial activities and psychology of the samurai class. Yet, as Winston L. King persuasively argues in *Zen and the Way of the Sword: Arming the Samurai Psyche*, Zen has been in a position to supply Japanese warriors with an apposite code of conduct because of its emphasis on practical action (as opposed to intellectual speculation), precision, and intuitive bodily awareness (King). Justifying Zen's relationship with *bushidō* should never, of course, become a means of excusing bloodshed on the grounds that it emanates from a world view which prioritizes concrete

experience to theory, and corporeality to abstraction — which would effectively turn Zen into a doctrine to which practically anybody could turn as a means of defending all kinds of nefarious activities. Rather, it shows that some of the most complex ideas in Japanese culture, of which *bushidō* is clearly one, have not derived monolithically out of single centers of meaning, but rather evolved out of preexisting ideas in often unexpected fashions. This has entailed if not exactly a distortion of the values from which novel perspectives have grown, at least a radical reconceptualization of their original intent and sphere of operation.

According to Roger T. Ames, *bushidō*'s connection with Zen is clearly borne out by the "death resolve" inherent in its ethos: "the proponent of *bushidō* would probably not see death as 'self-destruction,' 'self-annihilation,' or 'self-abnegation' ... Rather, he would be inclined to view it in a way more consistent with *mujō* — impermanence — expressed in the popular metaphor of the fleeting cherry blossom with petals that fall at the height of their beauty when they are fully what they are" (Ames, p. 286). Relatedly, despite the negative evaluations which this code of conduct has elicited in the West, where it has often been equated to blind loyalty, robotic obedience, and nihilism, *bushidō* entails 'a very real degree of personal freedom." The warrior's "freedom is not the freedom of choice based on a calculating and deliberating rational mind, but rather, like his Zen counterpart, freedom from the very calculating and deliberating mind that would constrain and delimit his action" (p. 293). Looked at in a broader aesthetic perspective, this emphasis on spontaneity could be seen as the essential bearing of all arts inspired — or even just tangentially touched — by Zen. Thomas Hoover promulgates this idea in his assessment of "the lessons of Zen Culture," maintaining that this outlook "has been designed to bring us in touch with a portion of ourselves we in the West scarcely know — our nonrational, nonverbal side" (Hoover, p. 224). The faculties hosted within those often neglected parts of our being are cajoled into play by Zen in order "to produce in the perceiver a complete sense of identification with the object" (p. 225). The ultimate goal of this process is the total transcendence of the self — the self being regarded as a construct which, far from abetting a person's identity in the ways Western humanist proclaims, actually imprisons the individual in the silent crypt of solipsism. The concept of *muga* encapsulates this perspective. As De Mente reminds us, *muga* is commonly rendered in English as "self-effacement" or "selfless-

ness," and denotes a human being's capacity to "accomplish a task perfectly without concentrating on the actions" (De Mente, p. 47). The attainment of *muga* indeed ensures that he or she will be able to focus on the task in hand without the encumbrance of a self petulantly requiring attention and credit at every turn.

In the journey toward *muga*, it is crucial for the mind and the body always to be trained in tandem, for the journey itself is both spiritual and material, both philosophical and enfleshed. As Parkes observes, this entails that no binary oppositions should ever obtain between the categories of "theory and practice, or reflection and action" (Parkes, p. 89)—which is why "Japanese history is full of figures whose achievements undercut such dichotomies: emperors who were exquisitely cultured individuals, Zen masters who were consummate swordsmen, and warriors who were exemplary men of letters. Over the centuries in which Japan was torn by civil wars, there grew up a tradition of samurai who were at the same time literati, men of refined culture who yielded the pen (or, rather, the brush) with as much skill as the sword" (pp. 89–90). It is indeed undeniable that from an aesthetic point of view, the tradition of monochrome painting with brush and ink, or *sumi-e*, bears substantial affinities with the art of the sword. Subjecting their pupils to strict and extensive training, both *bushidō* and *sumi-e* aim to achieve a seamless connection between the practitioner's body and his or her movements. In the specific case of ink and brush painting, explains Parkes, "the goal is to let the brush move itself. The appropriate condition for painting is one of 'no-mind,' and one's awareness is dispersed throughout the whole body — and even beyond the brush to the blank paper" (p. 90). Hoover corroborates the existence of an intimate aesthetic bond between *bushidō* and *sumi-e*, arguing that "like the slash of the Zen swordsman, the absolute accuracy of the Zen artist's brushstroke can come only from one whose mind and body are one" (Hoover, p. 113).

The result is a unique form of expression infused with metaphysical connotations. The description of traditional ink and brush painting offered in the website *Prairiewoods* bears witness to this contention with lyrical poignancy: "all civilizations leave an imprint of their lives: figures on rock, stone, or paper ... *Sumi-e* embraces the history of language, memory, and the desire to leave behind a trace ... *Sumi-e*, like any art form, is about a sense of transitions, about transformations. The objective of *sumi-e* is not

to recreate a subject to look perfectly like the original, but to capture its essence — that is, to express its essence. This is achieved not with more but with less. Therefore, useless details are omitted and every brush stroke contains meaning and purpose. There is no dabbling or going back to make corrections. The strokes themselves, then, are said to serve as a good metaphor for life itself. That is, there is no moment except for this moment" ("The Spirit of *Sumi-e*: An Introduction to East Asian Brush Painting"). *Sumi-e* captures the Zen notion of reality as a process of incessant flux, and hence as unremittingly embroiled in multifarious cycles of birth, death and rebirth. Concomitantly, its distinctive handling of the line in ways which are meant to convey at once a soothing sense of composure and an electrifying surge of dynamism reflects the decidedly antibinary attitude to the world intrinsic in both Zen specifically and Buddhism at large. This outlook has been traditionally immortalized by images of the Indian guru Daruma, said to have introduced Zen Buddhism, as a figure capable of symbolizing opposite feelings, and therefore stand for the inevitable coexistence of destructive and life-giving energies.

Japanese art's aversion to dualism is confirmed by its approach to the relationship between light and darkness. As Junichirō Tanizaki proposes in his seminal text *In Praise of Shadows*, light cannot be grasped without darkness — light, ironically, does not dissolve darkness but is, in fact, illuminated by it. This contention is validated, in the context of Japanese art, by the treatment of materials whose essence and beauty can only be adequately recognized with the assistance of obscurity. "Lacquerware decorated in gold," for example, "should be left in the dark," only partially touched by "a faint light." It is by dwelling discreetly in the shadows that the substance enables the emergence of a "dream world built by that strange light of candle and lamp, that wavering light bearing the pulse of the night," and indeed laying "a pattern on the surface of the night itself" (Tanizaki, p. 24). It is in the domain of traditional native architecture that the unique power of shadows as an infinitely varied source of beauty asserts itself most markedly, permitting invisible energies of ghostly distinction to work their "magic." The cultural willingness to accommodate "lack of clarity" as an appealing — rather than intimidating — reality ushers in a world imbued with "a quality of mystery and depth superior to that of any wall painting or ornament" (p. 33). This is a vision wherein "light and darkness," as Souseki Natsume maintains in *Kusamakura* (*The Grass Pil-*

low), "are but opposite sides of the same thing, so wherever the sunlight falls it must of necessity cast a shadow.... Try to tear joy and sorrow apart, and you have lost your hold on life. Try to cast them to one side, and the world crumbles" (Natsume, pp. 13–14).

The Tradition of Visual Storytelling

In engaging with the topos of creativity, anime often corroborates the arguments outlined above concerning the primacy of the body in Japanese aesthetics, insofar as it posits the corporeal dimension as instrumental in the conception and execution of any truly creative gesture. Borne out most eloquently by its dedication to corporeality, the aesthetic dimension of anime's treatment of creativity is further demonstrated by its cultural imbrication with a time-honored artistic phenomenon which has been an integral part of Japanese culture for many centuries, and in which its fundamental aesthetic tenets find resplendent formulation: namely, the tradition of narrative painting, or storytelling by means of sequentially arranged images. A classic example of this art consists of the *Chōjū-jinbutsu-giga* (literally, "animal-person caricatures"), a.k.a. *Scrolls of Frolicking Animals* or *Scrolls of Frolicking Animals and Humans*: a series of paintings from the twelfth and thirteenth centuries whose initial conception is conventionally attributed to the monk Toba Sōjō (born as Kakuyū; 1053–1140). These scrolls offer a satirical interpretation of the Buddhist priesthood, depicting its members in the guise of anthropomorphic beasts, such as roguish rabbits and monkeys, engaged in all manner of inane activities, farting contests included, and portraying the Buddha himself as a toad. Their terse lines, fluid rhythms, whimsical sense of humor, and tantalizing impression of aliveness clearly anticipate contemporary artifacts of the comic-book and animated varieties. Animals went to play an important role in the evolution of visual storytelling, paving the way for modern developments in anime as the worthy ancestors of some of the most wonderful supporting actors featuring regularly in its yarns — such as talking companions, guides and mascots in animal, quasi-animal or cyber-animal guises.

Among the most notable instances of Japanese narrative art is the gorgeous Edo Period scroll painting illustrating the tales known as "The Battles of the Twelve Animals," with its incredibly expressive boar, dog,

dragon, horse, monkey, ox, rabbit, rat, rooster, sheep, snake and tiger clad in classic samurai armor. "By showing humans in the guise of animals," writes Masako Watanabe, "this and other anthropomorphic tales offered an objective review of contemporary society, providing a vivid reflection of the socio-cultural climate of medieval Japan" (Watanabe, Masako, p. 109). "A Strange Marriage," from the same epoch, is most remarkable as an entertaining visual account of a magical fox wedding which, though eminently enjoyable as a fantasy tale unto itself, also works as a trenchant satire of contemporary Japan. According to Watanabe, the scroll is indeed "believed to reflect the artist Ukita Ikkei's biting criticism of the Tokugawa government and its attempt to shore up its waning authority by marrying an imperial princess to the shogun." One final example worthy of attention is the Edo-period scroll depicting "The Tale of Mice," the story of a wandering mouse who leaves home to satisfy his wife's craving for goose meat, is then prevented from returning home by a series of adventures and misunderstandings, and is eventually reunited with his family: the pictures of the mice, executed with meticulous care for costumes, accessories, and both the natural and architectural elements of their settings are on a par with some of the most accomplished scroll pictures devoted to literary classics — including *The Tale of Genji*— notwithstanding their humble protagonists. As Watanabe points out, "the skillfully executed illustrations in this scroll ... have a lyrical quality," and "the female characters, be they mice or human, are depicted in the same style as the ethereal beauties who populate the 'floating world' of seventeenth-century *ukiyo-e* paintings" (p.111). These pictures offer us precious glimpses into a sensibility that does not automatically grant precedence to the human animal over other animals; nor does it perceive the two categories as binarily opposed. Valuing intuition as a far more important asset than logic, in keeping with one of Zen's most axial lessons, this outlook celebrates non-human animals as incarnations of intuitive genius while also reminding us, by implication, of the rapacious folly of humans who regard themselves as superior on the shaky grounds of their alleged possession of the power of ratiocination.

Furthermore, the paintings bear witness to Japan's "long and rich tradition of pairing narrative texts with elaborate illustrations"—a creative practice of which contemporary "forms of animation and graphic art" are the latest inheritors (p. 3). Brigitte Koyama-Richard articulates a related argument in *Japanese Animation From Painted Scrolls to Pokémon*, arguing

that the forerunners of contemporary anime and manga are the ancient illuminated scrolls devoted to the description of "religious, literary, or historical scenes," to the invention of "a fantastical bestiary," and to the adaptation of "morality tales or stories designed for children" (Koyama-Richards, p. 12). Most crucially, from an aesthetic perspective, these scrolls exhibit structural and compositional qualities of a cinematic nature, accommodating in embryonic form some of the technical features characteristically associated with anime. Though scroll-painting was initially a Chinese import, the cinematic feel of Japanese scrolls results from a modification of the original style through the incorporation of novel elements of native ideation which were intended precisely to maximize the art's chromatic and dynamic connotations — such as "real-life facial expressions, blocks of color as in celluloid (cels), parallel movement, effects of zoom, the portrayal of characters linked to action" (p. 13). At the same time, the multiperspectival approach to both stories and characters found in the most accomplished anime echoes ancient narrative art's propensity to relate a narrative from diverse angles. Pictures like the Edo-Period scrolls mentioned above are not intended merely to complement a written narrative as static tableaux, but actually enact *both* the events recounted in the old stories *and* the telling thereof in an emphatically dynamic fashion. This point should not be underestimated, insofar as it is their concurrently performative and kinetic nature that enables those images to stand out most patently as anime's venerable elders.

TWO. EXPRESSIONS OF CREATIVITY IN ANIME

Millennium Actress (movie, dir. Satoshi Kon, 2001)

Millennium Actress yields a veritably epoch-making contribution to the history of anime's engagement with the topos of creativity by imparting its treatment of the theme with a tantalizing element of self-reflexivity and, more vitally, with myriad allusions to Japan's aesthetic legacy. The film chronicles the life story of a once hugely popular and now retired

actress, Chiyoko Fujiwara, by means of snippets of events from her actual experiences interwoven with scenes from the innumerable films in which she has starred over her prolific career. By gliding through disparate historical periods and locales with a prestidigitator's flair, the movie implicitly provides us with many opportunities for reflection on key aspects of Japan's time-honored aesthetics pertaining to each era and style. Most enlightening, in this regard, are the action's seamless fluctuations from frames capturing Chiyoko's real-life experiences and frames recording her on-set reverie, and transitions between any two of the films in which she has featured in a lead role. Thus, a scene in which Chiyoko as the heroine of a film set in ancient Japan exits a room may smoothly transmute into a scene in which Chiyoko accesses an entirely different world where she actually plays the part of a modern-day heroine. At one stage in Chiyoko's multidimensional adventure, for example, by simply crossing a threshold, the heroine travels from the bleak scenario of wartorn Manchuria to the sumptuous setting of a classic samurai saga. Similarly, a breakneck horse ride through a barrage of fierce battles and glowing skies may fluidly morph into a leisurely carriage jaunt amidst blossoming *sakura* and mellow breezes. As the scenes — and corresponding memories, longings and dreams — steadily accumulate, the roles of doomed princess, indomitable ninja, courtesan and space scientist (amongst several others) meet and merge in kaleidoscopic suffusion. The film never lets us forget, through this constantly shifting phantasmagoria, that its action is ultimately held together by a disarmingly simple leading thread: namely, Chiyoko's yearning to find her first and lifelong love, an injured artist and political dissident hounded down by the authorities for whom she provided a fleeting sanctuary in her family's storage house as a young girl.

As Kenneth Turan points out, "at first glance, the plot of *Millennium Actress* sounds so conventional that you wonder why its Japanese creators went to the trouble of making it as an animated film. But first glances can be deceptive.... For what ... director and co-screenwriter Satoshi Kon has in mind is the shredding of the laws of space and time" in a feat of "*trompe l'oeil* or fool-the-eye filmmaking, and animation can fool the eye with the best of them." Moreover, it is the movie's "matter-of-fact, realistic animation style" that throws most strikingly into relief the chaotic nature of its diegesis (Turan). The experiences of Chiyoko's filmic counterparts mirror her own real-life predicament insofar as just as the actress' existence is

sustained by the longing for a lost — and, strictly speaking, quite imaginary — love, so her alter egos' lives as characters are likewise validated by the vain pursuit of equally unattainable objects of desire. In this fashion, *Millennium Actress* is able to forge consistent dramatic connections among the various strands of its multifaceted tapestry. Especially notable, from an aesthetic perspective, is the employment of a storytelling motif imbued with mythological resonance: the image of a witch hellbent on spinning the destinies of both Kon's protagonist and her celluloid doppelgangers around a hideous cures: to be consumed by the "flames of eternal love" with no hope of either gratification or remission.

Cinema clearly constitutes the principal art form through which *Millennium Actress* engages most assiduously with topos of creativity throughout its colorful unfolding. Its protagonist's life story, moreover, also gives it a perfect pretext for sustained self-reflection, and hence for an implied critique of the entertainment industry as such. In an inspiring review, Ed Gonzalez proposes that *Millennium Actress* can indeed be seen to offer a self-referential commentary on the film industry itself, and that "comparisons to *Mulholland Drive*," in that regard, "aren't too far off," insofar as Kon's movie ultimately "concerns itself with our love affair with women in movies (many of whom are unceremoniously forgotten when they become too old). Here's a love story that not only spans a lifetime but thousands of years of political upheavals." In addition, there are intimations that the heroine "knew all along that she was chasing the shadow of a man," and that instead of pursuing love as a reality, she was actually "experiencing love vicariously through her acting." This makes Chiyoko's quest comparable to the experience of a spectator living through emotions secondhand courtesy of the screen's ephemeral simulacra. In fact, this self-reflexive gesture places *Millennium Actress* on the metadramatic plane of "a love poem to cinema itself" — an apposite reflection of the late director's own approach to cinema, since "Kon's love for the medium, like Chiyoko's eternal search, has no boundaries." At the same time, the film can also be interpreted as "a tale of perseverance" to the extent that Kon's celebration of "the defiant Chiyoko's power over various manmade creations and destructions in the film" (Gonzalez) functions as a supple metaphor for creativity's triumph over the dishonesty of the film world per se.

While cinema is indubitably the principal art form around which *Millennium Actress'* take on creativity revolves, it is also important to appre-

ciate the film's crucial use of the art of painting in one of its climactic — and philosophically most eloquent — scenes. This coincides with the finale of Chiyoko's desperate attempt to trace her life-long love (who, as it transpires at the end, has by then been dead for a long time). When the protagonist finally reaches the snow-mantled plains of Hokkaido, where the youth once vowed he would take her, the only symbolic token of human presence she discovers in the desolate landscape is an easel bearing the picture which he intended to complete upon returning home. The subject of the painting is the rebel artist himself, portrayed in the act of withdrawing into the distance with his back to the viewer. When Chiyoko struggles to catch up with him, the figure dissipates, leaving only the sublime waste land in its wake. At this point, Chiyoko is brought face to face with incontestable confirmation for the conclusiveness of her loss. The scene's emphasis on nature's unfathomable sublimity brings to mind the principle of *yūgen*, while its wrenching melancholy exemplifies the concept of *mono no aware* with rare beauty. Although the art of painting only gains explicit thematic prominence in this scene, from a stylistic point of view, it actually permeates the film's entire fabric. *Millennium Actress* indeed evinces throughout an eminently pictorial sensibility which often harks back, with variable degrees of explicitness, to the aforementioned woodblock prints known as *ukiyo-e*. As a matter of fact, in one scene, the film pays overt homage to that tradition by means of a frame inspired by one of Katsushika Hokusai's most famous paintings, *Beneath the Wave off Kanagawa* (c. 1830). The aesthetic of the *ukiyo-e* comes vibrantly to life in numerous tableaux encapsulating the distinctive aesthetic standards of disparate epochs in the form of architectural, ornamental and vestimentary details of great tactile resonance.

As "pictures of the floating world" devoted to the portrayal of the ephemeral spectacle of life and its pleasures, traditional woodblock prints tend to focus on scenes from ordinary life, achieving some of their most memorable results in the representation of the urban entertainment industry thriving in the heyday of their production. As Douglas Mannering remarks, this period, which extends from the first two decades of the seventeenth century to the 1860s, witnessed the emergence of "an affluent middle class with money to spend but no defined social or political role. Consequently its members gravitated towards the Yoshiwara, Edo's [i.e., Tokyo's] redlight district.... This was the milieu which the *ukiyo-e* artists

immortalized.... The most popular subject of all was beautiful women most often, though not always, the courtesans" (Mannering, p. 6). As noted in *Anime and Memory: Aesthetic, Cultural and Thematic Perspectives,* "*Millennium Actress* explicitly invokes this motif in the retrospective snatches documenting Chiyoko's cinematic part as a geisha. Yet, the film as a whole replicates the *ukiyo-e*'s atmosphere by means of its tone and imagery. The characteristic sense of dynamism inherent in traditional woodblock prints devoted to the representation of Kabuki actors, sumo wrestlers and other popular performers is simultaneously conveyed by Kon's emphasis on vibrant motion. Grace and elegance are often accorded a pivotal role but never allowed to crystallize into inert icons of beauty of the fashion-plate variety. Landscapes distinguished by a daring use of perspective, attention to the majestic presence of Nature behind and around the urban carousel, and a loving depiction of delicate facets of native flora and fauna likewise mirror the *ukiyio-e*'s predilections" (Cavallaro 2009b, p. 20). In bringing into play the *ukiyio-e* tradition, Kon's prismatic masterwork also gives original expression to the multiaccentual aesthetic principle of *iki*, and particularly to its embodiment of fashionable sophistication as an eminently bourgeois value imbued with sensual connotations. In the context of the *ukiyio-e* style itself, *iki* is most strikingly communicated by the tasteful representation of sexuality. In *Millennium Actress* itself, it is Kon's ability to constellate an intricate narrative in so crystalline a fashion as to make it seem quite acceptable even where it reaches its most convoluted or eccentric peaks that the ethos of *iki* manifests itself most effectively. In addition, the segments of *Millennium Actress* in which the visual codes of classic costume drama dominate the action (of which there are several), *iki* is typified by the Japanese garment per excellence, the kimono: a stylish synthesis of sartorial simplicity and ornamental richness so refined and variegated as to deserve autonomous aesthetic recognition as an artwork.

Millennium Actress as a whole is pervaded by a consuming sense of *mono no aware*. In Kon's inventive hands, this important aesthetic concept comes across as a deep sense of nostalgia for what is *always already* gone, and hence a potent aesthetic metaphor for the idea that transience is the inevitable essence of cinema itself as an art form. This ubiquitous mood is consistently reinforced by subtle intimations that even though the protagonist construes the trigger of her quest as the longing for future fulfillment in order to motivate herself and hence keep going, what really drives

her is the unappeasable yearning to recuperate an irretrievable moment from her early youth: i.e., her initial (and indeed *sole*) encounter with the desired object. A further aesthetic principle of pivotal significance to *Millennium Actress* as a whole is that of *wabi* as a fascination with the flawed and the incomplete. Kon has implicitly emphasized the centrality of *wabi* to the movie's aesthetic vision by drawing attention to the symbolic import of the image of "rubble." This visual motif finds paradigmatic expression in the scenes used to frame the film at its start and finish, which are devoted to the film studio behind Chiyoko's stellar career, as well as in the sequences recording the aftermath of the Great Tokyo Earthquake, when the heroine is said to have been born. In addition, *wabi* reigns supreme in the frames capturing the miserable mood of the postwar period. In each case, rubble provides a succinctly poignant emblem for the cycles of "death and rebirth" (Kon) on which the world's very existence ultimately pivots. A *wabi*-infused atmosphere also issues from the depiction of Chiyoko's secluded dwelling, where the interview reconstructing her life story is set. Its meticulously rendered architecture and decorative attributes indeed encapsulate both the aesthetic and the ethical foundations of *wabi*, communicating a mood of tranquillity and equanimity. Chiyoko's own manner offers an ideal match for this feeling, in that it invariably conveys a profound sense of restrained contentment and peaceful resignation. Especially relevant, in this regard, is the particular evaluation of the concept of *wabi* proposed by the architect Tadao Ando. "*Wabi* stems from the root *wa*," the artist reminds us, "which refers to harmony, peace, tranquillity, and balance. Generally speaking, *wabi* had the original meaning of sad, desolate, and lonely, but poetically it has come to mean simple ... and in tune with nature. Someone who is perfectly herself and never craves to be anything else would be described as *wabi*.... A *wabi* person ... understands the wisdom of rocks and grasshoppers" (Ando 2000).

Finally, *Millennium Actress* brings to mind a distinctively Japanese conception of art as the collusion of form and design (*katachi*). The focal aesthetic ideas posited by *katachi* as unsurpassable values are harmony and simplicity: principles which nature exhibits in even its most infinitesimal manifestations, and the genuine artist must learn to observe, process imaginatively, and eventually replicate in the artifact with such moderation and candor as to make his or her effort seem unforced. Even at its most spectacular, *Millennium Actress* honors the ethos of *katachi* by giving precedence

to the achievement of harmonious balance over theatrical glamour, and to the studious depiction of both the corporeal and the psychological dimensions in a style that will evoke a luminous sense of simplicity in spite of the labor-intensive tasks underlying its execution.

Ouran High School Host Club (TV series, dir. Takuya Igarashi, 2006)

Ouran High School Host Club regales us with a comprehensive and thoroughly structured dramatic construct which revolves around a comical approach to aesthetics based on a parodically exaggerated code of taste. In order to communicate unequivocally its humorous intent, the series makes it clear right from the start that its protagonists are essentially a bunch of overprivileged youths with too much time on their hands, who have chosen aesthetic sophistication as their pursuit, in much the same way as the students of an establishment less elite than Ouran High School might pick baseball, cookery or drama. Concomitantly, the action underscores straight away the corporeal nature of creativity, presenting the body as pivotal to the characters' performance of the stylized rituals to which the Host Club — an all-male club dedicated to entertaining the female students in exchange for their besotted admiration — owes its popularity. The body, no less importantly, constitutes the vehicle through which their artistic skills express themselves either as individual assets or as a collective endowment, depending on context and mood. At the same time, the body is regarded as the repository of not only aesthetic but also ethical values which have been enshrined in aristocratic etiquette, and passed down from generation to generation over the centuries. In fact, the anime's aesthetic code implicitly harks back to the Heian period itself, namely the zenith of Japan's aesthetic refinement, by locating the summit of sophistication with a person's ability to master numerous arts with utter self-confidence — a gift which the Heian aristocracy referred to as *miyabi*. Moreover, the Host Club's ethos echoes the precepts of both *bushidō* and *sumi-e* by emphasizing that an individual's talent must flow naturally and freely from the body itself. As its members' bodies express their creativity through performance, the Host Club's activities also come to resemble the Zen arts to the extent that they partake of the aesthetic ambivalence inherent in

those pursuits. Indeed, even though the Club's protocol and atmosphere compel the performers to obey preordained rules, thus fashioning, policing, and containing the body, they also give it scope for spontaneous, particularized expression.

As argued in the preceding chapter, Japanese culture has persistently evinced a proclivity to place intuition over rationality: an inclination which asserts itself with special fervor in the twin domains of art and aesthetics. In advancing its parodic world view, *Ouran High School Host Club* pushes this cultural attitude to ludicrous extremes, especially in the depiction of Tamaki Suou, the club's "king" or "father," and his tumultuous emotive responses to even the most trivial of supposedly touching occurrences. With Kyoya Otori, who plays the part of the club's "mother" and cunning financial administrator, the lampoon works more subtly insofar as the character's approach may at first appear to be wholly rational — even cynically calculating, in fact. However, we soon discover that the preposterously lucrative initiatives into which Kyoya channels his acumen are so absurd as to question severely their architect's reasonableness. As reason is thus ostracized from the club's alternate reality, conventional notions of morality become correspondingly alien to its protocol. Indulging in a playful travesty of Zen's prioritization of art over morality, the club's founders thus legitimize their every action as unassailable by either convention or common sense. To consolidate this self-indulgent stance, *Ouran High School Host Club*'s burlesque thrives on the idea that practically any activity may be elevated to artistic status. While the art of entertaining young ladies holds pride of place in the club's aesthetic pantheon, all sorts of other occupations are incrementally *artified* as the series progresses, and the club's appetite for new pursuits swells to Gargantuan levels. At one point, even the preparation and consumption of instant coffee — as opposed to aristocratic beverages of the kind normally dispensed by the profligate club members — is treated as a delicate art worthy of immense dedication. In the enactment of any daily ritual, what defines a person's excellence is the exhibition of natural flair: of a capacity to pull off the most sophisticated performance as though it entailed no toil in either intellectual or corporeal terms. Following nature, in this perspective, means understanding its laws so intimately as to be able to replicate them spontaneously within an artificial context. Relatedly, all pursuits coalesce as complementary components of a cumulative process of self-fashioning or self-drama-

tization which engages the club's members in an ongoing project of brico-lage. Indeed, much as each of them may lay claims to expertise in one specialized field, they are all, ultimately, consummate bricoleurs adept to making do with anything which circumstances send their way — as long as it can be turned into an art of sorts.

The Club's world picture is redolent of the ethos of decadence in its commitment to sumptuous self-indulgence, its taste for melodrama and sensationalism, its fascination with the bizarre, the artificial and the simulated, and its shameless cultivation of egocentricity and its spin-offs: self-absorption, narcissism, vanity. However, since the story progresses in an almost entirely comical atmosphere, *Ouran High School Host Club* does not exhibit any of the darker connotations carried by the concept of decadence in the modern artistic movements with which the term is often associated. Thus, it does not evince any of the ennui, world-weariness and morbid attraction to decay which one typically encounters in those milieux. In fact, the anime adopts a selective approach to decadence, extracting from its ideology only the views it deems consonant with its own overall philosophy of playful aestheticism. Most important among them is the notion of art for art's sake — namely, the belief that art must be unfettered by any didactic, ethical or functional purposes, and that the artwork, accordingly, should be entirely autonomous, self-contained, and autotelic. Pushed to absurd extremes, this position abets the show's parodic thrust from start to finish. To further its satirical stance, the series relies to a significant extent on the imaginative manipulation of a set of established character archetypes. Alongside the aforementioned Tamaki and Kyoya, we encounter the roguish identical twins Hikaru and Kaoru Hitachiin; the babyish Mitsukuni Haninozuka (a.k.a. "Honey"), who typifies the *shotacon* (a character pandering to the attraction to young boys) though he also excels at martial arts; and the strong and impassive Takashi Morinozuka (a.k.a. "Mori"). Approached as a trio, Mori, Tamaki and the twins incarnate the aesthetic formula of *shin-gyō-sō*. While Mori's silent disposition makes him appear solemn and formal even when he is, in fact, negotiating complex emotions, thus exemplifying the principle of *shin*, Hikaru and Kaoru embody the spirit of *sō* with their unremittingly mischievous ploys. Tamaki reveals traits of both typologies: the king's flamboyant efforts to ensure that nothing and no-one will ever challenge his fame as an irresistible heartthrob place him on the side of playfulness and flippancy, but

his deeply ingrained sensitivity and compassionateness — combined with an intelligence initially unsuspected — show him capable of quiet and unpretentious composure. These characters could easily descend to the level of trite formulae where they to become the anime's sole focus. In fact, they are endowed with unpredictable richness and multifacetedness by the presence in their midst of Haruhi Fujioka: the only student to have gained admission to Ouran High School, normally considered the undisputed province of the scions of the most affluent and prestigious families in the land, on the basis of her uncommon academic gifts rather than birthright. With her realistic personality and unaffectedly charming looks, Haruhi constitutes an appealing anime figure in her own right. From a dramatic perspective, however, her presence in the story is made most welcome by the fact that it operates as a filter through which the character types embodied by the club founders can be fully appreciated, and their nuances progressively discovered as the youths interact with Haruhi in a wide range of contexts.

Haruhi's filtering function is enhanced by the use of the gender-hopping motif: having found it convenient to adopt the semblance of a boy upon entering the school, it is in this guise that the heroine makes her acquaintance with the Host Club and becomes accidentally entangled with its quotidian exploits. Although her true identity is rapidly unveiled, she remains a boy for the purposes of club-related activities insofar as her androgynous cuteness is deemed certain to attract the female student body in drones — which immediately proves a correct supposition. Thus, we are able to perceive the cast not only through the eyes of a character whose level-headedness and sense of humor have the power to deflate the absurd aesthetic aspirations harbored by Tamaki and his cohort, but also do so from the double perspective provided by a person whose insights bridge conventional gender barriers. This strategy imparts the story with unabating freshness, allowing conventional personality types to gain novel connotations, and familiar patterns of behavior to reveal unexpected twists. As a result, even though *Ouran High School Host Club* does not yield "the most original plotline ever produced," as Melissa Sternenberg points out, ultimately this is "not important" insofar as "*Ouran* can appeal to both sides of the anime fandom: the veteran anime viewers who are tired of seeing the same character clichés re-hashed series after series" and long for unusual adaptations of those formulae, and the "newbies," who are given

sufficient background and contextual information to be able to relate to the characters without difficulty (Sternenberg). Moreover, the story's freshness is consistently intensified by its bold subversion of one of anime's most popular, and most exploited, dramatic subgenres: the so-called harem formula. DarkKanti elucidates this proposition as follows: "after the first episode it becomes apparent that *Ouran* is definitely something out of the ordinary. All too many times we see the standard anime harem where one guy is surrounded by a horde of girls who fall madly in love with the main character. However, in *Ouran* we see what many call a 'reverse harem' where there is one female protagonist surrounded by a group of boys who fall in love with the main character" (DarkKanti).

If the story's take on traditional aesthetics is incontrovertibly satirical, the art direction underpinning its visuals articulates a distinctive aesthetic of its own to deliver an unusually tasteful interpretation of pastiche. The campus itself instantly asserts its dominance as a major protagonist with its amalgamation of diverse architectural models, mainly of European derivation, and its deft imitations of illustrious landmarks, including London's Big Ben and Paris' Gardens of Versailles. The interiors, relatedly, allude to a variety of Western styles, with Neoclassical, Rococo and Baroque motifs among the most pervasive. These multiple sources are gracefully drawn together by the anime's treatment of color, where a marked preference for the red and red-violet palettes is evident from the start. Given these hues' romantic connotations, their prioritization can hardly come as a surprise in this context. What does come across as an uncommon feat is the enticing scenario emerging from the meticulous layering of myriad nuances within a comprehensive chromatic ensemble. The school's hallways, staircases and ceilings, and even some of the characters' private abodes, are all pigmented in shades derived from the same master palettes. To reinforce its chromatic preferences, moreover, the anime lays considerable symbolic emphasis on roses, which are alternately utilized as actual parts of the decor, and as metaphorical complements to shots depicting moments of heightened emotion. Inspired by nature, as is commonly the case with Japan's traditional colors, the hues encompassed by *Ouran High School Host Club*'s favorite palettes hark back to the indigenous environment and seasonal rhythms. Thus, if the show's architecture and interior design are based on predominantly Western sources, its chromatic sensibility exudes a quintessentially Japanese flavor. The actual names of the principal colors to which the visu-

als repeatedly return deserve mention in the present context because they convey more poignantly that any wordy description ever could the role played by native tradition in the elaboration of *Ouran High School Host Club*'s visual aesthetic. These names include *kōbai-iro* (red plum color), *sakura-iro* (cherry blossom color), *usubeni* (pale crimson), *momo-iro* (peach color), *nakabeni* (medium crimson), *arazome* (washed-out crimson), *tok-iha-iro* (ibis wing color), *enji-iro* (cochineal rouge), *sango-iro* (coral color), *umenezumi* (plum-blossom mouse), *chōshun-iro* (long spring color), *akabeni* (pure crimson), *jinzamomi* (thrice dyed crimson), *karakurenai* (foreign crimson), *akebono-iro* (dawn color), *akakō-iro* (red incense color), and *terigaki* (glazed persimmon). The more subdued of these hues — e.g., *arazome, tokiha-iro, umenezumi, chōshun-iro*— are consonant with the ethos of tasteful restraint promulgated by the principles of *wabi* and *sabi*. Others allude to the concept of *mono no aware* by reference to the transient glory of either blossom or maple leaves — the archetypal emblems of nature's seasonal splendor at its most captivating and most ephemeral. *Sakura-iro* and *momo-iro* belong to the former category, *enji-iro, akabeni,* and *karakurenai* to the latter. At times, deeper tones such as *enji-iro, akabeni* and *karakurenai*, while they may not be mysterious and shadow-laden enough to embody the idea of *yūgen* in an overt manner, are certainly capable of evoking a sense of solemnity and transcendental depth which echoes that very concept.

Much as the commitment to aesthetic excellence is treated satirically by the Host Club's colorful troupe, it has been handled very earnestly indeed by its director and scriptwriter. This is borne out by the gradual pace at which the series' prevalent mood alters, marking a subtle shift in the direction of seriousness without, however, relegating the comedy to the wings altogether. As Theron Martin observes, "while the second half of the series does continue the established pattern of free-wheeling comedy, it also much more frequently injects bits of seriousness into the content as it explores the backstories of the club itself and several individual members " (Martin 2009). In so doing, it injects the action with a vibrant sense of dramatic tension, engaging its humorous and somber elements in an elegant waltz of precisely the kind in which the school's courteous students would engage as their parties' centerpiece. Quite appropriately, it is in the impeccably balanced closing installment that the anime's knack of juggling contrasting moods reveals itself in its full colors. While Tamaki's personal

ordeal is sympathetically and soberly portrayed, the accidents surrounding his departure from Ouran and his friends' rescue mission abound with uninhibited farce. The madcap chase through woods, country lanes and shiny highways is downright hilarious — not least thanks to the juxtaposition of the state-of-the-art automobile spiriting Tamaki into a new life, and the old-fashioned horse-drawn carriage driven by Haruhi in rescuing-heroine mode. Yet, the sequence is so passionately suspenseful that we never forget, throughout its outrageous unfolding, that its outcome will determine the future of characters about whom we have by now come to care a good deal.

Another (TV series, dir. Tsutomu Mizushima, 2012)

The tangible ascendancy of dark and unspoken secrets defines *Another*'s atmosphere. The dialogue is peppered with cryptic allusions to mysterious incidents associated with a twenty-six-year-old curse which neither the anime's protagonist, Kōichi Sasakibara, nor its audience can initially presume to fathom. Both the youth — who, being unacquainted with the history and lore of the provincial town of Yomiyama to which he has recently relocated, is unaware of the events which cloud his class' tragic reputation — and the viewer are instantly placed in the position of amateur detectives enjoined to piece together a jumble of partial and nebulous clues. The series' emphasis on suggestion as opposed to direct statement mirrors an age-old tendency in Japanese art and aesthetics, where, as argued in the previous chapter, subtle hints at both meaning and form are deemed infinitely preferable to overt exposition. This stylistic preference characterizes the anime throughout its unfolding, even as the mystery-laden mood of its initial installments gradually gives way to more graphic drama. Faithful to indigenous tradition in stylistic terms, *Another* also attests to the enduring authority of time-honored conventions at the level of genre to the extent that it employs many of the visual motifs and symbolic formulae enshrined in classic Japanese horror. The sequences in which Kōichi visits a remote doll museum filled with grotesque ball-jointed mannequins epitomizes this trend with concise impactfulness. (This location will shortly be revisited in greater depth.) Also notable, in this matter, are the ubiquity of crows and dreary skies; the use of dusky lighting, particularly for the

scenes set in the hospital where the central enigma is first hinted at; and the prominence of damaged and decaying surfaces, such as the blood-red rust stains on the school's rooftop and the playground railings, and the peculiarly scratched desk in the protagonist's classroom. By exposing the scars of time on their bodily textures, locations like the hospital, the rooftop, and the playground pay homage to the aesthetics of *wabi* and *sabi* as a significant feature of the anime's pictorial makeup. At the same time, insofar as these concrete vestiges of age are harnessed to the evocation of a pervasive sense of mystery, they also enlist the charm of the imperfect and the old to the generation of a global atmosphere redolent of *yūgen*. Not surprisingly, these visual effects are matched by an ominously suspenseful soundtrack.

To reinforce its generic affiliations, the series also incorporates intertextual allusions to masters of mystery and horror, including H. P. Lovecraft, Stephen King, and John Saul. The background art contributes significantly to the evocation of the anime's creepy atmosphere, yet it is also remarkable in strictly aesthetic terms for its combination of two of the most defining attributes of Japanese art at its most vibrant: that is to say, a painstaking care for the tiniest details; and a propensity to lay bare those aspects of the work which bear witness to the underlying process of production in the belief that they are meaningful markers of creativity, not unsavory flaws. In several of the backgrounds, therefore, it is possible to identify the individual oil-paint brushstrokes which define the virtually omnipresent clouds. Finally, it is necessary to emphasize that as a mystery/horror yarn, *Another* owes much of its dramatic intensity to its early portrayal of the pivotal character of Mei in two distinct contexts without the exact relationship between the two being elucidated until the story is well under way. On the one hand, there is the Mei whom Kōichi meets in the hospital in the series' opening episode. On the other hand, there is the Mei who sometimes appears in Kōichi's classroom and is only, on such occasions, noticed by the youth himself while everyone else seems totally oblivious to her existence.

Creativity features explicitly in *Another* as one of the story's thematic strands. A few of the protagonist's classmates are also members of the Yomiyama North's Art Club, and flaunt their aesthetic leanings in the guise of more or less adventurous pictorial experiments. Kōichi himself aspires to become a fine art student, hoping to specialize in carving and sculpture.

Quite appropriately, given the series' dominant generic allegiances, the singular sense of unease communicated by Edvard Munch's works is referred to as an apt metonym for the human condition at large. It is at the figurative level, however, that *Another*'s stance on creativity declares its originality by engaging with an especially subtle creative phenomenon: identity replication. This is not dramatized as a literal occurrence, in the way it commonly is in anime inhabited by supernatural, cybernetic, or simulated organisms, but rather in metaphorical terms. Above all, it is incrementally conveyed by the story's emphasis on the recurrence of certain key roles, which retain the same intrinsic significance over time even though they are assumed by different people, and on puzzling overlaps in some of the characters' names — "Misaki," in particular, appears repeatedly as both a forename and a surname. Being founded on the principle of self-dispersal, the phenomenon of identity replication opens itself up to conflicting interpretations in both aesthetic and ethical terms. On the one hand, by proposing that the self is neither unique nor sacrosanct, it can be seen to subscribe to the idea of the self as nothing, and on a corresponding aesthetic of detachment, which are entirely congruous with Zen's views on selfhood. On the other hand, it can be regarded as a contradiction of Zen's perspective due to its insistence on the self as both the springboard and the object of creativity. Even in this reading, however, the self dramatized by *Another* offers a thought-provoking alternative to the myth of the unified and autonomous self promulgated for centuries by Western liberal humanism. In fact, it remains resolutely and defiantly fragmented, divided, estranged from its surroundings and ultimately even from its own essence. It is also worth noting that the classic Western ideal of the self has focused almost exclusively on the intellectual side of identity, relegating corporeality to the vulgar margins of philosophy. *Another*, by contrast, posits the body as absolutely axial to its conception of productivity to the extent that as a creative gesture, the self's replication is expressed and enacted by the body itself— hence, the physical apparatus functions as both the tool which enables the self's production, and the vehicle through which the product becomes manifest.

The topos of identity replication finds a potent iconographical correlative in the aforementioned doll museum: a venue invested with conceptual implications which deserve close attention in this context insofar as they enhance *Another*'s aesthetic message to a considerable degree. More-

over, the museum does not constitute a cinematically isolated event within the body of the anime as a whole, insofar as dolls play an important symbolic role in the presentation and unraveling of its enigmas. Shots of dolls of various styles are persistently intercut with the regular footage, at least in the first half of the series. The pivotal character of Mei is associated with dolls right from the start: when Kōichi first makes her acquaintance in the hospital lift, the girl is indeed carrying a doll, her apparent destination being the morgue where her "poor other half" supposedly lies. The museum itself is closely connected with Mei, as it transpires that it is actually part of her home, her adoptive mother Kirika being the artist responsible for the creation of the specimens on display. One of creatures, spookily arrayed in a luxurious coffin, appears to have been modeled on Mei herself sans eyepatch. Most importantly, a plausibly preternatural doll's eye, secreted under the conspicuous patch she normally dons, is presented as Mei's most distinctive somatic trait — and one with which Kōichi's and his classmates' futures may well prove entangled.

In foregrounding the doll figure, the anime draws attention to an important facet of Japanese culture through which both official knowledge and popular wisdom have communicated the country's aesthetics in metaphorical form. Known by the name of *ningyō*, which means simply "human shape," traditional Japanese dolls have assumed numerous guises and meanings over time in keeping with the development of both national and local customs, trends, rituals and crafts. Some of the most popular dolls have served to immortalize the myriad gods, spirits, demons, heroes, warriors, and monsters which people Japan's mythology and folklore. Numerous doll types have provided stylized depictions of children and babies, while others have functioned as emblems of members of the imperial court, and others still as incarnations of the ordinary inhabitants of different Japanese cities engaged in their everyday activities. It would therefore be hard to refute that the symbolic attributes of dolls of sundry shapes have been objects of profound fascination among the Japanese people for many centuries. Dolls still feature prominently in contemporary Japan, as demonstrated by the enduring hold on the collective imaginary of festivities such as the *Hina Matsuri* ("Girl's Day," 3 March), an event commemorated through the public display of decorative dolls as a figurative means of guaranteeing young girls' good fortune and health. The rigorous attention paid to both structural and chromatic details in the execution of

the *ningyō* proposed in *Another* imbues these entities with palpable uncanniness.

At the same time, the dolls' appearance suggests that scrupulous background research is likely to have underpinned their portrayal. As a result, it is possible to sense the presence of diverse influences of both Eastern and Western provenance behind the museum's eerie visuals, including the works of the Surrealist artist Hans Bellmer and of the contemporary Japanese artists Hiroko Igeta, Simon Yotsuya, and Etsuko Miura, alongside anatomical mannequins or even wax models such as the ones kept at La Specola museum in Florence. In addition, Kirika's artifacts occasionally hark back to nineteenth-century French Fashion Dolls, Bru Dolls, and even Barbie Dolls (especially "kinky" versions thereof). In addition, *Another* hints, more or less blatantly, at a wide variety of doll-related native arts and customs which carry anthropological relevance in both traditional and contemporary contexts. It is also worth noting that the figure of the *ningyō* is intimately associated with that of the mascot, as demonstrated by the adoption in legion societies and sects of talismanic articles invested with human or humanoid appearance. Dolls and mascots have been involved in a reciprocally supporting relationship over the centuries, since dolls can be employed as lucky charms and mascots, in turn, can assume the guise of dolls. The term "mascot" itself derives from the Provençal "*mascotto*," the feminine diminutive of "*masco*," which translates literally as "witch." The word "*masco*" is also connected with the Medieval Latin term "*masca*," which means "ghost." This is rather fortuitous for the purpose of the present discussion, given the anime's emphasis on the enduring agency of the dead among the living.

Another deploys the doll figure as a culturally significant vehicle for the exploration and exposure of deep-rooted uncertainties concerning the real meaning of being human. In so doing, it intimates that the creation of dolls of diverse types ultimately indicates a compulsive inclination to replicate the human form. By designing dolls in their own image, people strive to emulate the omnipotence that is traditionally ascribed to creation deities. Yet, what their efforts actually denote is a haunting apprehension of their inherent powerlessness. Humans, it is elliptically insinuated, produce dolls because they themselves feel like toys in the hands of remote forces which, though not necessarily spiteful, are nonetheless unconcerned with either their creatures' present ordeals or their future destinies. There-

fore, the entities we produce in order to perpetuate our self-image bear witness to a yearning to suppress our sense of puniness in the face of the universe's overwhelming vastness, and thereby declare our autonomy and inventiveness. Unfortunately, this effort amounts to nothing more than a pitiable creative exertion — which remains pathetic regardless of the quality of the artifacts per se. It is in fact bound to boomerang, as dolls inevitably bear witness not to our dominance but rather to our inescapable limitations. Executed so as to appear physically flawless, and hence exemplify humans at their best, dolls will not finally fulfill their intended function as gratifying replicas of real human beings insofar as they lack humanity's most salient feature: imperfection. A chillingly convincing rationale for this state of affairs comes from the villain in Mamoru Oshii's *Ghost in the Shell 2: Innocence*, a film already alluded to in Chapter 1. This character, named Kim, contends that "the human is no match for a doll, in its form, its elegance in motion, its very being. The inadequacies of human awareness become the inadequacies of life's reality. Perfection is possible only for those without consciousness, or perhaps endowed with infinite consciousness. In other words, for dolls and for gods." Kim also includes "animals" in his list, and reinforces this proposition by remarking that "Shelley's skylarks are suffused with a profound, instinctive joy. Joy we humans, driven by self-consciousness, can never know."

Oshii's film concurrently reflects on the obdurate vagueness of the concept of aliveness. Kim avers that dolls have held a singular power to "haunt" humans for centuries, for the reason that even though they appear unequivocally human, they are "nothing but human." They thus oblige us to wonder whether seemingly animate creatures are truly alive, and whether, conversely, objects which seem to be lifeless might in fact be alive. By extension, dolls "make us face the terror of being reduced to simple mechanisms and matter." These disquieting observations are largely a corollary of scientific progress: in striving to clarify the workings of the universe in mechanical terms, human beings have unintentionally opened up the possibility of their own existence being "reducible to basic, mechanical parts." It becomes proverbially difficult, at this point, to determining and quantify the exact extent to which human beings and their artificial complements actually differ. In the light of these observations, it is barely surprising that visitors of doll museums should often comment on the exceptionally unsettling sensations unleashed by the glassy-eyed exhibits.

Evidently inanimate, these entities nonetheless radiate an aura of awareness, of knowingness, and are therefore capable of engendering a sense of inner unrest which, in especially sensitive or fearful individuals, might even escalate into dismay. Mei comments on the atmosphere of unease which doll-populated locations have a singular power to evoke when she asks Kōichi: "don't you feel as though this place is drawing something out of you?" — a suggestion to which the youth, already shaken by the ghastly implications of the mysteries crowding upon him, promptly assents.

According to Mei, dolls are "hollow in both body and soul. That void connects them with death. But hollow things seek to fill their emptiness." These reflections echo the positions outlined in Chapter 1 regarding Japan's attitude to space. While emptiness may seem intimidating at times due to its intimate connection with the unknown, it is also the precondition of creativity, the natural abode of a sprawling dynasty of unforeseeable possibilities available for anyone to pursue. However, *Another* also intimates that this freedom should not be abused: in other words, emptiness must not be overfilled at random. This idea is dramatically conveyed through the proposition that the curse which looms over the protagonist's classmates and their families is periodically triggered by the presence in their midst of an "extra" person: to be more precise, of a human who is effectively dead but has preserved a physical appearance, a soul, and a body of memories for the simple reason that s/he has not grasped the fact that s/he is dead. These ominous presences, who are all "people connected to the class who have died over the years," constitute an intolerable surplus, an excess of meaning which cannot be accommodated within the group's interactive semiosis. It could even be argued that the living have actually called the curse upon themselves by treating the first Misaki — the dead student whence the phenomenon is held to have originated — as a breathing creature instead of acknowledging and accepting her demise. The deceased have a right to rest in peace, and their forceful reinsertion into the skein of life is bound to create an unpardonable imbalance — to cause a glut of presence where absence should be allowed to reign instead.

Another's spectral presences have a knack of appearing for a while in the class photographs taken upon graduation. Logically speaking, their condition ought to preclude the possibility of their forms being captured by a camera. They should remain unseen, ungraspable, unrecorded. Nevertheless, it is precisely in the visual space of photographs that they leave

their mark, albeit fleetingly. This phenomenon could be taken as evidence for the status of photography itself as the domain of invisibility par excellence. Indeed, as Roland Barthes maintains in *Camera Lucida*, "whatever it grants to vision and whatever its manner, a photograph is always invisible: it is not it that we see" (Barthes, p. 6). This is because the essence of the photograph is not what is actually present in the image as such but rather its referent, the object it purports to exhibit. In this logic, a photograph which incorporates an absent being is not so much an aberration as an intensification of its medium's intrinsic nature. Insofar as the referent can only ever exist, within the photograph itself, as an incorporeal trace, or a phantasmatic projection of the material entity it alludes to, the referent itself is inherently ghostly. Barthes' beautiful description of this state of affairs could barely be more pertinent to *Another*'s reality: "the person or thing photographed is ... a kind of little simulacrum, any *eidolon* emitted by the object, which I should like to call the *Spectrum* of the Photograph, because this word retains, through its root, a relation to 'spectacle' and adds to it that rather terrible thing which is there in every photograph: the return of the dead" (p. 9). Confirming the Japanese penchant for hues so subtle as to defy conventional classification, *Another* associates the dead with a distinctive, yet undefinable, color: a shade which cannot be compared to regular and generally recognized hues such as red, blue or green, but nonetheless carries an unmistakable suggestive power.

In the second half of the series, as its multilayered enigmas hurtle toward a sensational climax, the solution of the central mystery becomes a matter of identifying "another" at the center of the twenty-six-year-old curse. By extension, the identities of the main characters, both as individual endowments and as facets of a collective persona, become dependent on "another" for their very existence. If identities are open to replication, which makes them flimsy and unstable, it is also the case that their validity is fundamentally relational. No notion of self is tenable, in this scenario, independently of the self's shadowy other — in much the same way as a body is inseparable from its shadow, an original from its replica, or a flesh-and-bone entity from its doll-like doppelgänger. Bodies, originals, and flesh-and-bone entities only exist to the extent that they may cast shadows, be replicated, or become the models of synthetic simulacra. In designating the elusive "another" as a "dead" person who, through a flagrant violation of the dictates of both biology and logic, is able to go on functioning

among the living, the series uses death as a metaphor for negation and lack. At the same time, the suspension of the natural laws appertaining to death serves as a figurative correlative for the infiltration of being by non-being, of the self by the non-self, of the supposedly proper order of things by an illegitimate supernumerary. Insofar as the living may only justify and retain their legitimacy by isolating, containing, and eventually annihilating the alien intruder, their own existence comes to be predicated on a shifting margin of nonexistence, and their substance becomes inextricably intertwined with that which they seek to abolish. This state of affairs is permeated by the very ironies which one finds in Japanese aesthetics, since it ushers us into a world in which existence is coterminous with nonexistence, presence with absence, plenitude with emptiness.

Another's unresolved ironies, which the figure of the *ningyō* encapsulates in corporeal form, pervade the anime's entire fabric and define its dominant tone, tracing the incremental intensification of a state of collective tension from fear, though paranoia, to downright lunacy. According to Bamboo Dong, "that 'crazy' aspect is what makes the most recent episode [i.e., episode 11] of *Another* so fascinating. In the way that the students are so easily swayed by any glimmer of salvation, to the point where they'd discard their humanity, and the way that they're so quick to rally to scapegoatism, sheds an all too familiar light on the actions of humans in large groups. If we could watch this show and dismiss it as absurd, it might make for lighter entertainment, but perhaps the real horror is its uncomfortable accuracy in portraying mass psychology." It is therefore likely, argues the critic, that much as we may wish to engage with *Another* purely as a source of macabre entertainment, we will end up acknowledging just how "unfortunately realistic all this behavior is" (Bamboo Dong). This aspect of the anime is enhanced by its ingenious handling of the action's tempo. As Theron Martin points out, "is precisely calculated to a fault. Nearly every shot and line of dialogue in its first four episodes is meticulously designed to inculcate the kind of gloomy, ominous aura necessary to establish a proper horror series." The approach adopted in the early installments is thoughtfully maintained as the series progresses. Simultaneously, the anime takes the task of establishing a suitable atmosphere so seriously that its "very deliberate approach can get annoying after a while," especially as the story insists in a very calculated fashion on "not telling its protagonist what he needs to know." However, just as the viewer's tol-

erance is close to snapping point, "the series delivers a punch, and in a big way" (Martin 2012). What is truly tantalizing, however, is the dexterity with which both the action and the dialogue ensure that once the riddles surrounding Kōichi begin to unravel, they do so at a desultory and unreliable pace, so that any one disclosure, enlightening though it may be, has the effect of leaving a bubbling trail of additional questions in its wake. In fact, right through to the end of the series, the script delivers unexpected twists as a result of which the hidden truths exposed by the dénouement may take even the most prescient of viewers by surprise.

Concurrently, by focusing incrementally on the evolution of a private relationship between Kōichi and Mei, *Another* shows itself capable of transcending the boundaries of the standard mystery/horror yarn, and hence of engaging in cross-genre experimentation. Horror and mystery yarns — and not only in anime but also in live-action cinema — are somewhat notorious for devoting an inadequate amount of time to the portrayal of their principal characters, and attendant tendency to plunge into the action with a vehemence which will ensure there is no dearth of gory splashings in their wake, but do little to advance psychological complexity. While *Another* is neither shy nor sentimental when it comes to exposing the more gruesome effects of its horror-laden events, it is clearly not interested in prioritizing lurid spectacle to drama. In fact, its refined characterization techniques indicate that the depiction of its principal personae's qualities constitutes its focal concern. Avoiding the trap so often incurred by its generic peers, therefore, the series delivers a rich character gallery, going the extra mile to create a particularly solid and well fleshed-out lead couple. Kōichi and Mei are intelligently developed as the series progresses, endowed with intriguing personal backgrounds, and allowed to play off each other in an imaginative fashion. This creative gesture gains special resonance when both characters find themselves relegated to the status of invisible and unnamable members of the community by their terrified classmates. While up to now it has been tempting to dismiss Mei as a formulaic role whose sole function is to advance the progress of the story, at this stage in the series the girl begins to reveal a psychologically nuanced and attractive personality. When Kōichi and Mei are accepted back into the fold of the community in the belief that they may assist the devising of countermeasures able to stop the curse from fully taking its toll, the anime's sensitivity to the complexities of human interaction reveals itself in its full colors,

broadening the interactive tapestry to include a wide array of alternately jarring and complementary personalities.

Puella Magi Madoka Magica (TV series, dir. Akiyuki Shinbō, 2011)

As we have seen, *Ouran High School Host Club* offers a cheeky inversion of the harem formula, thereby reinventing a popular anime aesthetic with exhilarating glee. *Another* likewise engages in a bold experimental venture by stretching the artistic conventions of the mystery and horror genres so as to make them compatible with a sensitive anatomy of the vicissitudes of human interaction at its most fraught. With *Puella Magi Madoka Magica*, anime's appetite for experiment reaches heights rarely attained in contemporary and recent anime, its take on the magical girl (*mahō shōjo*) show being so imaginative, daring and nuanced as to stand out not merely as an adaptation of an established subgenre but rather as the genesis of a whole visual/dramatic aesthetic unto itself. The *mahō shōjo* typology represents both one of the most popular and one of the most overworked collections of tropes in the entire anime universe, having been persistently exploited, consumed to the limits of endurance, revived, declared defunct, and resuscitated yet again countless times over the past four decades. Honored, caricatured, and lampooned by turns, the magical girl formula has tended to remain loyal to the basic conventions set in place by its earliest avatars even in series where it has striven to depart most audaciously from the norm. It has therefore preserved many of the staple ingredients of the classic recipe, including the character of the apparently ordinary yet earnest girl who comes to gain supernatural abilities courtesy of a magical agent, usually portrayed in the guise of either a real animal or a cute fictional beast, and thereby undergoes a spectacular transformation marked by her acquisition of an elaborate costume and a weapon, wand or other totemic object.

Although magical girl anime with preeminently satirical or parodic leanings have exploited these ingredients as the iconographic fulcrum of a jocular experience, in the more serious manifestations of the subgenre, the emphasis has been placed on the *mahō shōjo* show's dramatic and ethical potentialities as a *bildungsroman*. Thus, as Miguel Douglas points out,

several anime have "not only aimed at exploring the realm of young girls with magical abilities," but also at offering "emotionally charged depictions of maturing alongside one's duty to save the world from evil, as the responsibility of growing up is ever present through the form of radical villains, disastrous circumstances, and the loss of a loved one." These factors are so common as to have become a core component of the *mahō shōjo* show's fare, to the point that many anime fans would automatically expect their appearance on the menu. Therefore, if *Puella Magi Madoka Magica* were simply using the magical girl formula as a vehicle for the exploration of self-development (which it unquestionably does anyway), it could barely aspire to uniqueness. What does distinguish it from its predecessors is its unprecedented tone: while most available series are "usually upbeat in their portrayal of the young protagonists and the discovery of their newfound powers, emotions, and growing responsibilities," *Puella Magi Madoka Magica* does not merely include the established components "but inverts the outlook of the genre to a surprisingly significant degree," thus subjecting the "foundational premise of magical girls" to an uncompromising interrogation (Douglas).

It is reasonable to claim, therefore, that with *Puella Magi Madoka Magica* the magical girl subgenre is not so much revised as drastically reconceptualized, the outcome being an aesthetically enthusing, intelligent, and unexpectedly disquieting story. It does not take long to realize, after entering the series' dizzying universe, that in this case, the stakes have been raised astronomically in both narrative and technical terms — that the series is indeed striving to accomplish something radically different by infiltrating the established modality with a multitude of wildly imaginative and perturbing elements. As Zac Bertschy maintains, "even in the first episode, the show is extremely effective at laying a foundation that there's something deeply wrong with all of this and it isn't going to end well. By the end of the fourth episode, after some really disturbing events and revelations have occurred, you're cringing, wondering just how deep this rabbit hole goes and how bad things are going to get." It is at this point in the action that the series' subversive import declares its full caliber with incontrovertible and spine-chilling power. What is most remarkable about this uncommon dramatic feat is not so much its content, challenging as this undoubtedly is, as the impassively balanced style in which it delivers such content. "There's a palpable sense of dread," Bertschy continues, "...one that drives

you to continue watching rather than succumbing to pure angst. There's an expertise in the way the plot unfolds, sparing the clumsy exposition and only sharing what it needs to at the right moments, explaining as it goes along, making sure the audience knows the consequences of what's happening without drowning in lore" (Bertschy 2012a). The manga adaptation of the anime series, illustrated by Hanokage, reflects these dramatic elements with commendable accuracy, maximizing their affective significance with its virtuoso graphics and expansive sense of space.

Puella Magi Madoka Magica is certainly not the first anime to have evinced a highly innovative approach to the *mahō shōjo* show. Before proceeding with the current assessment of the 2011 series, it is therefore desirable to examine a couple of major precedents in the history of that popular typology which have also striven to reimagine its parameters with both passion and pluck. These predecessors deserve consideration in the present context insofar as they shed light on an important sector of the ample generic storehouse developed over time by the twin arts of anime and manga. In addition, they can help us appreciate the extent to which these arts, like Japanese aesthetics at large, are not blindly devoted to the preservation of long-established principles, and are in fact keen on experimenting and even undermining tradition to test just how far its creative resilience might extend. One of the earliest and most radical reassessments of the *mahō shōjo* modality is proposed by two anime series based on a hugely popular CLAMP manga published in *Nakayoshi* magazine between 1993 and 1995: *Magic Knight Rayearth* (dir. Masami Obari, 1994–1995) and *Magic Knight Rayearth 2* (dir. Toshihiro Hirano, 1995). In effect, as argued in *CLAMP in Context*, "if a *mahō shōjo* yarn was ever truly able to open the door to an enchanted world, then CLAMP's *Magic Knight Rayearth* deserves recognition as the trusty guardian of the key to that door. At the same time as it delivers a classic epic yarn centered on the tropes of the princess in distress and of her salvation by a contingent of valiant knights, *Magic Knight Rayearth* subjects the established form to radical refashioning on both the thematic and the graphic planes. In thematic terms, it incrementally reveals a proclivity to deal dispassionately with some of the darkest human drives. In purely graphic terms, the title's daring is attested to by its intrepid insertion of a prominent *mecha* element into the codes and conventions traditionally associated with the heroic saga" (Cavallaro 2012, p. 64).

No less importantly, *Magic Knight Rayearth* stands out by virtue of its imaginative deployment of one of the principal features of *shōjo* manga created by female artists, as described in the article "*Shōjo* Manga: A Unique Genre." This distinctive formal category is here said to revolve around "a unique set of semiotic codes. Unlike comics written for men, which advance in a linear fashion from one frame to the next, *shōjo* manga employ an irregular narrative progression and make liberal use of modified frame shapes. There are frames without outlines, extremely long vertical or horizontal rectangles, portraits of the protagonists superimposed on top of several separate frames, and flowered patterns used as decorative backdrops behind the characters" ("*Shōjo* Manga: A Unique Genre"). Although these stylistic features are by no means exclusive to CLAMP's opus, few people would deny that in CLAMP's hands, they reach unparalleled formulation. In the process, they sustain the show's experimental aspirations with admirable consistency even when *Magic Knight Rayearth* appears to conform to the generic conventions enshrined in the regular *shōjo* adventure. A crucial addition to the heady experimental cocktail delivered by CLAMP's manga consists of its RPG elements. *Magic Knight Rayearth* indeed comments on the fundamental principles which govern the internal functionings of the typical RPG in order to convey the idea that its three heroines undertake their missions in the awareness that they are embodying predetermined roles, even as they gradually come to care for the fate of the world into which they have been forcibly inserted, and for the motley people they encounter along the way. This modicum of self-consciousness is intensified by occasional intimations that the girls actually treasure the idea that they have morphed into imaginary personae. However, the first story arc's heartbreaking culmination, where the Magic Knights are induced to carry out an act which has been pre-established on their behalf and they would never have chosen to undertake of their own volition, brutally shatters their erstwhile positive attitude to fantastic impersonation. At that climactic stage in the action, *Magic Knight Rayearth* dispenses altogether with the more amusing connotations of the RPG metaphor. It thus makes it incontrovertibly and grievously clear that the heroines have no more control over the reality to which they have been transposed than players of a role-playing game acting according to a rigorously predetermined set of codes and conventions. The girls, it transpires, have only been playing set roles all along, and never been really accorded any auton-

omy or initiative. *Magic Knight Rayearth*'s attitude to games and their ethical implications evolves gradually over time as a means of intensifying the complexity of the issues with which its story seeks to engage well beyond the formulaic strictures of the magical girl genre. In the first part of the series, the Magic Knights are not actually aware of their identities as players in a preordained game, much as they may fancy the idea that they have become fantasy characters, for the simple reason that they are oblivious to their impotence in the hands of the forces which have both created the rules of the game in the first place and recruited them as passive instruments in the achievement of their objectives. In the second arc, by contrast, the girls seem to have fathomed the nature of the epic mission into which they have been inveigled, and thus gained cognizance of the arbitrariness of the laws governing their moves. They can therefore feel that they are free *not* to abide by the system that has been imposed upon them or, at the very least, have the power to twist its ethics and reconfigure its coordinates in accordance with their own independent goals.

Another intrepid adaptation of the *mahō shōjo* formula is supplied by the series *Princess Tutu*, broadcast in 2002 and directed by Junichi Satō. Satō's expertise in the field can hardly be questioned when one considers that his credentials include the direction of the *mahō shōjo* show which even casual anime viewers would instantly associate with that subgenre, namely, *Sailor Moon*. *Princess Tutu* appears to comply with the standard set of codes and conventions associated with that format in its opening episodes, and continues to leave their overall validity unquestioned until roughly the half-way mark. From that point onward, however, practically all of the expectations which typically surround the *mahō shōjo* category are methodically disrupted or displaced. Accordingly, the second half of the anime, explodes the boundary between reality and fiction so prodigiously as to render it altogether unrecognizable. This is not the place to embark on a detail evaluation of *Princess Tutu*'s experimental flair on the thematic plane: to do so would require us to explore in some depth its dramatization of the vagaries of storytelling at its most convoluted and self-reflexive, and inevitably lead to unacceptably lengthy disquisitions. What does deserve emphasis, in the present context, is the extent to which *Princess Tutu* foregrounds its nature as a child of vision and sound to deliver a virtuoso formal experiment. The series' score relies substantially on Tchaikovsky's music — particularly *The Nutcracker* but also *Swan Lake* and

Sleeping Beauty— and often allows this music itself to direct its visual flow, even though it also integrates pieces by several other composers, including Mendelssohn, Prokofiev, Ravel, Mussorgsky, Schumann, Bizet, Saint-Saens, Wagner, Beethoven, Strauss, Satie, Mozart, Chopin, Rimsky-Korsakov, and Kaoru Wada. In its approach to this kaleidoscopic acoustic scenario, *Princess Tutu* elaborates a unique and infinitely inspiring landscape of musical-visual correspondences. At times, it relies on suggestive conciseness in the interests of dramatic impact, but more often than not it capitalizes on its generous dramatic breadth (which amounts to no less than thirty-eight installments) in order to explore the wonderful possibilities inherent in figurative landscape as a metaphor for music. It thereby brings into existence a resonant environment in which earth, air and water blend and disperse by turns in an ceaselessly changing architecture of rhythms and shapes. As it delicately charts the adventure's diurnal and seasonal cycles, the series' landscape thus appears to encapsulate the spirit of sound in a truly symphonic fashion.

While *Puella Magi Madoka Magica*, like *Magic Knight Rayearth* and *Princess Tutu* before it, bend the rules of the magical girl subgenre with irreverent gusto, it also represents an entirely autonomous development in the field to the extent that it persistently infuses the drama with thought-provoking conceptual reflections in a hitherto unassayed manner. In *Puella Magi Madoka Magica*'s inspired yarn, a magical girl's prime responsibility is to fight witches: namely, personifications of hopelessness and despair able to catalyze the emergence of these life-destroying affects anywhere in the world. One of the most unusual twists to the norm proposed by *Puella Magi Madoka Magica* in its early stages consists of its use of an unusual persona: a magical girl named Homura Akemi tenaciously resolved to prevent the protagonist, Madoka Kaname, from joining the ranks of her kind. We eventually realize that the reason behind Homura's efforts, though she may initially appear to be Madoka's adversary or even a witch, is not enmity but rather a selfless desire to protect the titular heroine from a destiny which she knows to be tantamount not to a supreme bonus but rather to a poisoned chalice. Indeed, the fate awaiting Madoka when she finally resolves, out of her own heroic selflessness, to enter a contract with Kyubey — the magical creature with whom the girls seal their contracts when they decide to acquire their superpowers — is one of utter loneliness, entrapment in one's duty, and endlessly renewed despair.

100

Like countless *mahō shōjo* series before it, *Puella Magi Madoka Magica* examines the process of maturation by means of allegorical rites of passage centered on the defeat of supernatural forces. What it seeks to foreground, however, is not so much the jubilant outcome of this symbolic enterprise as the darkly onerous nature of the responsibility entailed in becoming a champion of justice. What is therefore most profoundly and disarmingly new about *Puella Magi Madoka Magica* is its contention that there is nothing either glamorous or romantic about being a magical girl. "Essentially," as Douglas persuasively argues, "*Puella Magi Madoka Magica* is a deconstruction of the very *mahō shōjo* genre it subscribes to. While many series may look into the duality that exists between its young female protagonists as they attempt to live an ordinary life alongside that of being a magical girl, *Puella Magi Madoka Magica* is a series that edges itself continuously towards exploring the dark recesses of becoming a magical girl." As a corollary of this aesthetic choice, the anime's primary concern soon turns out to be a frank exposure of "the tragic results that stem from making that final leap into becoming a slayer of evil minions and witches, exploring the psychological states of self-doubt and personal criticism as the young girls come to grip with the harsh reality of their choice. It's that choice that remains at the forefront of the series — a choice that fulfills a single desire, but only in exchange for a life of obligation." It will barely come as a surprise, in the light of this jarring generic reorientation, to hear that *Puella Magi Madoka Magica* is prepared to address topics from which most *mahō shōjo* anime would readily back away as antithetical with their feel-good messages. Thus, "subjects such as death, psychological instability, suicide, jealously, and even rivalry are taken into consideration as viable dynamics of a plot that is as mature as it is sensible in its deconstruction" (Douglas).

Another major respect, highlighted by Eternal, in which *Puella Magi Madoka Magica* offers a drastic departure from practically any other magical girl plot to date is that it seeks to concentrate on "the in-universe magical girl system over the characters' own relationships, resulting in a story that's more evocative from an intellectual point of view than an emotional one" (Eternal). Thus, although the drama is coursed by complex and often intractable emotions, its speculative dimension tends to stand out as more defining an aspect of its overall makeup than its affective component. The series consequently attests to the philosophical potentialities inherent in

the art of anime at large. Simultaneously, as a product of a distinctive facet of Japanese culture, *Puella Magi Madoka Magica* also pays homage to this culture's unique aesthetic vision. It thus reminds us that in that milieu, ideas are almost invariably embodied in tangible forms governed by specific aesthetic criteria. It is quite natural, in this perspective, for abstract concepts such as hope and despair, selfishness and altruism, damnation and redemption, to be given palpable expression in the shape of thoroughly individualized characters and a no less distinctive environment. This is not to say that Madoka, Homura, Sanaka, and their various friends and foes are merely personifications of the kind one regularly encounters in the allegorical works popular in the West in the Middle Ages. In fact, while embodying ideas, Madoka and company also come across as painfully credible people: giving a disembodied concept a physical form, in the context of Japanese aesthetics, does not mean exploiting such as a form as a lifeless vessel but rather implies imparting it with dynamism, a will, and a soul.

The penchant for philosophical reflection evinced by *Puella Magi Madoka Magica*— and distinguishing it from most, or even all, of its magical girl associates — also demonstrates its implicit connection with an important aspect of the indigenous narrative and dramatic tradition: that is to say, a preference for introspection. It is worth emphasizing, on this point, that in spite of its standing as an inherently fashion-driven strand of modern popular entertainment, anime has time and again evinced marked introspective leanings. Often prominent even in titles governed by the formal priorities of eminently dynamic genres, such as action adventure, these tendencies echo a long-standing indigenous propensity which is especially prominent in the realm of literature. Describing this important facet of Japanese aesthetics in comparative terms, J. Thomas Rimer explains: "in the Western novel, many readers would agree that until the middle of the nineteenth century, outward events more often than not took pride of place over interior responses ... the Japanese tradition ... appears to have begun the other way around. Early works that purport to tell a story ... nevertheless gave pride of place to the interior feelings and responses of their ... narrators or characters" (Rimer, pp. 3–4). This imparts them with "a remarkably modern effect," stylistically intensified by their emphasis on "the ebb and flow of the thoughts" (p. 5) in preference to action per se. "As Japan entered the modern world," Rimer continues, "the polarity began to shift swiftly toward that of an exterior chronicle. Yet

even so, in many of the great classics of the twentieth century ... the emphasis continues to remain on the sometimes restless interior feelings of the central characters" (p. 6). This is the very feeling we get in anime which — regardless of the contingent amount of kinesis and exterior spectacle they may contain — foreground their characters' psychologies, inner conflicts, and intimate reflections even in the midst of earth-shattering phenomena and epic confrontations.

On the surface, *Puella Magi Madoka Magica* may well not seem a likely candidate for inclusion in the illustrious tradition of introspective fiction. It is, after all, packed with many of the ingredients found in legion *mahō shōjo* shows of recent decades despite its overtly innovative thrust. These include, as intimated earlier, the magical creature functioning as both an employer and a guide, as well as the acquisition of unsuspected superpowers, and the spectacular display of battles with cosmic repercussions. Undoubtedly, the anime handles these elements with uncommon flair thanks to a sensitive script, impeccable editing, and the unmatched technical expertise of the studio responsible for its production, Shaft. However, not even these remarkable features would necessarily have been sufficient to grant the series admission to the ranks of introspective fiction were it not for its engagement with serious philosophical issues with equal proportions of sensitivity, poise and compassionate sadness. Before assessing these issues in some detail, it is important to recognize that the effectiveness of their dramatic treatment in the series as a whole owes much to the lyrical disposition of its tone. According to Rimer, "a major reason" for Japanese fiction's introspective tendencies "lies in the centrality of poetry in the Japanese literary tradition"— namely, a form which was characterized from inception by a strong sense of "intimacy." "While sometimes created in the social environment of the court for public purposes," poetry was essentially "couched in terms of a personal and lyrical response to nature." This is the root of "the persistent strain of lyricism in all of Japanese literature" (p. 7). In this perspective, introspection and lyricism go hand in hand. While its characters' inner divisions are often the focus of the introspective scenes yielded by *Puella Magi Madoka Magica*, nature is persistently presented as the trigger for moments of solitary reflection tinged with poetic connotations. Whenever the anime realizes its vast aesthetic potential to the full, we are treated to a poetic integration of external vision and personal feelings. On such occasions, intuition is prioritized to intellectual

abstraction in ways which hark back to both the lessons of Zen and the attitude to creativity traditionally fostered by Japanese aesthetics. Hence, fluid and frequently unpredictable trains of thought and feeling appear to be activated by images rather concepts. Conceptualization tends to follow as the characters struggle to make sense of their uncertainties and fears and devise strategies to resolve their crippling crises, but the first natural prompt is intrinsically intuitive. These situations produce moments of contemplation and wonder replete with numinous undertones even in some of the least mystical, or indeed lyrical, sequences.

In assessing the anime's philosophical dimension, its ethical spectrum deserves special consideration. At one extreme lies a cold, cynical and calculating mentality which focuses solely on tangible objectives and on the most efficient means of achieving the desired results in the service of self-preservation, and with no concessions whatsoever to notions of altruism or solidarity. As Bertschy maintains, within this frame of reference. "one concept in particular takes center stage: the idea that happiness and the naiveté that's inherent to being happy is toxic and antithetical to survival. Hardened cynicism and ruthless self-preservation is the only way you'll truly survive; the innate need to protect the ones you love will cost you everything, including your humanity and any memory that you ever existed. Abandoning your desire to help those around you is key" (Bertschy 2012b). This undilutedly Darwinian approach is championed by the character of the smug and superconfident magical girl Kyoko. At the opposite end of the spectrum lies Sayaka, a character who has embraced her fate as a magical girl with the specific intention of saving a friend in distress, and is determined to devote her preternatural gift to the protection of every other human's wellbeing. Sadly, Sayaka's generous outlook is also what ultimately seals her inevitable downfall. In an impeccably crafted narrative buildup attesting to the show's uncommon storytelling quality, we discover that by entering a contract with Kyubei, Sayaka has relinquished her very humanity since, in the cruel logic of the show, separating the soul from the body is the most realistic way of guaranteeing a witch-fighter's effectiveness: a body devoid of its life spirit is just a serviceable instrument capable of withstanding pain and discomfort by barely registering their occurrence, if at all. This condition is bound to be deeply pernicious if one assesses it not simply within the parameters of the anime's universe but, more importantly still, vis-à-vis the aesthetic legacy which informs

Japanese culture, where the body, as we have seen, is valued as a major agent in the expression and enactment of human creativity. Moreover, insofar as this tradition implicitly posits creativity as a defining aspect of being human *at all*, a world view which disrespects the body is effectively abusing the concept of *humanity itself*. Not surprisingly, therefore, Sayaka ends up disintegrating under the burden of her soul-destroying choice, poisoned by a polluted spirit, trapped in a virtually mechanized body, and effectively reduced to a state of death-in-life. The girl's misery is depicted so penetratingly as to come across as viscerally affecting.

While Sayaka takes up Kyubei's proposition at an early stage in the drama, Madoka hesitates until she feels left with no choice by advent of Walpurgisnacht, a witch with the power to annihilate legions. When the protagonist eventually resolves to take on the role of a magical girl, a somewhat inevitable climax toward which the entire action has been relentlessly building, "the payoff is intense. It winds up justifying all the self-doubt the Madoka character goes through in the episodes leading up to this and feels like an even bigger take (and gentle commentary on) the entire idea of a 'magical girl.'" Indeed, the heroine's metamorphosis does not simply amount the standard donning of fairy-talish garb, and attendant acquisition of symbolic accessories, since what Madoka "transforms into" is "the *very concept of hope itself*" (Bertschy 2012c). This is not to say, however, that when the protagonist embraces her momentous duty, everything around her becomes suddenly rose-colored and mushy. In fact, "the universe is still a cold and uncaring place, fraught with misery and despair. If *Madoka Magica* is saying anything, it's saying that life will absolutely crush you and entropy is inevitable, but there's reason to hope. That wishing for your loved ones to be safe and fighting for the things you believe in is the most important thing a human being can hope to do, even in the face of all that. If that isn't a happy ending, then I don't know what is." (Bertschy 2012b).

The series' radical redefinition of its parent subgenre reaches its climax as a trenchant rejection of the trite good-versus-evil recipe. In fact, when she eventually resolves to become a magical girl, and hence an immortal entity destined to fight evil ad infinitum, Madoka is well aware that this decision condemns her to a life of constant warfare. What the girl's decision effectively amounts to is a sacrificial preparedness to surrender her very soul to the task of destroying all witches who exist, have existed, or will

ever exist, both in order to protect ordinary people by enabling them to retain the hopes which witches oppose, and to relieve the obnoxious creatures themselves of the burdens which cause them to hold grudges, and hence act malevolently in the first place. Madoka is in fact determined to absorb into her being all the bad karma which witches have willy-nilly accumulated over the millennia, thus shielding them from themselves even before they have assumed their witchly identities. There is no doubt that the heroine must bear an enormous curse in exchange for her wish, insofar as "enough hope to give birth to a new universe," which is precisely what her actions ultimately entail, "means enough despair to bring an end to the old one." This proposition can be read as an allegory for the incessant interweaving of good and evil throughout the cosmos. At the same time, it delivers a bleakly ironical interpretation of the concept of creativity itself by suggesting that the ultimate act of creation — the generation of hope itself and hence of the precondition of anything else ever being brought into being — is also an act of eternal and horrifying destruction. Ultimately, Madoka has no choice but to become an amorphous and depersonalized "force of nature" with no memories of her existence in te ordinary human world, and no proof of her existence therein. To all intent and purpose, she will "no longer be part of this universe." Yet, from the protagonist's own — inexhaustibly optimistic — perspective, such a life is not to be shunned, for it will allow her always to be with everyone, everywhere in the world, even if she will not be in a position to interact with them or they with her in any literal sense.

From this attitude stems the message yielded by the series' closing moments: indeed, although *Puella Magi Madoka Magica*'s dramatic emphasis remains to the end on the darker, and hitherto unexplored, underside of the magical girl typology, director Akiyuki Shinbō does allow us at least a glimpse of a positive message. Taking the heroine's own hopeful vision as a starting point, the ending suggests that Madoka's memory has not in fact been entirely obliterated from her former reality, and thus celebrates the importance of friendship, compassion, and selflessness as values no less immortal than the longsuffering Madoka herself. This uplifting message should no doubt be treasured. Yet, it would be hard to deny that the chief reason for which *Puella Magi Madoka Magica* abides in one's memory is its standing as a gritty and unsentimental existential meditation — and these are the attributes which enable it to reinvent the *mahō shōjo*'s aesthetic

legacy with unprecedented courage. It is also worth noting, on this point, that the anime does not end with a joyous celebration of the heroine's sacrifice, but rather a sobering cautionary footnote. The finale indeed suggests that the existence of fiendish creatures embodying humanity's negative emotions is a precondition of life itself. Hence, the witches' elimination does not constitute the world's conclusive cleansing of all destructive energies but actually signals the advent of a new host of unhappy demons.

Shaft's taste for surreal phantasmagorias, montages, collages, warped perspectives, deliciously eerie landscapes, juxtapositions of myth-encrusted and futuristic settings is everywhere palpable, its effectiveness often gaining from the studio's deft use of irony. The representation of the school is an apt case in point. When viewers are first introduced to this location, they could legitimately assume that the plot is going to lead them into sci-fi territory, since the school building instantly comes across as an undiluted triumph of cutting-edge visionary architecture combining the most radiant modernist aspirations with a postmodernist flair for jocular spatial pastiche. As it turns out, of course, classifying *Puella Magi Madoka Magica* as a sci-fi anime would be not simply inaccurate but altogether preposterous. Throughout the show, moreover, Shaft's hearty taste for vertiginous perspectives and free-floating locations communicates a notion of scenery which acknowledges no limits and no thresholds: an *unbounded* space indeed if there ever was one. While acknowledging Shaft's undisputable genius, it is also vital, from an aesthetic point of view, to acknowledge the anime's portrayal of its multifarious witches as one of its most distinctive stylistic features. As Tim Jones points out, the witches "come in a variety of shapes and sizes, each drawn with imaginative, highly stylized art styles, typically across equally stylized backgrounds. Popcorn-head bugs, flying scissors, chocolate ball-shaped giant heads, and android angel-like beings are just a few of the forms they take" (Jones 2012a). Bertschy concurs with this assessment, remarking that while the designs of the magical girls themselves often evince "simplistic features and petticoats and jeweled sticks and whatnot," with the introduction of its unusual witches, *Puella Magi Madoka Magica* "descends into almost psychedelic madness, a pastiche of cutout monarch butterflies and mustachioed dustballs filling the screen. It's unlike anything else out there, visually, and it evolves from episode to episode — each witch encounter is different from the last, following a different set of design rules, with grotesquely beautiful results" (Bertschy 2012a).

Prior to helming *Puella Magi Madoka Magica*, Shinbō had already demonstrated his penchant for some challenging revisions of conventional generic molds, often peppered with surreal flourishes, in several contexts: most notably, for the purpose of the present discussion, in the supernatural horror OVA *Petite Cossette*. The principal reason for which this work is deemed to be a title of particular relevance to this study lies with its engagement with art on the overtly thematic plane as well as on the figurative plane. *Petite Cossette* seems therefore to deserve close consideration at this juncture as an appropriate complementary title. Shinbō's typical taste for surreal effects declares its ascendancy as a major aesthetic trait from the OVA's early stages, as art student Eiri Kurahashi chances upon a seemingly living girl moving within a precious piece of Venetian glassware in the antique shop where he is employed. Having rapidly become besotted with this peculiar being, whose name turns out to be Cossette, Eiri discovers that she was once a nobleman's daughter in eighteenth-century France, and that the cause of her current entrapment was her murder at the hand of her betrothed, the artist Marcelo Orlando. For Cossette to achieve the peace she yearns for, a man would have to love her so much as to be willing to receive punishment for Marcelo Orlando's crime as a sacrificial surrogate for the wicked artist.

The anime capitalizes on Shinbō's penchant for experiment by delivering an adventurous interpretation of many of the classic — and even stereotypical — visual tropes one would readily expect to encounter in a horror story, a supernatural mystery, a haunted-house thriller or a Gothic saga. These encompass a great deal of crumbling ruins, graveyards, corpses garbed in their sepulchral vestments, clunky chains and clocks, eyeless china dolls, and just enough candelabra and vertiginous spiral staircases to whet the appetite of antiquarian enthusiasts. *Petite Cossette*'s aesthetic sophistication is such as to purge these images of their more banal connotations and take its audience on a surreal journey through the human soul's murkiest nooks. Moreover, as Martin suggests, the OVA's background art and character design are sufficient unto themselves to gain it lasting recognition: "*Petit Cossette* is loaded with gorgeously-rendered backgrounds which are so finely-detailed that it is sometimes hard to distinguish between an artistic rendering and an actual still shot of a real-life scene. Characters are specifically designed to be appealing without capturing too much of the typical anime drawing style. As a result Cossette herself looks more

beautiful than cute, almost more a walking talking porcelain doll than a living girl." The uncommon subtlety evinced by the OVA's visual sensibility is fully borne out by its treatment of the topos of art itself as both a metonym and a symbol for creativity at large. Accordingly, "the portraits of [Cossette] used both in the episodes and in the closer are exceptionally vibrant, capturing the spirit of classic 18th century art and making it no mystery how Eiri was able to fall for her in the story" (Martin 2005).

Another notable facet of *Petite Cossette*'s artistry consists of its frequent deployment of sketches, line drawings, rough crayon squiggles, and still images of its principal settings filtered so as to resemble paintings executed in the Impressionist style. The pencil drawings of Cossette fondly executed by Eiri throughout the story, and with greater and greater frequency as his infatuation with Cossette grows, are especially remarkable. These stylistic gestures can be interpreted as a metacommentary on the development of the visuals themselves, to the extent that they figuratively call attention to the design stages underlying the moving images we see on the screen once the animated work has reached fruition. *The Fairy Tale and Anime* expounds this idea as follows: "the ... figure here at work is an invisible artist chronicling from the shadowy space of the anime's theatrical wings the regression of the moving image to its embryonic phases, and progression thenceforth toward sophisticated levels of kinesis ... although the graphic elements that explicitly call attention to the series' constructed status may seem utterly unrealistic in the mimetic sense of the term, they actually represent the vital foundation of that magical illusion of motion which animation at large seeks to evoke.... Where pointedly rudimentary scrawls are given prominence, the materiality of the image is so intense as to bring to mind not only the act of drawing but also more emphatically physical practices such as carving or sculpting. This is made most evident by the moments of horror that punctuate Eiri and Cossette's affective ordeal, where an impression of sculptural solidity is frequently communicated by the use of shapes and expressions that seem to have been hewn out of wood or stone" (Cavallaro 2011, p. 44).

It is at the cinematographical level that Shinbō's distinctive aesthetic is most palpably discernible. The OVA abounds with atypical camera moves — such as nebulous, distorted and disorientating perspectives, puzzling angles, and rapid cuts — and hence conjures up a dreamlike mood in which night and day, reality and illusion, self and non-self, become per-

plexingly interchangeable. *Petite Cossette*'s aesthetic vision reaches its culmination with Shinbō's imaginative amalgamation of dynamic and chromatic effects. The scenes in which the eponymous heroine seems to move smoothly through the iridescent stained-glass goblet in which she is imprisoned, while other characters are captured through warping lenses overlaid with elaborate patterns and sinister shadows, are undoubtedly the most memorable results of the director's experiments with the collusion of motion and chroma. At the same time, the OVA's cumulative dramatic impact owes much to the rampant atmosphere of paranoia which relentlessly oozes from its frames as the action careens toward its nightmarish climax. The sequences in which the articles surrounding Cossette seem to sense that Eiri is a reincarnation of the insane artist believed to have murdered Cossette in eighteenth-century France, and hence lash out their vindictive fury against the innocent youth, are indubitably among the most memorable of the show's aesthetic achievements. Finally if one is to do full justice to Shinbō's aesthetic vision, then it is vital to acknowledge that *Petite Cossette* is not just an experiment in spooky surrealism. In fact, the OVA also carries philosophical implications which bear witness to the depth of its director's vision. Thus, both the individual identities and the macrocosmic relations of power portrayed in the OVA serve as an effective means of reflecting on broad cultural issues of potentially substantial magnitude. By oscillating nimbly between the present day and the eighteenth century, and thus telescoping history to suit its rhythms and import, *Petite Cossette* intimates that the murderous depravity at the core of its drama does not merely constitute a convenient plot trigger but also functions as a metaphor for the state of corruption affecting the entire society in which it is set (in both its present-day and eighteenth-century manifestations). This message is deftly conveyed through the depiction of the titular heroine as an ambiguous creature imprisoned in history and yet, ironically, empowered by her captive status to journey across diverse temporal zones, and thus implicitly demonstrate the moral unsoundness of both.

Bokurano (TV series, dir. Hiroyuki Morita, 2007)

As we have seen, *Puella Magi Madoka Magica* perpetuates the penchant for introspection inherent in the aesthetic of Japanese storytelling

with its radical reinvention of the *mahō shōjo* formula. The TV series *Bokurano* demonstrates the same proclivity by redefining, with comparable passion and a preparedness to venture even deeper into the mind's gloomier recesses, another hugely popular anime subgenre: the *mecha* (giant robot) show. Like *Puella Magi Madoka Magica*, *Bokurano* adopts a deconstructive take on the generic category at its base by exposing the self-dismantling tendencies latent in the *mecha* show's oft-recycled ingredients. In other words, the anime shows us how the epic ambitions pursued by that subgenre already harbor within their folds the conditions of their collapse. These are signaled by repeated, albeit discreet, insinuations that those aspirations are downright untenable in a world woven from the exploitative will of a handful of unscrupulous puppet masters. In the process, as Shadowmage explains, "*Bokurano* indirectly brings up numerous questions about greed, sordid politics and the costs of survival. A lot of time is spent developing the politics of the battles as the government tries to suppress information about the giant robot through misdirection, coercion and murder" (Shadowmage). These reflective tendencies are traits which, in classic renditions of the giant robot formula, are frequently obfuscated by the action's heroic paraphernalia but are bound to emerge in their full iniquity when the epic pomp and the spectacle take second place to a dispassionate anatomy of troubled psyches — in *Bokurano*'s case, those of a bunch of kids haunted by familial strife, crippling memories of abuse at the hands of exploitative adults, and a pervasively dysfunctional social milieu. The emotional burdens which these individuals have been forced to carry from an early age are so heavy as to appear to foreclose their chances of moving on toward a rosier future. In this respect, the show's sustained meditation on the past's burdensome legacy can be seen as a logical corollary of its pivotal narrative premise: as Shadowmage pithily points out, "reflecting on the past is one of the few things a person with no future can do" (Shadowmage). As we shall see shortly, the idea that the anime's protagonists have in effect been deprived of any viable future is brutally literalized by the story's development. In all of this, *Bokurano*'s action sequences are almost entirely forgotten once the fighters have faded from the screen, leaving only the vestiges of horrific destruction in their dismal wake. The protagonists' inner conflicts, conversely, abide in memory, particularly as most episodes address hidden aspects of their personal tribulations with a rare flair for introspective drama.

111

Bokurano's protagonists, fifteen thirteen-year-old kids with variously checkered pasts, are fortuitously recruited as test subjects for a new videogame in the course of an innocent summertime field trip by the seashore. While the deal is initially welcomed as an unexpected respite from a reality of quandaries and traumas, the kids soon discover that they have been caught into a hellish deathtrap. The game involves a colossal robot named Zearth which the protagonists are expected to pilot one at a time from within a cockpit containing replicas of chairs holding special sentimental significance due to their connection with the kids' childhood. Each of the fifteen intended battles requires the pilot to vanquish another equally ominous *mecha*, failure to accomplish this task being certain to result in the annihilation of the entire universe. There would be nothing especially original or tantalizing about this situation were it not for the fact that the anime lends the familiar *mecha* yarn a sadistic twist by proposing that while each successful fight will prevent the threatened apocalypse, the kid responsible for its handling will inevitably die, since the formidable Zearth is fueled by its pilot's life energy. It is not until the series has hit the half-way mark that the children begin grasp who their adversaries really are, and what the goal of each battle truly amounts to. The revelation that the protagonists and their battles have a major impact on the inhabitants of numerous parallel worlds, in particular, invests *Bokurano*'s dramatic identity with initially unforeseen levels of conceptual complexity. Indeed, by presenting its world as a facet of a potentially limitless metauniverse, or multiverse, the anime enhances its introspective dimension to grapple not only with the sphere of private emotions, anxieties and pain, but also with a daunting hypothetical cosmology, and with its implications for the meaning of existence as such. When the military eventually resolve to intervene in order to put an end to the protagonists' atrocious plight — much to the children's glee — their coldblooded tutor remains oblivious to any external challenge, seeming indifferent even to the existence of potentially adversarial agents.

Ironically, preposterous though the kids' predicament is, its progress is persistently charted with impeccable dramatic logic and a degree of psychological realism which many live-action dramas would do well to emulate. As Rossman pithily observes, *Bokurano*'s protagonists "are damned if they do, and damned if they don't" (Rossman). VivisQueen elaborates this point by suggesting that the so-called "game" at the heart of *Bokurano* is

a crusade which effectively enslaves the protagonists to "airtight rules that make the notion of escape nothing more than a pipedream." In addition, the kids are not informed of the terms governing the deal in advance, but are actually forced to learn them "mostly through trial and error, each revelation rendering the situation more abject than before. Like agreeing to a game of russian roulette only to realise just as you're about to pull the trigger that there are six bullets in the chamber instead of one" (VivisQueen 2010). The children's ordeal is made especially painful to watch by the fact that the ratlike character coordinating the action, known as Koemushi (a.k.a. Dung Beetle), is not simply unconcerned with the kids' suffering, which would be unpalatable enough in the circumstances. In fact, he goes out of his way to ridicule both the kids themselves and their misfortune, sprinkling spiteful sarcasm on every action and every thought. "Dung Beetle mocks each of their deaths," notes Rossman, "and laughs at each new pilot when they're selected (and they're marked by some funky tattoo somewhere on their body lest they forget that they're about to die one way or another), and he's also been known to mock their virginities and their family lives when he's feeling frisky" (Rossman). The design of the piloting chairs on models provided by cherished childhood mementoes fuels the pervasive sense of mockery as a sinister irony.

What is most alarming about the anime's overall mood is the intimation that there is no ultimate rationale for the kids' suffering — that much as they struggle to find some justification or validation for the horror to which they have fallen prey, random chance is the sole cause of their misfortune. *Bokurano*'s world view does not totally preclude either hope or redemption; yet, it makes it incontrovertibly clear that to seek for explanations other than happenstance to the grotesqueries of human existence is bound to be misleading, mystifying, circular — in other words, a total waste of time. Thus, though the protagonists insistently wonder why they should be the ones chosen as apposite sacrificial victims, they regularly come up with no satisfactory results. "Is it fate? Is it a trial? Is it punishment?" ponders VivisQueen. "The cruellest answer is the truth: they were at the wrong place at the wrong time. They are not chosen ones. Society at large has no idea they even exist and the minds behind the game are indifferent to whether they win or not" (VivisQueen). At the same time, however, *Bokurano* is careful to preserve a modicum of hopefulness even amidst its searing indictment of societal iniquity. Shadowmage offers a touching

description of this latently optimistic message, proposing that "ultimately, *Bokurano* is a celebration of life. It shows humanity at its worst, but more importantly, it shows the children: humanity at its best" (Shadowmage).

In maximizing the psychological dimension of the *mecha* modality, *Bokurano* finds a distinguished antecedent in Hideaki Anno's *Neon Genesis Evangelion*. Few anime aficionados would dispute the eminence of this series — a work which, as is well known in anime circles, has been either keenly loved or, no less ardently, detested by hundreds of viewers across the globe. As noted in *The Art of Studio Gainax*, "translating its *mecha* element into an allegorical correlative for the characters' inner struggles, the saga yields a hard-core psychodrama capable of matching David Lynch's convoluted imagination at its most baleful. Like many *mecha* shows, *Evangelion* features action sequences interspersed with massive-scale urban destruction and occasional dabs of comedy. Unlike other series, however, it delves dispassionately into the characters' twisted personalities, as the fear of abandonment and betrayal, the omnipresent phantom of loneliness and a no less ubiquitous sense of disconnectedness from their world persistently threaten to paralyze them beyond remedy. The result is a deeply estranging yet engrossingly familiar mosaic of emotional turmoil" (Cavallaro 2009a, p. 61). A comparable, though less visceral, dramatization of the topos of the hapless teenager reluctantly inveigled into *mecha* piloting by either fate or, more disturbingly, by abusive and exploitative adults is also central to the TV series *Fafner* (dir. Nobuyoshi Habara, 2004), where the young protagonists are drawn into a war against a race of aliens known as "Festum." The kids' exploitation as sacrificial victims imparts *Fafner* with a pointedly somber mood which echoes *Neon Genesis Evangelion* while also foreshadowing *Bokurano*. On the psychological plane, *Bokurano* goes further than both *Neon Genesis Evangelion* and *Fafner* in its single-minded focus on the story's darker implications. Indeed, while Anno's series regales the eye with sensational battles prefaced by suspenseful and palpably atmospheric entrances, *Bokurano* tends to marginalize the dynamic element — impressive though its action sequences indubitably are — in favor of an ongoing examination of the protagonists' tormented psyches. It is also worth noting, from a strictly aesthetic standpoint, that the Evangelion Units boast elegant proportions, chromatic vibrance, and a flair for athletic — and even balletic — motion. *Bokurano*'s giant robots, by contrast, are bulky, towering presences which seem to materialize out of the blue to dominate the

urban scenery like prehistoric menhirs with a malevolent futuristic twist — monoliths from a doomed future pregnant with baleful premonitions.

While *Bokurano*'s deliberate avoidance of glamor brings to mind the ethos of *wabi* and *sabi*, its *mecha*'s looming masses are redolent of *yūgen* at its most intimidatingly sublime. These aesthetic effects are enfolded by an unusual interpretation of *mono no aware*—a deep sense of longing for a lost and irretrievable childhood innocence which is rendered all the more poignant by the fact that the anime's protagonists have never, strictly speaking, truly experienced such a state of bliss. Their entrapment in the warped logic of a lethal game seals their destiny with a ruthless sense of finality. This version of *mono no aware* is deeply paradoxical, since the time-honored aesthetic concept is employed as a means of evoking not an atmosphere of mellow nostalgia, as tends to be the case in most of the traditional narratives which have brought it into play, but rather a mood of almost overwhelming distress. *Bokurano*'s construal of *mono no aware* is not the bittersweet musing over beauty's transience associated with cherry blossom or fireworks briefly lighting the summer sky. In fact, it is a wrenching, consuming, melancholy drenched with horror. Finally, at the same time as it invokes the aesthetic principles of *wabi*, *sabi*, *yūgen* and *mono no aware*, the series elliptically engages with traditional Japanese aesthetics by delivering a dark ironical inversion of the idea that art should follow the lessons of nature not through mechanical imitation but rather through the close study and imaginative reinvention of nature's innermost workings. In *Bokurano*, the observation of nature is not conducive to creative reconstruction but rather to a sadistic perversion of its mechanisms and processes. Relatedly, the conception of talent as the spontaneous flowing of a person's creative abilities from the body — as epitomized by *sumi-e* and by the art of the sword, for example — is cruelly distorted to demonstrate that skill will only, and inexorably, lead to death. A supposedly competent *mecha* pilot is de facto reduced to a blindly self-destructive pawn in a grotesque and vicious game — and clearly *not* respected as an autonomous artist.

Guilty Crown (TV series, dir. Tetsuro Araki, 2011)

Guilty Crown offers a unique interpretation of one of the most popular anime subgenres ever, the dystopian sci-fi saga, injecting new life into even

those formulae which, overexploited by less attentive animators, have become trite and unappealing. The anime's knack of revitalizing a well-established form impacts favorably on virtually every aspect of *Guilty Crown*'s diegesis, yielding a rich, yet not confusingly ample, cast of engaging characters. In addition, the series abounds with daunting contemplative moments, thus perpetuating the preference for introspection inherent in traditional Japanese storytelling. *Guilty Crown*'s meditative dimension is instantly emphasized by the early segment of its opening installment, and continues to assert itself as a major aspect of the anime's aesthetic identity as the plot delves deeper and deeper into the nefarious repercussions of an unholy alliance between science and politics, while simultaneously delivering a sensitive anatomy of the personal ordeals endured by its personae amid a plethora of familial and romantic tensions.

Most importantly, for those viewers who value anime's potential for intelligent reflection, *Guilty Crown* honors this capacity to the fullest with its portrayal of the female lead, Inori Yuzuriha, thereby raising some challenging philosophical questions about the meaning and purpose of human identity. As the drama unfolds, it becomes increasingly arduous to establish conclusively who or what the long-suffering and painfully beautiful Inori truly is. Her character undergoes repeated, though often delicate, transformations, and her personality accordingly assumes different symbolic connotations as her roles multiply. These include that of the lead singer for the music group Egoist, and hence of an internet idol; that of a brave member of the militant resistance group "Funeral Parlor"; that of a cute school girl embodying the very essence of *kawaii* at its most enticing; that of a loyal companion prepared to stand by her loved ones at the cost of her own life; that of a quasi-mythological monster (*bakemono*), entering the fray with bestial ferociousness; that of a sacrificial victim meant to enable the rebirth of the creature held responsible for the outbreak of the virus which has thrust Japan into first chaos and then tyranny; and finally, that of a bittersweet memory of timeless significance. In depicting its heroine as a multifaceted character defying irrefutable categorization in either psychological or physical terms, the anime also invite us, by metaphorical implication, to be willing to see the identities of all of its personae as likewise moveable feasts shot with contradictions, incongruities and aporias. In fact, if we are prepared to take its philosophical subtexts seriously, the anime also encourages us to consider the applicability of that questioning approach to real life — to *our own* life.

While it is important to acknowledge the series' introspective dimension, it is no less vital to appreciate that *Guilty Crown*'s reflective strand would not be half as effective from an aesthetic point of view were it not for its continual juxtaposition with high-octane action. Indeed, as Carl Kimlinger aptly observes in his review of the series, "Araki is a master of execution. His skills are easiest to spot in the action sequences.... He loves to swoop his 'camera' and loves pure motion. Characters leap and clash and slash with fantastic fluidity. He also loves to push things way over the top. Think organic missiles downing stealth fighters and gorgeous swirling orbs of energy fired like point-blank artillery. And it all works beautifully. His action scenes are feasts of visual excess as exciting as they are eye-popping ... and ear-pleasing — they're often set to very pretty and increasingly well-utilized insert songs" (Kimlinger 2012). The anime's flair for introspection could easily have been obscured by its exciting action sequences had director Tetsuro Araki and his team allowed the spectacle to gain unquestioned precedence over the story's reflective strands. In fact, few anime of recent years have achieved as effectively as *Guilty Crown* that aesthetic balance of introspection and action which ultimately constitutes the marker of a memorable cinematic accomplishment in the domains of animation and live-action drama alike.

While all of these facets of the series' aesthetic deserve consideration, what is most tantalizing about *Guilty Crown* for the purpose of the present study is its use as a thematic hinge of a concept which captures in figurative form a key aspect of traditional Japanese aesthetics itself: the "void." In the anime's self-tailored language, this term designates the physical manifestation of a person's innermost essence in emblematic guise, and is hence held to capture his or her most distinctive, most intimate, and most guarded abilities, proclivities, aspirations, fixations and phobias. As such, voids may assume a stunning variety of forms: for example, they may manifest themselves as conventional or futuristic weapons, as portentous shields, as prosthetic limbs, as rolls of all-healing bandages, or even as devices for creating perfect holographic duplicates of people and objects (and this is only a very selective, illustrative list). Though a person's void looks the same every time it is drawn, it does not have a fixed, immutable essence, but rather varies as its user perfects his or her mastery of the power it hosts, or adapts it in relation to contingent circumstances. This element of unpredictability and change reflects the view of the cosmos as a reality in a state of incessant becoming central to diverse Eastern philosophies and, by

extension, to the realm of Japanese aesthetics itself. The ultimate void, dubbed the Void Genome, consists of a peculiar genetic sequence with the capacity to endow its user with the so-called Power of Kings, namely the ability to extract other people's voids from the deepest recesses of their secret selves. It is on Shu, an unsociable youth with pathologically low self-esteem, that fate thrusts the Power of Kings through a random concatenation of events, thus ushering the disaffected youth into a world of unforeseen responsibilities, emotions and relationships. The acquisition of that awesome skill eventually leads to Shu's recruitment as a member of the aforementioned resistance organization known as Funeral Parlor, as a result of which he gradually learns how to relate to other human beings, and hence to recover the vestigial self buried beneath the dark mantle of his insecurity and anguish. Concurrently, Shu gradually discovers many unpalatable truths concerning his country's history and his own family's entanglement with some of its least elevating chapters.

Especially important, within the protagonist's developmental curve, are his interactions with Gai Tsutsugami, Funeral Parlor's charismatic leader, with the enigmatic Inori, and with the kaleidoscopic gallery of personalities offered by Gai's and Inori's valiant associates — particularly, the paraplegic but indomitable Kana Hanazawa, the formidable hacker Tsugumi, and Funell, a pet robot endowed with a surprisingly rich emotional range. In addition, Shu develops new relationships with the school friends he has hitherto avoided or merely sought to ingratiate for the sake of peace, as his martial duties require him to reassess his entire environment and all of the people within its folds — including the character of his stepmother, the exceptionally talented scientist Haruka Ouma. *Guilty Crown* accomplishes a deft synthesis of the macrocosmic dimension of global affairs and the microcosmic dimension of the individual's private vicissitudes in the episodes where Shu, having embraced his duties as Funeral Parlor's prime fighter due to his possession of the Void Genome, and remained for long uncertain about his role and right to deploy his powers, grows so thoroughly disenchanted with all conceivable ideals as to turn into a callous tyrant. Though deeply unsavory, the youth's behavior at this stage in the drama is so sensitively portrayed that we are never allowed to forget its roots in Shu's vulnerability and embattled personality — a disposition which his unsolicited involvement in the horrors of civil warfare has exacerbated to pathological degrees.

With its use of the concept of the void, the anime offers a powerful visualization of a principle inherent in Japanese aesthetics since antiquity: the belief that the artist's ultimate duty is not to aim for fidelity to outward appearances in the service of mimesis, but rather to identify nature's essences and present to the senses in as terse and unforced a fashion as humanly possible. Relatedly, the anime abides by the time-honored rule that following nature's lessons should never amount to its slavish mimicry, but should in fact accomplish an imaginative reinvention of nature, and a comparably inspired reformulation of its governing mechanisms in accordance with the laws of art. This proposition is confirmed by the representation and animation of the voids themselves: there is something curiously "natural" about the way these entities look and move — and indeed about the processes through which they are extracted from people's bodies and are then deployed by their owners — despite the blatant artificiality of the entire idea. Similarly, the pace at which crystalline encrustations can be seen incrementally to accrue over the bodies of people who have been infected by the so-called "Apocalypse Virus" convey an impression of natural organic growth even though they are blatantly fictional and thoroughly constructed cinematic effects. The impression of naturalness is a direct corollary of an attentive examination of the natural world, and attendant respect for its laws. At the same time, however, the portentous crystals draw attention to their constructedness — and hence to the anime's adherence to the laws of art rather than to those of nature per se — by means of their conspicuous color. The shade of blue which distinguishes the sinister formations, redolent of a vibrant cobalt, indeed stands out as an emphatically human-made aesthetic property, not as a realistic reflection of a natural hue. As seen in Chapter 1, blue is an especially important presence in Japan's traditional palette and, by extension, a long-established facet of indigenous aesthetics. The anime's appropriation and original interpretation of this color could therefore be read as a metonymic indicator of its ability simultaneously to absorb and reinvent the cultural forces whence it emanates both as an aesthetic entity and as a source of entertainment.

Throughout the series, voids are so beautifully drawn and animated as to constitute memorable artworks in their own right. Yet, it is vital to acknowledge that it is ultimately the human body itself, even more than the void issuing from it, that *Guilty Crown* posits as the supreme artwork. This is because the body, even though it functions as the void's receptacle,

is never reduced to the status of a mere vessel or shell: on the contrary, it stands out as the decisive creative outcome as the entity that comes to life when its void can be deployed by it to in order to express itself most genuinely and most effectively.

At the same time as they bring into focus a distinctive attitude to the relationship between nature and art, *Guilty Crown*'s voids also emphasize the crucial importance of the notions of emptiness, absence and lack in Japanese aesthetics at large. Indeed, the conception of a person's very *core* as a "void" suggests that the most important things in life rest precisely with those seemingly negative ideas. *Guilty Crown* perpetuates Japanese culture's valorization of emptiness as the cradle of bountiful meanings by exploding the conventional understanding of the void as a meaningless blank, and in fact positing it as a metaphor for what is most valuable and unique about each and every human being. At the same time, however, the series endeavors to throw into relief each void's — and, by implication, each person's — inevitable connection with all the countless voids — and hence people — that fill the earth at any one point in time, and indeed have filled it since time immemorial. Each void is unique but no void stands a chance of expressing its identity outside the all-connecting tapestry which is the world itself. This conception of the void harks back to Zen Buddhism. As Helen J. Baroni explains, emptiness is "the fundamental concept of Mahayana Buddhism [the Buddhist category comprising Zen alongside other schools] regarding ultimate reality, which asserts that all phenomena are empty of self-nature. Emptiness is an English translation of the Sanskrit term *shunyata*, also rendered as 'void' or 'nothingness' by some authors. *Shunyata* is the denial that things in the phenomenal world, including sentient beings, inanimate objects, and ideas, have an independent, unchanging, and eternal essence. Emptiness is not a nihilistic denial of reality or existence in absolute terms, but the recognition that all phenomena are relative and dependent on causation. To assert that all things are empty means that they are interdependent ... and are continually susceptible to change" (Baroni, p. 82). This perspective is judiciously brought into focus by anime through a sustained emphasis on the importance of interaction as the fundamental mechanism governing the workings of humans, their environments, and their constructs. None of the individual selves which *Guilty Crown* portrays, beautifully individuated though they are in both psychological and physical terms, could function outside the

intricate web of interconnections, relationships, alliances, and conflicts which shape the drama at the kinetic and the meditative levels alike. As the interpersonal dynamics articulated in the series develop and morph over time, ceaselessly assembling and disassembling as mobile constellations, the crux of identity is located with a fluid and open sense of relationality rather than with any notions of permanence or plenitude.

The anime's introspective and dynamic dimensions are mirrored by its palettes: a component of *Guilty Crown*'s visual identity which bears witness with arresting eloquence to its imbrication with traditional Japanese aesthetics. In effect, it could be argued that distinctive palettes are used throughout the anime both as aesthetic encodings and as psychological correlatives of its introspective and dynamic qualities. The anime's chromatic "consciousness," so to speak — i.e., what we see on the gorgeous surfaces of its punctiliously fabricated reality — is a pointedly *cool* palette; its "unconscious," namely the affective streams coursing beneath the action's visible stage, is a *warm* palette. *Guilty Crown*'s chromatic properties, brought resplendently to life by Araki's direction and by Production I.G's consummate technical expertise, are already established as one of the story's most salient features in the original character designs executed by Redjuice, as borne out by the twin volumes reproducing the artist's "animation notebooks" (now considered rare collectible items). It is here worth noting, incidentally, that Redjuice's art books also host the words which encapsulate in a cryptically symbolic vein both the bearing of the anime's title and the essence of Shu's preternatural ability: "somewhere, a voice calls upon me. Herein lies power. The power to connect, and the power to take shape: this is the guilty crown" (Redjuice, p. 9). Throughout both volumes, the cool palette asserts itself most poignantly in a number of nocturnal urbanscapes imbued with an ominous feel of foreboding and cosmic sadness. An interesting chromatic contrast is provided, in the context of these vistas, by the representation of Tokyo Tower in their midst as a foreboding reddish brown edifice emitting a blinding lilac-shaded beam, its symbolic positioning evoking that of a totem pole within a traditional community. The cool palette also dominates Redjuice's depiction of the story's futuristic technology, extending to both individual items of state-of-the-art equipment and entire settings devoted to accommodating machinery, weapons, and robots.

Before addressing Redjuice's handling of the series' warm palette, it

is vital to note that the range of reds, red-violets, oranges and red-oranges assiduously employed by *Guilty Crown* across its diegesis is not just a *generalized* warm palette of the kind one could expect to find in *any* cultural milieu, but a very specifically Japanese range of hues reaching back into the golden age of the country's artistic history. *Guilty Crown*'s warm palette includes all of the key shades in that range mentioned earlier vis-à-vis *Ouran High School Host Club*: *kōbai-iro, sakura-iro, usubeni, momo-iro, nakabeni, arazome, tokiha-iro, enji-iro, sango-iro, umenezumi, chōshun-iro, akabeni, jinzamomi, karakurenai, akebono-iro, akakō-iro,* and *terigaki.* In addition, *Guilty Crown* also brings into play *shishi-iro* (meat color), *araishu* (rinsed out red), *tokigaracha* (brewed mustard brown), *asagi* (light yellow, sunlight yellow), *torinoko-iro* (eggshell paper color), *shiracha* (white tea), *usukō* (pale incense), *ōdo-iro* (earth yellow, ochre), *biwacha* (loquat brown), *chōjicha* (clove brown), *kincha* (golden brown), *kuchiba-iro* (decaying leaves color), *benjukon* (red bronze), *sharegaki* (stylish persimmon), *usugaki* (pale persimmon), *akashirotsurubami* (sawtooth oak), *kaba-iro* (cattail color), and *kurumizome* (walnut color). In both Redjuice's animation notebooks and the anime itself, the warm palette is predominant in the rendition of scorching explosions, searing light beams, and the devastated portions of the metropolis left in their wake by those destructive agencies, which are so vividly portrayed as to appear to be still blistering with smoldering embers. The warm palette finds its primary expression in the representation of Inori's physique and clothing, characterizing not only the stylish outfits associated with the girl's professional commitments as both an artist and a fighter, but also, albeit in a more muted and gentle vein, her domestic garb. Even the subtle shade of pink used in the rendition of Inori's hair, and of the no less delicate shade of red adopted for the coloring of her irises, echo the chromatic nuances of Japan's distinctive palette. Given Redjuice's emphasis on the warm end of the spectrum in the depiction of the girl's somatic traits, Inori's portraits invariably express an overall feeling of harmony even when she is only clad in a skimpy black slip. This feeling is so powerful as to affect the viewer in more than a merely visual way: in fact, it is capable of caressing the whole sensorium, just as her tenderly anguished songs do. Even images placing Inori in settings colored in cool shades still associate this character symbolically with the aesthetic principle of warmth by means of peripheral, yet striking, details: e.g., a cluster of red peonies, or a branch laden with autumnal maple leaves flut-

tering in the night wind to accompany the dance of her fluttering pink locks.

A prevalently warm palette is also employed, fittingly, in pictures with a light-hearted tone which portray the key characters in convivial or even jocular situations. These scenes are not, it must be emphasized, actually part of the series per se but have been produced either for ancillary purposes, or as a means of enhancing the characters' personalities by visually speculating about their plausible appearance and conduct in non-stressful circumstances. The enhancement of the characters' personalities by recourse to images which place them in contexts other than those dramatized in the actual series is akin to the exercises undertaken by Method actors in order to identify with their roles as fully and consistently as possible. Finally, Redjuice's sensitive treatment of Japan's traditional color ranges is beautifully confirmed by the pictures which capitalize on the aesthetic mechanism of chromatic contrast — especially, those which juxtapose Shu — associated with a cold shade of blue meant to connote his power to extract voids from people's bodies — and Inori — associated with the warm end of the spectrum as she typically is throughout the story.

Among the most memorable of the images included in Redjuice's animation notebooks are those devoted to the character of Mana: Shu's sister, as well as the supposed originator of the baleful virus behind Japan's apocalyptic calamities. Quite appropriately, given the latent connection between the two girls, Redjuice's representations of Mana exhibit a predominance of the same hues we find repeatedly used in pictures of Inori. At the same time, however, the artist subtly establishes an affective contrast between Mana and Inori by infusing the images devoted to the former with intimations of conflict and discord — e.g., by locating Mana in the midst of glacial lights shining against a midnight blue background. Mana haunts the art compilations as a liminal presence in much the same way as her implied presence pervades the series itself as a lurking force of unspeakable malevolence and magnitude. These baleful attributes belie the girl's lovely appearance as an embodiment of *kawaii* at its sweetest. In the anime itself, a touch of malice appears to tinge Mana's mien from an early stage, though its recognition requires attentive inspection on the viewer's part. Through the figure of Mana, the visuals suggest that the past is stubbornly refusing to rest peacefully where it belongs, and in fact keeps creeping back through the fissures separating the otherworld from this world, invading the latter's

interstices at every opportunity. This can be seen as a symptom of the unresolved anxieties which torment the anime's fictional society: namely, feelings of trepidation and uncertainty from which people are powerless to free themselves unless those affects are properly examined, and thus resolved or at least managed. Therefore, Mana's spectral power is really a metaphor for the unnegotiated fears and doubts of the living humans who have survived her apparent demise.

The interpretation of haunting proposed by both the anime and the original character designs with their treatment of the character of Mana is strongly redolent of Avery F. Gordon's approach to that phenomenon as developed in her influential volume *Ghostly Matters*. For Gordon, "the term *haunting*" refers to "those singular yet repetitive instances when home becomes unfamiliar, when your bearings on the world lose direction, when the over-and-done-with comes alive, when what's been your blind spot comes into view. Haunting raises specters, and it alters the experience of being in time, the way we separate the past, the present, and the future. The specters ... appear when the trouble they represent and symptomize is no longer being contained or repressed or blocked from view" (Gordon, "Introduction to the New Edition"). In the series itself, various flashbacks are introduced as a means of revealing certain crucial events in Mana's and Shu's childhood prior to and during the catastrophic events which have rocked Japan's history. Through these sequences, the character of the effectively long-gone girl comes to acquire the force of a sentient and determining presence among the living, which allows the uncanny Beyond to cross over into ordinary reality and hence destabilize its everyday assumptions. The sheer vigor with which this destabilizing act is performed is one would not instinctively associate with the figure of a pink-haired cutie in a fluffy and fur-trimmed Christmas-style coat. As a result, all the characters who somehow experience intimations of Mana's haunting presence in their midst are to some extent affected, as though their world's coordinates had suffered a drastic paradigm shift.

It is worth noting that the use of the concept of the void as the fulcrum of an anime's entire aesthetic is not solely indigenous to *Guilty Crown*. In fact, it is also pivotal to the composite world of *The Familiar of Zero*, a franchise comprising four series (at least to date). The first of these was helmed by Yoshiaki Iwasaki and originally broadcast in 2006. The sequels *The Familiar of Zero 2: The Knight of the Twin Moons* and *The Familiar of*

Zero 3: The Princess's Rondo were both directed by Yuu Kou and aired in 2007 and 2008 respectively, while the latest sequel, *Familiar of Zero F*, was again helmed by Iwasaki and broadcast in 2012. Given its emphasis on the idea of the void, which in turn echoes — as argued — a critical facet of traditional Japanese aesthetics at large, it is felt that the anime rightly deserves some attention in this context. In the magic-oriented ethos of the franchise, the "void" (a.k.a. the "fifth element") is the most formidable element which any self-respecting wizard or witch could ever hope to control. Sadly for Louise de Vallière, the protagonist, the capacity to master the void is a power which tends to remain hidden unless appropriate circumstances for its emergence arise. In the case of Louise, not only is her ability to control the void at first hidden from view: she is actually so hopeless a student as to have gained the scornful nickname of "Louise the Zero," a neat way of suggesting that she is quite simply one of the most inept magicians of all times. The franchise's interpretation of magic is deeply influenced by both Western alchemy and the Japanese doctrine of the Five Elements (to be revisited in detail in the following chapter). Relatedly, a mage's competence is assessed in terms of his or her capacity to manipulate any one or more of the four standard elements. A "line mage," for instance, is a wizard or witch who can only master one element, while a "square mage" can handle all four with ease. Louise, as her nickname indicates, initially seems powerless to wield any influence on *any* of the elements. It is not until the girl, as a second-year student at the prestigious Academy of Magic located in the Kingdom of Tristain, summons her familiar that her hidden gift begins to manifest itself, though no-one yet suspects its connection with the greatest of magical powers one could wish for. In undertaking the summoning task, as all students in her cohort are traditionally expected to do, Louise accidentally calls forth a present-day Japanese kid, Hiragi Saito, who finds his transposition from hectic Tokyo to the dreamlike alternate reality of Tristain utterly befuddling. The first series conveys Saito's confusion with palpable immediacy by means of its setting — a mystifying stylistic mélange, redolent of *Ouran High School Host Club*'s own setting, in which architectural and decorative ingredients drawn from disparate epochs in European history and their respective aesthetics alternately merge and clash, special emphasis being accorded to Renaissance, Neoclassical, Rococo and Victorian motifs for their more theatrical potentialities. Initially complicated by the twin obstacles of

Louise's haughtiness and Saito's disorientation, the two characters' partnership gradually evolves into the kernel of an aesthetically sophisticated drama replete with tantalizing action. We thus gradually discover that Saito, too, is endowed with dormant faculties which only a mage of the void has the power to activate. These skills, which earn him the privileged status of a "Gandalfr," include extraordinary strength, nimbleness, speed, and resistance to injury.

DAISETZ TEITARO SUZUKI ON ZEN AND CREATIVITY

Among the most remarkable features characterizing Zen we find these: spirituality, directness of expression, disregard of form or conventionalism, and frequently an almost wanton delight in going astray from respectability. For instance, when form requires a systematic treatment of the subject in question, a Zen painter may wipe out every trace of such and let an insignificant piece of rock occupy just one corner of the field. Where absolute cleanliness is the thing sought after, a Zen gardener may have a few dead leaves scattered over the garden. A Zen sword-player may stand in an almost nonchalant attitude before the foe as if the latter can strike him in any way he liked; but when he actually tries his best, the Zen man would over-awe him with his very unconcernedness. In these respects, Zen is unexpectedness itself, it is beyond logical or common-sense calculation. The main reason for Zen's unexpectedness or incalculability comes from its transcending conceptualization. It expresses itself in the most impossible or irrational manner; it does not allow anything to stand between itself and its expression. In fact, the only thing that limits Zen is its wanting to express itself. But this limitation is imposed upon everything human and indeed upon things divine as long as these are to be made intelligible.

The spirit of Zen is then the going beyond conceptualization, and this means to grasp the spirit of the most intimate manner. — Suzuki 2000, p. 10

3

Nature

Spring soon ends — / Birds will weep while in / The eyes of fish are tears—
Matsuo Bashō

*In matters aesthetic, taste remains an observation of deserved worth, and
that should take care of that— except that we are not at all agreed as to
what good sense consists of. Some countries say one thing, some say another.
The Japanese traditionally maintain that we have been given a standard
to use. It is there, handy, daily: things as they are, or Nature itself.—*
Donald Richie

ONE. CULTURAL BACKGROUND

Nature and Architecture

Japanese culture's connection with nature has played a vital role in the
evolution of indigenous aesthetics, acquiring novel nuances over time in
conjunction with historical upheavals and multifarious foreign influences.
The indigenous religion of Shintō, examined in the previous chapter, has
played a major role in the evolution of Japan's distinctive approach to the
natural environment. It is worth noting, in this respect, that the intro-
duction of Buddhism into Japanese culture in the sixth century, which
paved the way to its growth as the country's major religion, did not in the
least threaten Shintō's survival. In fact, as Masako Watanabe maintains,
"Shintō began a process of syncretism, adopting Buddhist deities ... to
correspond to local Shintō deities. With time, Shintō deities were regarded

as manifestations of Buddhist ones" (Watanabe, Masako, p. 7). The two religions have since coexisted harmoniously, allowing Buddhist and Shintō rituals to punctuate everyday life both at home and at work as compatible or complementary agencies. The chief reason behind Shintō's endurance alongside Buddhism is simple, yet inestimably important: this tradition embodies Japanese culture's intimate bond with nature in the purest and most enthusiastic of terms. Indeed, even though Buddhism also commends reverence for the natural world, its transcendental thrust sometimes casts a shadow over the possibility of enjoying it with the kind of sensual freedom which Shintō, conversely, is keen to foster. Both traditions, however, posit life's impermanence as a major building block of their belief systems: honoring humanity's tie with nature means partaking of the inexorable impermanence of its beauties and its pleasures. While nature's ever-changing forms epitomize the concept of transitoriness, human-made edifices are seen to mirror this state of affairs as likewise metamorphic structures which participate at all times in the rhythms of their mutating environment rather than presume to master it as solid and fixed loci of power. Ancestral sensibilities emanating from the native attitude to the relationship between humankind and nature have not only survived the ravages of time and the advent of alien trends but also supplied the cement which has allowed disparate influences, discoveries and experiments to coalesce. It could therefore be argued that the relationship between human beings and the natural environment constitutes the fulcrum around which a multiplicity of cultural forces have constellated over time. As Mira Locher observes in her superb volume *Traditional Japanese Architecture*, the geography of Japan, and specifically its "rugged quality," has contributed crucially to instilling into its people a deep sense of "awe and respect" for nature (Locher, p. 17). Furthermore, "Japanese culture developed with the constant threat of destructive natural forces — earthquakes, *tsunami* ... typhoons, and active volcanoes. This very harsh natural environment did not result in a culture of fear and constant battle against nature, but rather a culture of respect for nature with an understanding and appreciation for the ephemeral quality of all life" (Locher, p. 18). At the same time, geomancy (or *fusui*, the Japanese equivalent of the better known Chinese *feng shui*) "gave a kind of mythical meaning to common responses to climate" (p. 48) by providing an aesthetic template for the positive organization of space in consonance with nature's latent energies.

3. Nature

The belief that humanity is inextricably intertwined with nature has resulted in a conception of space which regards inside and outside as complementary facets of a seamless continuum. This is clearly attested to by the significance traditionally accorded by native architecture to the *engawa* (veranda) as a pointedly transitional area. Exterior walls are also conceived of as flexible boundaries in the simple, airy and refined style of the classic Japanese residence, since they usually consist of movable sliding panels. At night or in the wet season, wood panels are used, whereas screens of mounted paper replace them in warmer weather. The main reason behind the unique openness of Japan's traditional domestic interior is that whereas in the West, the exterior and interior walls are normally required to sustain the weight of a building, in Japanese architecture, this function is served by the pillar. The best part of the load of a classic dwelling is borne by the *daikokubashira*—i.e., "pillar of Daikoku," the deity of prosperity and good luck—while additional pillars are employed as inconspicuous supplements. The result is an exceptionally unconfined sense of space even in the context of a dwelling of modest dimensions. This liberating atmosphere contrasts sharply with the oppressive feel of the minuscule and cluttered apartments one often encounters in the larger metropolitan areas, where any awareness of the natural environment must be left to the imagination. Japanese architecture's intimate connection with nature is emphasized by an article on the traditional home published in the *Yoshino Newsletter*, where it is proposed that Japanese edifices are a natural "response" to the country's "weather, its geography and its harmony with all of those elements," whereas "European structures were built as barriers against the forces of nature" ("Elements of a Traditional Japanese Interior"). The importance of this concept is further underscored by Daisanne McLane: "Japanese houses have been built to conserve energy and resources, and to harmonize with nature, for more than 500 years." For example, "inside the *machiya*, Kyoto's 19th-century townhouses, natural sunlight, handmade bamboo shades, and *shōji* paper screens create the illusion of outdoor living in long, narrow city buildings" (McLane, p. 6). Moreover, as Locher observes, since *machiya* are built close to one another on narrow lots of land, "small courtyard gardens or *tsuboniwa* (literally '*tsubo* garden'—a *tsubo* is a unit of measurement equal to two *tatami* mats, about 3.24 square meters or 36 square feet), are designed into the buildings to bring in light and air and create a tie to nature." While reinforcing the bond between humanity and the natural

environment so central to Japanese aesthetics, this architectural practice confirms the Japanese aversion to strict divisions between the inside and the outside, insofar as "the inclusion of the *tsuboniwa* in the *machiya* transposed the well-developed paradigm of the house in the garden to a new type: the garden in the house" (Locher, p. 34).

Japan's architectural history reveals a pronounced tendency to conceive of buildings and their surroundings as fluidly interdependent entities, which actually dates back to the Heian period, when complex architectural schemes known as *shinden* meant precisely to maximize the dialogue between inside and outside were designed for the aristocracy. As Locher explains, "the architecture of the *shinden* style reflects the school of Buddhist thought that was prevalent at the time, Pure Land Buddhism (*jōdoshū*)," seeking to capture its conceptions of "energy, vitality, and creativity with forms that appear to be lighter and more open than previous Buddhist buildings and which have a strong connection to a designed landscape." Though magnificent, *shinden*-style buildings eschew grandiosity in favor of a playful engagement with the present moment, as borne out by the fact that they are constructed "on a slightly smaller scale, with lighter timber framing and greater curvature to the roof, which imparts an impression of weightlessness" (p. 27). At the same time, "the landscape is used in a less formal and more playful manner and has a strong connection to the architecture" (p. 28). With the transition to the feudal militarism of the Kamakura period, the interaction between architecture and nature remains a major priority. Thus, while austerity is commended as a major aesthetic ideal, the effort to integrate buildings and surrounding landscapes gains novel momentum. The architectural style prevalent in the period, known as *shoin*, departs from the rigid geometrical and symmetrical arrangement characteristic of the Heian *shinden* to capitalize instead on "a zigzag movement in plan," whereby "some buildings are connected to one another by smaller buildings attached at their corners.... These buildings look out onto a garden with paths for strolling, pavilions for resting, and ponds for boating." The *shoin*'s structural and environmental features are further developed in the following stage of Japan's architectural history, the *sukiya* style. This trend is frequently held to epitomize Japan's traditional architecture at large, partly because "it is the final historical style that emerged before Japan began to industrialize," and partly because "twentieth- and twenty-first century architects in Japan and

abroad have found inspiration" in its distinctive features — primarily, "the regularity of the structural grid, the expressive use of materials, the informal aesthetic ... and the strong connection between inside and outside" (pp. 29–30).

Another major component of the traditional Japanese home which attests to the interpenetration of inside and outside consists of the afore-cited lightweight space dividers employed to organize space within the home with minimum fuss and exceptional flexibility, so as to retain an overall atmosphere of uncluttered simplicity, compactness and airiness while also paying homage to seasonal changes. As Atsushi Ueda explains, "a main advantage of these partitions is that they can all be easily removed to convert a whole floor of the house into a single large room ... a farmhouse can be turned into a banquet hall on a ceremonial occasion" (Ueda, A., p. 62). In terms of Japan's architectural history, this approach to space has entailed that "in contrast to the western or Chinese house to which rooms of similar size were added on in succession, the Japanese house retains its single room and inflates it when necessary, rather like blowing up a balloon" (p. 64). The psychological implications of traditional space dividers are also worthy of consideration. According to the Jungian psychologist Hayao Kawai, these devices are indeed emblematic of a deeply ingrained aboriginal disposition: "one of the characteristics of the Japanese people," argues the scholar, "is the absence of a clear distinction between exterior and interior world, conscious and unconscious.... In short for [the] Japanese the wall between this world and the other world is ... a surprisingly thin one. That the membrane between inner and outer or this and that world is paper-thin like a *fusuma* (sliding room-divider) or *shōji* (a paper door-window) reflects the nature of the Japanese ego" (Kawai, p. 103).

No less worth of emphasis, as a clear indicator of the primacy of nature in Japan's traditional architecture, is its use of structural symbols. As Locher emphasizes, "the most obvious symbolic element in traditional Japanese architecture is the roof," serving as "a clear expression of shelter and of the containing of space for multiple activities," while also function-ing as a signifier of "wealth and social status" by means the "materials used to construct" it and "the amount of embellishment in the details" (Locher, p. 53). It is through its materials and ornamental elements that the roof announces most palpably its allegiance to the natural world. Atsushi Ueda emphasizes the central part played by this key architectural component

with the simple statement "Japanese architecture is roofs, whereas western architecture is walls." He also bemoans, in this respect, the fate of near extinction met by the roof in modern Japan, arguing that "the history of the modernization of Japanese architecture can be called the history of the elimination of the roof.... Anyone who has visited the Japanese countryside understands how charming and substantial a thatched-roof farmhouse looks in the distance, with the eaves hanging down so far that it seems as if the roof is all there is to the structure.... It is sad indeed that the siren call of 'modernization' is leaving fewer and fewer Japanese-style roofed structures" (Ueda, A., p. 22). If the roof constitutes — or, at any rate, has for long constituted — the primary symbol in a building's external structure, columns play a comparably crucial symbolic function within the home. Particularly significant are the aforementioned *daikokubashira*, which serves as the building's primary support, and the *tokobashira* ("*toko* pillar"), which defines one side of the *tokonoma* (or *toko*), an alcove situated in the reception room. Columns derive at least part of their symbolic significance from their ceremonial status in the context of Shintō, where, as Norman F. Carver explains, "they were placed as a means of approaching the gods.... The aura of strength given off by such pillars would have come to be perceived as the divine authority that dwelled in them emanating into the surrounding space" (Carver, p. 10). Emphasizing the vital part played by nature's unadulterated materials in the enhancement of a column's symbolic function, Locher rightly contends that "a fine *tokobashira* might be a cherry wood column with the beautifully figured bark left intact or perhaps a wonderfully gnarled length of pine, used in a way that expresses the time-worn character of the wood" (Locher, p. 30).

As noted in Chapter 1, with the end of the *sakoku*, the Japanese government was eager to fashion an image of the nation which would convey its industrialized, and hence modernized, status. This objective was conducive to the imposition of building techniques and materials onto local practitioners of a kind which Japan had never witnessed before. Yet, even despite these potentially dramatic reorientations, certain traditional aesthetic tenets remained pivotal to Japan's value system, prime among them being the belief in the existence of an inextricable connection between humanity and nature. Accordingly, in the face of the architectural styles imported from the West to supplant native construction methods, a num-

ber of artists focused on the creation of alternative approaches which would allow for an eclectic synthesis of Japanese and Western components, and for the integration of traditional indigenous motifs with novel elements of their own conception made possible by recent technological advances. In so doing, they strove to remain loyal to age-old techniques, and to go on employing the natural materials which had distinguished native architecture for centuries. As diligently documented by Locher, this tendency is attested to by numerous publications released from the 1930s onward, and aiming to outline the essential attributes of Japanese architecture, where nature is invariably accorded a key role. Kenzō Tange, for example, commends the employment of nature's resources in a natural fashion as a means of conveying a deep sense of harmony between built space and its natural environment (Tange, Kawazoe and Watanabe), while Hideto Kishida highlights the presence of wood and the evocation of an overall sense of respect for nature's beauty as fundamental factors (Kishida). Kazuo Nishi and Kazuo Hozomi place the interaction between the building and its environment, and between interior and exterior dimensions, among the major definers of native architecture (Nishi and Hozomi). Teiji Itō likewise emphasizes the tendency to connect nature and architecture as pivotal to the Japanese approach to construction, while also highlighting the employment of natural materials such as wood, stone and earth as one of its main traits (Itō, Noguchi and Futagawa). Significantly, the Ise Grand Shrine — one of the holiest and most illustrious of all Shintō monuments — features prominently in these writings as the prototype of classic Japanese architecture, which obliquely reminds us of the centrality of Shintō's world view to the native approach to the relationship between man-made structures and the natural habitat. In addition, the teahouse is frequently posited as the quintessence of Japanese architecture, which supposedly enables it to go on embodying unambiguously indigenous values even in its adaptations by modern artists. Arata Isozaki, one of the many architects supporting this argument, maintains that "the Japanese tearoom evolved into an architectural form found nowhere else" (Isozaki 2007, p. 28). The most evocative description of the test posed by the teahouse for contemporary architects comes from Tadao Ando, who views it as a challenge to conceive "an infinitely expanding universe in an enclosed, very small space" (Ando 2007, p. 60). Isozaki suggests that Ando has indeed succeeded in imbuing his teahouses with a feeling of the sublime, lyrically stating that these

buildings enfold "infinitely expanding space" (Isozaki 2007, p. 29). This awe-inspiring atmosphere resonates with the aesthetic legacy of *yūgen*, inaugurating endless creative opportunities in the exploration of the dialogue between nature and art.

Some of the most vibrant contemporary expressions of Japanese art's regard for nature can be found in the works of Ando himself and Kengo Kuma, where energy is typically generated by the fluid interaction of stone, wood, water and air. Ando himself has underscored the importance of this process as follows: "I do not believe architecture should speak too much. It should remain silent and let Nature in the guise of sunlight and wind speak" (cited in Lim, p. 19). Moreover, Ando's conception of the natural world is evidently attracted to its most intangible expressions — those ubiquitous yet elusive fields of energy in which animistic forces perpetually renew themselves. "Such things as light and wind," the artist maintains, "only have meaning when they are introduced inside a house in a form cut off from the outside world. The isolated fragments of light and air suggest the entire natural world. The forms I have created have altered and acquired meaning through elementary nature (light and air) that give indications of the passage of time and the changing of the season" (cited in Frampton). Ando's consummately fluid designs and delicate handling of the play of light and shadow, shrouded in minimalistic silk-smooth concrete structures, invites the natural environment not only to seep into his works but also to find therein a congenial and hospitable abode. Furthermore, both Ando's and Kuma's works hark back to the time-honored philosophy of the Five Elements (*godai*): Japan's counterpart to the Chinese *Wu Xing*. The theory of the Five Elements, briefly referred to in the previous chapter in relation to *The Familiar of Zero*, posits earth (*chi* or *tsuchi*), fire (*ka* or *hi*), air (*fuu* or *kaze*), water (*sui* or *mizu*), and the void (*kuu* or *sora*) as the fundamental forces shaping the universe, seeing both their intrinsic individual qualities and their incessant interaction as the generators of the life energy on which all species depend. By harking back to the theory of the Five Elements, Ando's and Kuma's works honor Japan's traditional architecture itself, insofar as this doctrine has influenced for many centuries the construction of various indigenous structures — including countless pagodas (*buttō*), and the sorts of stone lanterns (*ishidōrō*) one encounters in gardens and temples, both of which comprise five tiers symbolizing the gradual ascent of life energy from earth to the void.

The Voice of Tradition

In outlining the key ingredients of the attitude to nature enshrined in traditional Japanese culture, a particularly useful point of reference is supplied by Donald Keene in his discussion of Japan's aesthetic preferences with a focus on the *Tsurezuregusa* ("Essays in Idleness"): a volume composed between 1330 and 1333 by Kenkō, a Shintō priest who became a Buddhist priest in the latter part of his life. This doctrinal switch may seem strange, since Shintō characteristically values the vitality and purity of one's present life and views death as a form of decay, whereas Buddhism regards the world as a place of suffering to be transcended. However, Kenkō seems never to have turned into an extremist after his conversion: hence, even though he maintained that "the possessions that people accumulate in this world do not last, he did not condemn them as hateful dross, as a more orthodox Buddhist priest might have.... Ultimately this world was not enough, but Kenkō seems to be saying that while we are here we should try to enrich our lives with beauty" (Keene, p. 28). It is to this liberal attitude that the insights he offers in the *Tsurezuregusa* owe their enduring relevance, energy, and overall interest for any lay person eager to explore Japan's aesthetic predilections. The key ideas extracted by Keene from the ancient cleric's writings are "suggestion," "irregularity" (encompassing "incompleteness" and "asymmetry"), "simplicity," and "perishability."

As emphasized in the context of this study's opening chapter, the principle of suggestion constitutes a pivotal aspect of traditional Japanese aesthetics as a whole. Intriguingly, Kenkō extends the concept's significance beyond the strictly aesthetic domain by urging his readers to pay heed to the effects of suggestion on their own psychological processes and intuitive faculties: i.e., memories, musings, visions, and, above all, the imagination. To exemplify this challenging contention with direct reference to the natural realm, the priest observes, "in all things, it is the beginnings and the ends that are interesting ... how incomparably lovely is the moon, almost greenish in its light, when seen through the tops of the cedars deep in the mountains, or when it hides for a moment behind clustering clouds during a sudden shower.... And are we to look at the moon and the cherry blossoms with our eyes alone? How much more evocative and pleasing is it to think about the spring without stirring from the house, to dream of the moonlight though we remain in our room" (cited in Keene, pp. 30–31). Keene's

commentary on the affective implications of suggestion as envisaged by Kenkō is itself worthy of citation, in the present context, because it helpfully situates the priest's argument in a distinctively Japanese frame of reference. According to the critic, "the Western ideal of the climactic moment — when Laocoön and his sons are caught in the terrible embrace of the serpent, when the soprano hits high C, or when the rose is in full bloom — grants little importance to the beginnings and ends. The Japanese have also been aware of the appeal of climactic moments ... but ... have been aware that the full moon (or the full flowering of a tree), however lovely, blocks the play of the imagination.... Beginnings that suggest what is to come, or ends that suggest what has been, allow the imagination room to expand beyond the literal facts" (Keene, p. 31).

Like the concept of suggestion, the ideal of irregularity has also been already highlighted in Chapter 1 as a major ingredient of native aesthetics. It is here worth emphasizing, however, that the principal reason for which Japanese artists, designers and writers deem "uniformity" quite "undesirable" is its preclusion of the possibility of further development. "Leaving something incomplete," by contrast, "makes it interesting, and gives one the feeling that there is room for growth." The production of a deliberately unfinished work is the ultimate creative gesture, in this perspective, insofar as it inaugurates a virtually limitless series of further creative efforts by implicitly encouraging the work's receiver to contribute to its growth. The indigenous commitment to the immense creative potentialities inherent in a work that shuns uniformity is corroborated by the realization that "the Japanese have been partial not only to incompleteness but to another variety of irregularity, asymmetry." In literature, a recurring outcome of this proclivity is the avoidance of "parallelism," as exemplified by the fact that "the standard verse forms are irregular numbers of lines — five for the *tanka*, three for the *haiku*" (p. 32). The preference for irregularity is also eminently observable in the realm of everyday activities, as borne out by the teaching of indigenous characters in schools: "Japanese children are taught in calligraphy lessons never to bisect a horizontal stroke with a vertical one: the vertical stroke should always cross the horizontal one at some point not equidistant from both ends. A symmetrical character is considered to be 'dead'" (p. 33). These observations intimate that in the context of traditional Japanese aesthetics, the written word is itself regarded as an animate species, and therefore a denizen of nature no less than it is,

inevitably, a product of culture. The seventeenth-century Japanese callig-rapher Ojio Yūshō goes so far as to propose that "characters were first cre-ated in the image of a human figure." The proficient calligrapher, argues Yūshō, must be able to handle the brush so competently as to evoke the movements of a living human body (cited in Ueda, M., p. 176). In Makoto Ueda's words, "every student of calligraphy must strive to produce living characters" endowed with several attributes meant to indicate not only their essential animateness and dynamism but also their ethical qualities. Hence, Yūshō contends that a properly traced calligraphic character must be seen to have a "soul," "individuality," "force," "morals," "ardor," "nobil-ity," a "voice" and a "spirit" (Ueda, M., pp. 177–178). The intrinsic aliveness of written language will be revisited in the second part of this chapter vis-à-vis the anime *Mushi-Shi*.

With the principle simplicity, we encounter again a concept which, though already familiar to readers of this discussion, deserves additional recognition in relation to Kenkō's writings. The priest elects residential architecture as a major arena in which the indigenous attraction to sim-plicity finds paradigmatic, and instantly recognizable, expression. "A house though it may not be in the current fashion or elaborately decorated," avers Kenkō, "will appeal to us by its unassuming beauty — a grove of trees with an undefinably ancient look; a garden where plants, growing of their own accord, have a special charm ... and a few personal effects left lying about, giving the place an air of having been lived in.... A house which multitudes of workmen have polished with every care, where strange and rare ... furnishings are displayed, and even the bushes and trees of the gar-den have been trained unnaturally, is ugly to look at and most depressing" (cited in Keene, p. 34). The culinary realm offers another notable instance of simplicity at its most vibrant: Japanese food, as Keene points out, "lacks the intensity of flavor found in the cuisines of other countries of Asia... Just as the faint perfume of the plum blossom is preferred to the heavy odor of the lily ... the taste of natural ingredients, not tampered with by sauces, is the ideal of Japanese cuisine" (Keene, p. 37). Simplicity reaches its apogee in one of the Zen arts examined in some detail in the previous chapter, the tea ceremony. This time-honored ritual, as we have seen, could in many ways be regarded as the very distillation of Zen aesthetics, and hence of the ongoing search for minimalist expression which charac-terizes that school of thought. Perishability, the fourth of the key principles

commended by Kenkō, is epitomized by the instinctive aversion to "gleaming newness" which has distinguished Japanese culture for centuries, as a result of which "a work that has passed through many hands and shows it" (p. 38) will invariably be deemed superior to a work flaunting the markers of freshness. In Kenkō's view, the indigenous fascination with ephemerality is logically congruous with the acceptance of humanity's own inherent transience and, relatedly, with a mature recognition that the instability of all life is the primary source of its emotive impact. "If man were never to fade away," the priest reflects "but lingered on forever in this world, how things would lose their power to move us! The most precious thing in life is uncertainty" (cited in Keene, p. 39).

Shades of Beauty

The belief that humanity cannot exist independently of nature lies at the core of Japan's traditional value system. As intimated in Chapter 1, this idea has affected profoundly the development of indigenous aesthetics, leading to the elevation of nature's lessons as the blueprint for practically every aspect of the artist's endeavor. This propensity, it will be recalled, has not entailed a slavish adherence to the model but rather a self-conscious commitment to its careful observation, intimate comprehension, and imaginative reinvention. As Donald Richie suggests, such an elaborate procedure emanates from a world view which distinguishes the Japanese take on nature from both its European and its Chinese counterparts. Dissatisfied with the mimetic approach favored by many other cultures, Japan indeed appears to have operated on the premise that "the nature of Nature could not be presented through literal description." It has therefore sought to develop and perfect a set of methodologies which will enable creators to replicate "the means of nature rather than its results," the most essential being the knack of "showing structure, emphasizing texture — even boldly displaying an almost ostentations lack of artifice" (Richie 2007, p. 19). As indicated in the preceding chapter, the cognate aesthetic principles of *wabi* and *sabi* encapsulate these stylistic propensities in a paradigmatic fashion. Moreover, the eschewal of mimesis in favor of a search for the essences which breathe beneath the natural world's surfaces has been conducive to a preference for symbolic modes of representation and performance. The

use of ritualized gestures in Nō drama, discussed in Chapter 2, offers an eloquent example of this trend.

Relatedly, instead of pursuing faithfulness to external semblances as its ultimate objective, Japanese art has traditionally aimed for an effect which is roughly comparable to "elegance," but is actually a much more prismatic and adaptable idea than this term is able to suggest in an Anglophone context. The core ingredients of the Japanese notion of elegance, according to Richie, are "a sense of refinement, of beauty in movement, appearance, or manners; a tasteful opulence in form, decoration, or presentation; a restraint and grace of style" (p. 25). The multifacetedness of this conception of elegance is borne out by the existence of several indigenous words which, though they are all roughly translatable into that single English term, carry quite distinct, context-bound and historically specific meanings on home turf. One such word is *fūryū*, a term now adopted "mainly in advertising copy in fashion magazines" to designate "something like 'stylish,'" but actually boasting a long and rich history of semantic modifications. A definer of "social rectitude" in the Heian period, *fūryū* was later invested with specifically aesthetic connotations as a marker of "refined manners" (p. 33). As noted in the preceding chapter, in the specific context of Heian society, the apotheosis of refinement — encapsulated by an individual's ability to master disparate arts and skills with utter aplomb — was referred to as *miyabi*. With the decline of Heian civilization, this concept did not vanish alongside its courtly champions but actually survived in a subtly altered guise suited to the new era and its ideological priorities. The "Ashikaga shogun Yoshimasa, who ruled from 1449 to 1473" played a major role in investing *fūryū* with fresh attributes: the fifteenth century in Japan was just one civil war after another. Yet, if the shogun could not make peace he might still cultivate the peaceful qualities of the unostentatious, the subdued, the meditative, all of which shortly became elements of *fūryū*" (p. 34). Another definer of elegance which has undergone intriguing transformations over time is *shibui*: a word which "originally described something astringent, dryish," but gradually came to be associated with "the sophistication necessary for the elegant appreciation of the subtle and the unobtrusive, sour and bitter though this taste might seem" (p. 40). Other well-known signifiers of particular interpretations of elegance are "*ate*— a Heian-period term meaning refinement, gentility" and "*fūga*," a synthesis of "elegance (*yūbi*)" as such and "sublimity (*yūdai*)" (p. 53).

If the aesthetic notion of elegance is many-sided, the idea of beauty is itself hard to pin down in the context of traditional Japanese culture. Sōetsu Yanagi, the founder of the *Mingei* ("folk arts") movement, uses the term *myō* to describe this elusive quality. However, as Boyé Lafayette De Mente observes, "the everyday meaning of *myō* is 'strangeness, queerness, mystery,' or 'skill,'" and gains further complexity in Daisetz Suzuki's usage of the word to designate "the total essence of all that is unique in things Japanese ... the unconscious expression of the 'something' in Japanese life and art that goes beyond technique and conscious effort" (De Mente, p. 80). It is also worth pointing out, in this matter, that the Japanese language accommodates a variety of words employed in ordinary discourse to describe different types and degrees of beauty in relation to the contexts in which they manifest themselves. The word *utsukushii*, which translates literally as "beautiful," is generally applied to "natural scenery," while *migoto* ("excellent, admirable, outstanding, skillful") usually designates "an extraordinary physical feat." The word *kirei*, which means "clean," as well as "beautiful" or "pretty," is normally applied to human beings, and the conception of beauty it implies is influenced by the Shintō belief that "physical cleanliness, neatness, and order are attributes of godliness, of respecting and revering one's self as well as the various gods." To describe an impressive artwork or other product, *subarashii* ("wonderful, splendid, a wonderful success") tends to be the word of choice (pp. 97–98).

The aesthetic principle which, in recent decades, has come to be readily associated with Japan by popular culture the world over has been *kawaii*. Viewing *kawaii* as synonymous with everything childlike, tender, lovable, charming and, above all else, cute, the West has tended to regard it as a contemporary phenomenon. In fact, as Akiko Fukai indicates, "the peculiarly Japanese aesthetic of *kawaii* was articulated as early as the eleventh century by the author of *The Pillow Book*, Sei Shounagon, when she wrote: 'All small things are adorable'" (Fukai, p. 25). Undeniably, the partnership of the small and the beautiful is axial to countless areas of Japan's creative endeavor. According to Sunamita Lim, this proclivity is exemplified by the native inclination to capitalize on "creative ways for doing more with less" (Lim, p. 14). In addition, the taste for pretty ornamental objects is deeply ingrained in Japanese aesthetics. According to cultural analyst Tomoyuki Sugiyama, "cute" is indeed an essential aspect of "Japan's harmony-loving culture." For instance, the tendency to collect figurines and

other tiny ornaments as mementoes — so very distinctive of the modern *kawaii* vogue —"can be traced back 400 years to the Edo period, when tiny carved 'netsuke' charms were wildly popular" ("Japan smitten by love of cute"). It is here worth recalling, incidentally, that *netsuke*— literally, "root-fix" — were originally designed to serve a wholly practical purpose as toggles by which various items could be attached to the belt, and hence make it possible to carry them around in the absence of pockets from the regular indigenous robe. *Netsuke* still stand out as fascinating artifacts expressive of a unique aesthetic sense, deriving eternal sparkle from their use of comical, grotesque and risqué motifs in the otherwise orthodox representation of gods alongside ordinary humans and other animals.

Today, the passion for cute characters — and the ever-sprawling galaxy of collectible merchandise they inspire — is alive in people of virtually any age, social provenance and sexual orientation. At the same time, it is pivotal to the establishment and consolidation of disparate versions of the notion of corporate identity. On the one hand, as Diana Lee emphasizes, the cult of cuteness could be seen to originate in a culturally ingrained "need to be liked" and "accepted in society." These tendencies are quite congruous with the Japanese perception of politeness as a means of achieving societal and familial harmony, and clearly hark back to the principle of *makoto* examined in the previous chapter. On the other hand, it could be seen as a ludic evasion of the duties and responsibilities which accompany an "austere life in work, family and social responsibility," and thus as a means of defying the more "traditional values of Japanese lifestyle" (Lee). According to Sharon Kinsella, such a stance results from social alienation, and indicates a desire to take comfort from the creation of "relationships" with "cute objects" in the absence of actual bonds with flesh-and-blood "people" (Kinsella, p. 228). Nevertheless, *kawaii* can also be interpreted, rather less bleakly, as a latter-day development of the Buddhist valorization of the concepts of "weakness" and "inability" as qualities which deserve recognition and approval (Lee). It is feasible, in fact, to see *kawaii*'s endorsement of the beauty of childlike simplicity and playful freedom as an offshoot of the lessons of Zen. In the spirit of *kawaii*, as in Zen, those goals are part and parcel of a consummately non-teleological approach to reality. In the realm of art, this involves that artifacts are allowed to stand as autonomous — and wonderfully transient — entities instead of being expected to receive their raison d'être from an external validator, such as a compilation of eth-

ical precepts or an artistic canon. In addition, artificial though they are, the images produced by the *kawaii* trend exude an aura of spontaneity which, in the context of Zen, is itself akin to freedom.

On the whole, the ideal vision of elegance and beauty fostered by Japanese culture over the centuries has been consistently underpinned by the supreme value of *wa*, "harmony," and by the related concept of *heisei* ("tranquility"). According to De Mente, "the concept of harmony was so important in the traditional culture that it was one of the seventeen articles that are often described as Japan's first constitution, written in A.D. 604. This law stated that all behavior was to be conducted in a harmonious manner — not only social behavior but business and political behavior as well." In the aesthetic sphere, the pursuit of *wa* has motivated artists to channel "an incredible amount of time and effort" into ensuring that "all the elements of the object — the material, shape, surface, ornamentation, and so on — were absolutely harmonious" (pp. 7–8). *Heisei* constitutes a vital complement of *wa* insofar as the endeavor to weave into the artwork "a profound quality of reflective tranquility" is effectively inseparable from the pursuit of an all-embracing compositional equilibrium. Affective and formal balance should blend seamlessly in both the artist's creative labor and the creation itself. Ideally, *heisei* "allows one to commune with nature on the deepest level and appreciate the transitory nature of life": in this perspective, deeply influenced by both Shintō and Zen, no serenity can ever be achieved on either the physical or the spiritual planes unless one is willing to recognize that impermanence is "the first law of the universe." These objectives still sustain contemporary Japanese design to the extent that "despite the surfeit of materialism that exists in today's Japan, this mind-set remains a powerful force not only in the traditional arts and crafts but in modern commercial designs as well, where it compels designers to strive for the ultimate in form and functionality" (pp. 9–10).

Garden Art

The propensity to observe nature closely for the purpose of reconstituting its forms in accordance with particular aesthetic priorities, instead of mirroring it mechanically in the service of mimesis, reaches its apotheosis in Japanese garden art. As Koichi Kawana explains, the discriminate recre-

ation of nature demands that "the garden designer must conceal his creative innovations under the guise of nature." For example, paths may exhibit "the most intricate and creative patterns" upon close inspection, but these are made quite "inconspicuous by the utilization of natural and subdued colors and textures." Concurrently, "meticulously trained and trimmed oversized *bonsai* style pines appear to be century old trees which have developed naturally in the garden" (Kawana). This account makes it quite clear that the impression of naturalness gorgeously achieved by so many indigenous gardens over the centuries is in fact the outcome of intensive manual and mental labor. It is through love of nature conducive to selfless observation that its laws are grasped and replicated. As Matsuo Bashō advises, "go to the pine if you want to learn about the pine, or to the bamboo if you want to learn about the bamboo. And in doing so, you must leave your subjective preoccupation with yourself. Otherwise you impose yourself on the object and do not learn" (cited in Slawson, p. 40). Conversely, it is by translating nature's laws into artistic practice that love of nature enables the dedicated practitioner to tend to each of its myriad specimens as a living entity worthy of undiluted attention. The studious care devoted to the mending of wounded trees epitomizes this idea, demonstrating that no task is ever too menial for the person who values the spirit with which a task is undertaken as far more significant that its objective. These aesthetic perspectives are intensified by the orchestration of the garden's dialogue with the elements and their temporal effects, exposing the phenomena of "weathering or *fuka*, erosion or *shinbaku*, and wear or *mematsu*" as important factes of the garden's reality. Honoring the aesthetic principle of "*koko*," which entails that "things improve or mature with time," the committed designer knows that it is only "with time and proper care" that "the true beauty" of a lovingly tended garden may "manifest itself" (Kawana).

Garden art is especially interesting in the present context because in this field of creative endeavor, Japan's aversion to mimetic realism is coupled with a conception of nature that exhibits eminently cinematic leanings — and hence latent affinities with the art of anime itself. Indeed, traditional garden art does not confine itself to reconstructing nature according to its own laws: it also *frames* it so as to make it experienceable from diverse angles and, no less vitally, in such a way that images become inseparable from the principle of motion. Garden art, in this respect, offers a *cinematization* of nature predicated on the criterion of multiperspecti-

valism. This aesthetic trend evolved gradually over time as each successive epoch in Japanese history elaborated its distinctive approach to ornamental horticulture, and attendant design principles. Throughout the Asuka (538–710), Nara (710–794) and Heian (794–1185) eras, the aristocracy had favored the construction of ample boating gardens. The aristocracy of the Heian period, specifically, wished to experience the garden as a framed picture. David A. Slawson elaborates this visual analogy as follows: "a classical Japanese garden ... was primarily viewed like a painting, from the shelter of the residential quarters. To be sure, Heian courtiers did penetrate the space of those three-dimensional landscape pictures when they took their pleasure boats out onto the pond ... such gardens may be compared to a landscape scroll being unrolled horizontally before the eyes of a seated observer" (Slawson, p. 80). The principle of multiperspectivalism was already at work in Heian gardens to the extent that the garden-as-picture could be viewed from different angles as the visitors' boats glided along the pond. However, the concept of framing was yet to develop the animational qualities to be found in gardens of later epochs insofar as it depended on techniques of a fundamentally stationary kind. The "scroll" garden of the Heian period, a landscape "revealed all at once in a single frame," was later superseded by the "stroll" garden, a panorama which "unfolds in a sequence of many frames" (p. 81). It was in the Kamakura period (1185–1333) that more modestly proportioned pond gardens designed primarily for strolling came into prominence. The stroll gardens turned the multiperspectival approach into an absolute aesthetic priority. Using a pond with a central island (*nakajima*) surrounded by hilly paths as its key player, the strolling garden was designed so as to assure that its visitors could experience a wide range of views as they ambled around the pond. As Katsuhiko Mizuno explains, the main principle underpinning the construction of strolling gardens was precisely to offer an aesthetic habitat in which visitors would be able "to enjoy pleasing scenes from wherever they happened to be in the garden. Accordingly, the gardens featured a variety of ingenious artifices to ensure delightful views from different angles, including artificial hills to climb and waterfalls to complement the surrounding scenery" (Mizuno, p. 2). The aesthetic deployment of manifold perspectives is likewise central to the enjoyment of scenic viewing gardens of the kind designed in both the Kamakura period and the Muromachi period (1336–1573). Initially intended to be viewed essentially from within the home, these gardens

gradually developed according to design tenets which enhanced their viewability from diverse external angles by people walking about on verandas. In the Edo period (1603–1868), the fascination with multiperspectivalism in garden art was conducive to the conception of "round windows with sliding paper doors behind them, especially designed for teahouses," which facilitated the evocation of strikingly cinematic, indeed animational, effects. "When the doors were open," Mizuno points out, "a circular segment of the garden could be seen from inside the teahouse, and the window served as a kind of picture frame.... The scenery viewed through the windows changed depending on how wide the doors were open" (p. 30).

All facets of the traditional Japanese garden, even the least evident and least prominent, ooze with aesthetic, religious and metaphorical connotations. In consonance with Japan's inveterate connection with the sea, water plays an especially important part, operating as an emblem of that vital natural force in a variety of guises. The actual amount of water at hand is itself inconsequential: even a trickle can function as an effective metonym for the wide oceans as long as it is ingeniously presented and choreographed with the rest of the landscape. As Kawana emphasizes, "one is supposed to be able to enjoy the tranquility of the sea in contemplation of a bucketful of water contained in a stone water basin." In fact, as dry gardens (*karesansui*) stunningly demonstrate, water may be dispensed with altogether in a literal sense through the deployment of gravel and sand to convey powerful images of the sea in diverse states of activity. In addition, since in Japan's traditional world view, "a sea without islands is unthinkable," gardens have tended to accommodate insular elements pregnant with symbolic meaning — for example, the Crane Island (*Tsurushima*) and the Turtle Island (*Kameshima*), both of which are well-known emblems of longevity inherited from Chinese lore. Unlike the *nakajima*, which can be reached by means of bridges and often accommodates "teahouses and arbors," holy islands of those special types, "are inaccessible to human beings and no bridges are constructed to reach them." Dry gardens, as shown in more details later in this discussion, do not miss out when it comes to islands but actually offer aesthetically inspired interpretations of these major design components by means of emblematic "rocks of interesting shapes set in gravel or sand" (Kawana).

In the context of garden art, several of the aesthetic concepts discussed in both this and previous chapters can be seen to play key roles. These include *yūgen*, as the evocation of inscrutable heights and depths through

the play of light and shadow; *wabi, sabi* and *shibui,* as related expressions of inconspicuous elegance through the unadorned, the aged, and the subdued; *miegakure,* as the eschewal of total presentation through the careful occlusion of certain parts of the scenery as a means of stimulating the viewer's imagination; and *seijaku,* as the communication of energy-infused peace. The lynchpin of effective garden design is ultimately simplicity: an aesthetic value which makes itself felt in the elimination of "all non-essential elements" as an attempt "to reach the essence of things." Hence, the traditional garden "calls for the predominant utilization of monochromatic green. Flowers in natural colors should be used only to enhance the value of the monochromatic color." Relatedly, the principle of *kanso* teaches that "beauty" must be "attained through omission and elimination." In this context, "simplicity means the achievement of maximum effect with minimum means" — which, after all, is precisely the fundamental law according to which nature performs the myriad tasks which cumulatively compose its phantasmagoric fabric. The quest for refined simplicity reaches its culmination with the *karesansui,* where the splendor of nature is condensed in a microcosm consisting of carefully placed rocks and painstakingly clipped bushes. At the same time, the distribution of forms confirms the crucial significance of emptiness and absence in Japan's traditional approach to spatiality. As Kawana points out, "void or negative space expressed by gravel covers the majority of the ground and is as important to the garden as is the stone arrangement" (Kawana). Slawson corroborates this proposition, arguing that "the spacing between rocks can ... produce a visual sensation as intriguing and intense as any arising from the character of the rocks themselves" (Slawson, p. 95).

TWO. INTERPRETATIONS
OF NATURE IN ANIME

Natsume's Book of Friends (TV series, dir. Takahiro Omori, 2008, 2009, 2011, 2012)

Anime centered on the unraveling of supernatural mysteries are so numerous that it would be utterly preposterous, in the present context, to

presume even to provide a comprehensive list thereof, let alone an analysis of their yarns and techniques. Shows in which the supernatural is deployed as a metaphor for complex psychological issues — or else as a lens through which such issues may be explored — are less frequently found across the history of anime as a whole, but are relatively prominent in anime released over the past decade. An especially notable example is provided by the franchise comprising the film *xxxHOLiC the Movie: A Midsummer Night's Dream* (2005), the TV series *xxxHOLiC* (2006) and *xxxHOLiC: Kei* (2008), and the OVAs *xxxHOLiC: Shunmuki* (2009), *xxxHOLiC Rou* (2010), and *xxxHOLiC Rou Adayume* (2011), all of which are based on a hugely popular manga by CLAMP, and have been helmed by Tsutomu Mizushima. In its various configurations, *xxxHOLiC* resorts to supernatural phenomena and their often unpredictable ramifications as a means of investigating the thorny relationship between addiction and desire. In so doing, the franchise persistently proposes that the motley people who seek the assistance of *xxxHOLiC*'s key character, the formidable witch Yūko, to be rid of afflictions that have been seemingly caused by otherworldly agencies are really the victims of consummately human addictive drives of which the supernatural is not so much the trigger as the supplier of apposite metaphors. *xxxHOLiC*'s overall message is that unless these characters confront their genuine desires, they will remain forever powerless to emancipate themselves from the tyranny of their obsessions. To reinforce its poignant ethical lesson without sinking to the level of patronizing didacticism, *xxxHOLiC* lays emphasis on the magnitude of the exorbitant price to be paid for allowing a habit to become so consuming as to degenerate into a full-blown disease.

Two anime with an emphasis on the supernatural deserve special consideration in the present context due to their explicit engagement with nature, and especially Shintō's interpretation thereof: *Natsume's Book of Friends* and *Mushi-Shi*. The four seasons of the TV anime *Natsume's Book of Friends* (2008, 2009, 2011, 2012), all of which have been directed by Takahiro Ômori, offer a very original interpretation of the classis topos of the supernatural quest as an enterprise saturated with age-old customs and values. The four series' protagonist, Natsume Takashi, has been cursed since childhood with the power to sense the existence of supernatural creatures of all sorts, cumulatively dubbed *yōkai* in Japanese. This is a talent which has been bequeathed upon the innocent boy by his late grandmother

Reiko, and warily guarded as "an absolute secret." Natsume feels compelled to reconsider his commitment to secrecy when he gains possession of a portentous item known as the "Book of Friends," a tome highly prized in the supernatural realm which he has been passed down to him by Reiko as an heirloom. The volume hosts the names of all the spirits defeated by Natsume's elder during her lifetime, and hence subjugated by recourse to otherworldly decrees, and imprisoned within the pages of the Book of Friends. Regarding the youth's possession of the formidable book as their sole hope of transcending the thralldom to which Reiko's actions have condemned them, countless supernatural beings have been harassing Natsume since an early age without him being aware of the cause of their seemingly unnatural interest in a regular human boy. However, once he realizes that the Book of Friends holds the key to the *yōkai*'s emancipation, he resolves to devote his existence to the release of the very creatures whom his grandmother spent her own life enslaving. The process requires him to return the names housed in the awesome text to their rightful proprietors and, by this means, to nullify the old bonds. Natsume's book serves as an inventive way of delivering a sustained commentary on the intersection of the natural realm with the domain of textuality. In so doing, it reminds us that just as anime is a construct offering a distilled and inevitably partial version of nature, so nature as experienced by humans (whether or not they interact with the supernatural like the protagonist of *Natsume's Book of Friends*) is inexorably mediated by a set of perceptions, interpretations, judgments and criteria spawned by specific ideologies within particular cultural and historical milieux — in other words, by a *text* in the broad sense of the term: a *tissue* (the meaning of the Latin *textus* at the root of the English word "text"), produced through the creative act of weaving (*texere* = "to weave").

It is important to appreciate, in assessing the philosophical implications of Natsume's quest, that the act of naming has been traditionally accorded momentous significance in legion cultures across the globe. The assignation and removal of names have accordingly been invested with supernatural connotations, and deemed synonymous with the conferral or negation of a creature's very identity. Fairy lore — as a close Western relative of Japanese *yōkai* lore — attests to this proposition, its denizens being renowned for their aversion to being invoked (or even referred to) by their proper names, and preference instead for ingratiating titles such as the

Gentry, the Little People, the Honest Folk, the Others, the Fair Folk, the Good Folk, the Hill Folk, the Wee Folk, the Green Children, the People of Peace, the Good Ladies. As Desirée Isphording points out, "in days past, and even still in many rural vestiges where the undercurrent of the Otherworld is still palpable, the word 'faery,' though known and understood, is rarely heard slipping from the tongues of those who take to heart the perceptions, experiences, and traditions of their elders. According to folklore and legend, the faeries themselves are not overly fond of the term (and it's never a good idea to court even the possibility of offending the fae). One source I discovered even claims that for every time you pronounce the word, a year is deducted from your lifespan. The word Faery was couched in veils of caution. Collectors of folklore utilized the word in their queries, but their informants usually navigated around it with a hypersensitivity and fear like one tracing the edge of a cliff on a moonless night.... Therefore, other terms and phrases were used in Faery's stead in order to keep their wrath at bay and/or to appease them. Flattering euphemisms, nebulous references, polite addresses, descriptions of awe and respect linger in their wake" (Isphording). Given the crucial importance of names in the overall development of *Natsume's Book of Friends*, this point deserves further elaboration in this context. J. C. Cooper's reflections in the matter are especially worthy of notice. The scholar argues that the taboo associated with "the Power of the Name," which is the mystical underpinning of the "prohibition against using the names" of particular beings, originates in "the universal belief in the creative force of sound: 'In the beginning was the Word ... and the Word was God.'" The ceremonial importance of individual designations must also be taken into consideration when examining the superstitions and fears which surround the act of naming, to the extent that a "name is also a powerful means of exorcism, and is the basis of incantation in which 'words of power' can compel elemental forces and open doors magically, as Ali Baba's 'Open sesame.'" Furthermore, the use of a human being's or a supernatural creature's "true name" is believed in many cultures to procure "magic power over the soul" (Cooper, p. 64). As A. M. Hocart observes, on this point, "a man's name is commonly treated as part of his person. In Babylon what had no name did not exist" (Hocart; cited in Cooper, p. 64).

Natsume's grandmother clearly owed much of her proficiency as a magic practitioner to the flair with which she could deprive the vanquished

spirits of their rightful appellations. In Natsume's case, by contrast, names are properties which the youth strives to *give back* to their rightful owners, not *take away* from them Of course, history abounds with situations in which the act of name-giving has proved no less oppressive than the act of name-suppression, as notoriously evinced by legion colonialist initiatives, where the allocation of names to the colonized has invariably amounted to a form of identity violation. Refreshingly, Natsume remains true to his objective to the end without ever succumbing to power fantasies of the colonial ilk. Relatedly, the franchise as a whole yields a refreshingly non-hierarchical world picture by showing that Natsume has no inclination to pose as a hero, champion of justice, or portentous ghostbuster. In fact, he does not even seem particularly scared of the creatures he meets regardless of their goals. Thus, as noted in the *Anime-Planet* review of the first season, "Natsume's relationship with them is one of mutual curiosity and respect; he approaches them with the sympathy he would give to any human being. This in turn goes a long way to humanising the spirits and making their predicaments emotional as well as entertaining" (VivisQueen 2008). The attitude evinced by Natsume as the drama unfolds is typically distinguished b a marked sense of self-restraint, composure and earnest commitment. Never indulging in emotive explosions or other self-dramatizing flourishes of the kind, the youth prefers instead to study the natural world around him with the same devotion, patience and love one might expect of an artist keen on learning nature's secret lessons. Despite his exceptional abilities, therefore, Natsume comes across as a profoundly and touchingly human character. This impression is consolidated by the anime's subtle elaboration of a double plot, whereby it concurrently traces the *yōkai*'s liberation from the Book of Friends, and the protagonist's own journey of self-discovery, charting his evolution from the status of a lonely orphan afflicted by an unappeasable yearning to belong to that of a self-possessed and resilient youth able to trust his inner strength without ever surrendering to the monsters of arrogance, vanity, or pride.

Some viewers might be inclined, somewhat cynically, to regard Natsume's bizarre predicament as a mere dramatic pretext for a potentially interminable chain of encounters between the human world and the supernatural Other. However, even the most disenchanted of spectators would feasibly concede that *Natsume's Book of Friends* deploys its protagonist's peculiar skills to engage with some intricate existential issues regarding the

very meaning of identity. Indeed, the youth's knack of perceiving, and interacting with, the Other ultimately enjoins us to wonder whether a person who, like Natsume, partakes of both the human and the supernatural spheres should be seen as *both* human *and* otherworldly, or, alternately, as *neither* human *nor* otherworldly. The former option is tantamount to a case of split personality; the latter to an effective erasure of self-identity. The conception of Natsume as an embodiment of the concept of divided selfhood echoes the cultural condition discussed in Chapter 1 vis-à-vis contemporary Japanese society as a world riven by ideological, affective and cognitive dissonances. By contrast, Natsume as an exemplification of identity erasure harks back to Zen's postulation of the removal of the self as the precondition of authentic existence. As we shall see, these issues are brought sharply into focus in the anime's closing stages, where the protagonist is faced with potentially life-changing decisions of far-reaching ethical resonance. What must be stressed at this juncture is that across its four seasons, *Natsume's Book of Friends* posits the self as an entirely fluid entity, and often communicates this proposition through its inspired depiction of space. The anime does not explicitly pursue the principle of geographical variety as a marker of either dramatic vibrance or aesthetic excellence. In fact, the action constantly returns to the same (or very similar) settings. These mainly consist of poetically refined landscapes (and occasional urbanscapes) charting the seasonal rhythms in a fashion that epitomizes the spirit of *mono no aware* at its purest, while also evincing rare sensitivity to the less obvious ramifications of its symbolic import. When they are infiltrated by supernatural forces, these locations come to acquire an all-suffusing numinous aura, and thus contribute vitally to the consolidation of the story's metaphysical backbone. Therefore, the sense of spatial richness yielded by the *Natsume's Book of Friends* franchise throughout does not issue from the drama's setting as such but rather from the speculative dimension in which nature and art coalesce into metaphors and symbols. Furthermore, in all of its configurations, and therefore even at its artiest and most stylized, the conception of space offered by *Natsume's Book of Friends* oozes with a tangible feel of materiality which elliptically serves to remind us of Japanese aesthetics' deep-seated inclination to conceive of art in all its forms as an eminently physical phenomenon. (The anime's approach to space will be returned to later in this analysis.)

Natsume undertakes his quest in the company of a cute, yet cynical

and often ornery, cat named Madara — whom the boy addresses with mock reverence as Nyanko-sensei, i.e., "Mister Little Meow." Another regular member of the cast is Natsume's spiritualist friend Natori Shūichi, a popular actor who, being endowed with preternatural skills akin to Natsume's own, holds a side job as an expert in the expulsion of demons. Natori is not introduced into the story until the ninth installment of the first season. This detail is worthy of notice insofar as it bears witness to the anime's ability to diversify a dramatic structure which may at first appear repetitive through the carefully thought-out introduction of occasional new personae at unexpected points. As Ben Leary observes, Natori is really "the kind of character you'd rather expect to find in a high school romantic comedy, in the capacity of rival to the male lead. He's a well-known television actor, a smooth talker, and very popular with the girls. His scenes have a more pronounced tendency to the cartoonish than the show has displayed so far. Whenever he does anything that makes female onlookers weak at the knees, a glittering background framed with roses appears behind him. On top of everything else he keeps two female attendant spirits and moonlights as an exorcist" (Leary). If assessed in terms of the *shin-gyō-sō* aesthetic formula, Natori could be regarded as the epitome of *sō* by virtue of his relaxed and debonair disposition. Natsume himself comes across as a blend of *shin* and *sō* due to his oscillation between gravity and playfulness. Nyanko-sensei, finally, veers toward the *shin* end of the personality spectrum, not because the feline is *literally* formal or austere, as *shin* would imply, but rather because he is implicitly invested by tradition with a solemn role: that of both a spiritual guide and a magical guardian. In this respect, the creature is heir to the long and illustrious tradition of narrative storytelling, examined in the previous chapter, in which animals are consistently accorded paramount significance on both the dramatic and the symbolic planes.

As a result of its protagonist's typical conduct, the cumulative effect conveyed by Natsume's adventures is one of rare dramatic composure. The pace at which the tales springing from the magical book unfold is accordingly deliberate and mellow. The character designs used in the portrayal of the human actors consistently reflect this sedate approach to the action's tempo. In effect, their pointedly understated and delicately nuanced appearance might initially evoke an impression of dullness. One soon realizes, however, that the actors' ostensibly simplistic looks are in fact the

outcome of thoughtful and meticulous application, and that their execution is actually underpinned by the time-honored aesthetic principles of *wabi* and *sabi*. By contrast, the style adopted in the depiction of the anime's otherworldly characters exhibits a distinctive passion for pronounced visual individuation combined with a generous distribution of oddities and quirks, which range from the gently amusing to the downright grotesque. It is their sheer diversity, thrown into relief by a deft handling of juxtaposition and visual irony, that renders the anime's legion spirits immediately alluring. Hence, *Natsume's Book of Friends* an certainly be credited with the power to treat us to one of the most varied and endearing parade of supernatural creatures to have regaled the anime screen in recent decades. As Stig Høgset aptly points out, in this matter, "you might actually argue that the *yōkai* themselves make up most of the main cast of this series, and they come with a large variety of shapes, sizes and personality traits; from the little male *kitsune* [fox spirit] who wants to be strong so he can get by, to the guardian deity known as the 'Dew God' who tied himself to a shrine so that human worship would give him powers. A lot of the *yōkai* also have animalistic traits on humanoid bodies, while others took on human forms after dying as an animal. There are some real oddballs out there among the *yōkai*, like the twosome that made me suspect that the creator of *Natsume's Book of Friends* is a fan of Ren and Stimpy. And there are also some who would just as well eat Natsume on the spot just because they were hungry" (Høgset).

While some creatures are so outrageously odd as to edge on the absurd, others seem to have been hewn out of the deepest and most quintessential nightmare by evoking the baleful incubi and succubi found in Gothic/Romantic literature and painting. If the human characters' physiques and visual features are typically so unostentatious as to suggest that the poetics of *wabi* and *sabi* have provide the predominant aesthetic guidelines for their depiction, the *yōkai*'s portrayal, by contrast, seems informed by the principle of *fūryū* as currently understood — i.e., "stylish." In the case of the *yōkai*, *fūryū* is also denotative of a conception of elegance which lends itself to humorous interpretation even if its effects are not at first intended to be unequivocally hilarious. In addition, the creatures repeatedly come across as lively incarnations of *myō* as the quintessence of the headiest of aesthetic cocktails: weirdness, irregularity and mystery. At times, the *yōkai*'s designs allude to the aesthetic of *kawaii* by blending oddities of an incon-

trovertibly outlandish nature with endearing touches of a familiar and well-tested notion of cuteness. If we were to draw an analogy between the tonal scale of *Natsume's Book of Friends* as a whole and the seasons, it could be suggested that the almost astringent minimalism, redolent of the aesthetic tenet of *shibui*, of several of its human character designs is akin to winter, whereas its softer moments are so delicately flavorful as to recall John Keats' famous portrayal of autumn as the "Season of mists and mellow fruitfulness, / Close bosom-friend of the maturing sun" (Keats). The depiction of the *yōkai*, by contrast, bring to mind spring and summer: the former in the case of the prettier and fluffier specimens of that race, and the latter in that of the more flamboyant and enterprising types.

As a keen investigator of the supernatural realm in all its vagaries, Natsume is constantly engaged in more or less perilous forays into its darkest nooks. The idea of home, in this regard, supplies the boy with a steady point of reference. Nevertheless, it can never provide an insulated cocoon or utopian haven to which he could reliably retreat at times of danger or doubt. Home, in Natsume's world, is not so much a safe point of arrival as the take-off point for a challenging expedition into the Beyond. This is a destiny which the youth could hardly presume to transcend when one considers that when he refrains from leaving his home to embark on a *yōkai*-related mission, the supernatural domain is perfectly capable of finding a way of reaching out to him by penetrating his very bedroom. In the course of his adventures, the protagonist gradually achieves both stability and resilience, yet remains ever susceptible to the possibility of further development. As a result, both his actions and his inner disposition inevitably fluctuate between stasis and kinesis. Yi-Fu Tuan's reflections on the relationship between space and identity are eminently applicable to Natsume's situation: "rootedness ... sets the self into a mold too soon," while "mobility carried to excess ... makes it difficult, if not impossible, for a strong sense of self to jell. A self that is coherent and firm, yet capable of growth, would seem to call for an alternation of stillness and motion, stability and change" (p. 4). Concurrently, *Natsume's Book of Friends* also echoes Tuan's suggestion that as a "material environment" in its own right, "geographical place" is at once "natural" and "artifactual," insofar as its settings come across at once as convincing portions of the natural world, and pointedly constructed animated pictures. According to Tuan, "artworks such as a painting, photograph, poem, story, movie, dance, or musi-

cal composition can also be a place" — a place by which we can be "nur-
tured" in much the same way as we are "nurtured by the towns and cities
and landscapes we live in or visit" (Tuan, p. 3). This argument is relevant
to *Natsume's Book of Friends* to the extent that in its context, the arena
wherein the characters — both human and otherworldly — may grow and
learn is provided precisely by a visual/cinematic construct. The notion of
nurture referred to by Tuan is crucial, in the present context, insofar as it
draws attention to the incessantly transforming influence which space is
bound to wield upon both our bodies and our minds and therefore remind
us, once again, that the "self ... is not fixed" (p. 4). It is also vital to recognize,
in evaluating the anime's approach to space, that its four series do not
posit spatial richness as a given by recourse to lavish locations and props,
but rather conjure it up from one episode to the next by presenting it as
an organic outcome of the ongoing collusion of nature and art. In so doing,
the franchise encapsulates Tuan's perspective to the extent that it presents
the fictional space in which its adventures unfold as a fertile terrain in
which identity is always open to metamorphosis and displacement. As
intimated earlier, Natsume himself harbors an inherently fluid personality,
being simultaneously rooted in an ordinary human community, and afloat
in a hybrid world in which he can interact with both humans and spirits
without fully belonging to either camp. As a consequence of this inner
division, which Tuan would describe as a "bipolar tug" (p. 7), the youth
is simultaneously sensitive to "the call of open space" and "the call of home"
(p. 8).

In a memorable climactic moment, the sense of rootlessness haunting
Natsume from start to finish is succinctly conveyed by the scene in which
the youth looks at an old photograph of his parents, and painful memories
resurface to flood his mind. This is soon followed by a visit to the old
house where Natsume used to live with his dad, which is about to be sold.
Intriguingly, a *yōkai* possesses him at this stage in the drama, and offers to
free him of the reminiscences that pain him so much. At this point, Nat-
sume must face a crucial — and potentially wrenching — choice which
implicitly raises as existential question of great import for us all. Indeed,
the drama suggests that retaining one's genuine humanity requires one's
acceptance of pain, for pain is inextricable from the experience of being
human per se; hence, the retention of one's mnemonic baggage, unpleasant
though this may be, is ultimately instrumental in the retention of one's

humanity. Conversely, being relieved of the burden of the past by super-natural intervention entails a degree of involvement with the Beyond so intense as to amount, in effect, to the partial loss of one's humanity. The question both Natsume and the audience are thus enjoined to address is this: "is it preferable to be human and laden, or not-quite-so-human and free? This already hairy situation is complicated by Natsume's exposure to another, equally tough, moral question which the anime obliquely raises as disparate recollections roll through Natsume's mind like a compressed film of his whole life. These images require both the protagonist and the audience to ponder dispassionately the ontological status of both humans and *yōkai*, and ask themselves whether the superiority of humans is an assumption which can be indisputably demonstrated. It would be hard to claim, in looking at the visuals encapsulating Natsume's reminiscences, that *all* human beings are unproblematically nicer than *all yōkai*— Nat-sume's memories in fact intimate that there have been numerous occasions in his life when humans have been far less kind to him than preternatural beings, and unscrupulously excluded him from their company while *yōkai*, by contrast, have been only too happy to join him in revelry and play. In the course of his *yōkai*-encrusted peregrinations, Natsume is often forced to confront an unpalatable ethical conundrum: whether, in order to remain true to his vocation, he should side with the human camp or with its non-human counterpart. This same question still echoes in the air as the anime draws to its close.

Mushi-Shi (TV series, dir. Hiroshi Nagahama, 2005)

The Shintoist conception of the natural world as a living tapestry inhabited by living energies and presences is extended to the farthest reaches of matter in the anime *Mushi-Shi* (TV series, dir. Hiroshi Naga-hama, 2005), where the world is said to be pervaded by infinitesimal, invisible, and largely erratic entities akin to the subatomic particles researched by quantum physics: the titular *mushi*. As the script informs us, these elusive life forms "dwell, unseen, in the shadows — a host of crea-tures completely different from the flora and fauna familiar to us, an invis-ible world of life within our own." Even though the *mushi*'s latent presence affects the ordinary human world quite incessantly, only very few people

have the capacity to sense them at all. As matter of course, the *mushi* do not intentionally seek to either endanger or inconvenience their human counterparts. Nevertheless, the creatures' irreducible otherness frequently implies that whenever they come into contact with ordinary people, neither they nor the humans involved are likely to gain from the encounter. The anime's protagonist, Ginko, is a *mushi-shi* ("*mushi* hunter"): namely, an itinerant researcher of these primordial entities who lends his assistance to the people whose lives have in one or another been affected by supernatural phenomena triggered by the *mushi*. In the representation of its protagonist, *Mushi-Shi* harks back to the traditional figure of the nomadic medicine man, a versatile magic practitioner well-versed in healing, exorcism and divination. However, the distinctive spirit with which Ginko approaches his supernatural tasks is also reminiscent of Zen's world view in its prior-itization of intuition to cold rationalization: a proclivity which, as seen, has had a profound and durable impact on the entire development of Japa-nese aesthetics. In Ginko's characterization, as in Zen, that tendency is encapsulated by a preference for laconic speech, as though to suggest that the hidden reality with which the wanderer is preternaturally capable of interacting eludes human language and its vaporous attempts at intellectual explanation. In addition, Ginko's attitude echoes Zen's teachings to the extent that the character's ultimate aim is to teach his "patients" how to coexist harmoniously with the world's impenetrable dimensions.

As *Mushi-Shi*'s protagonist journeys from place to place in his inde-fatigable voyage through the unknown, he chances upon all manner of bizarre characters and their respective predicaments. These include a nearly-drowned woman who has morphed into transparent jelly as a result of drinking water infested by *mushi*; a girl whose eyesight has been damaged by *mushi*, rendering her intolerant to any regular source of light except for the sparkling river symbolizing the font of all life; a coat ostensibly con-taminated by *mushi*; a man fixated on rainbows; a boy who has acquired a new sense of hearing; a girl believed to be a living god; a boy who has developed horns; a shrine believed to have the power to grant people a second life; a man who seems to have received from *mushi* a bunch of visionary dreams harmful to the welfare of his community. Since the *mushi* are an essentially nonbelligerent race, Ginko never aims to hurt them, or even combat their attempts at self-assertion, which he deems intrinsically legitimate. He therefore resorts to physical strength only when the creatures

themselves appear to threaten the safety of innocent humans. As a result, the itinerant practitioner has nothing in common with the formulaic monster exterminators that have populated action adventure anime since the art's early days. His personality, in fact, conjures up the image of a keen researcher, an explorer or even a protoscientist of sorts. Many of Ginko's cases take us back, with varying degrees of explicitness, to characters and events enshrined in native lore since antiquity, and hence to the aesthetic conventions attached to those legendary materials by centuries of repetition, adaptation, and reinvention. *Mushi-Shi*'s motley crowd is rendered appealing by the sheer fact that each of its members has a unique story to tell: even though the content of the story may be flimsy or absurd in the eyes of some spectators, the telling itself is made gripping by the disarming innocence of each character's urge to share it with Ginko — and, by implication, with the anime's audience.

On both the stylistic and the narrative planes, *Mushi-Shi* comes across as a veritable paean to the Zen-inspired aesthetic principle of *kanso* with its persistent commitment to condensing things down to their ultimate essence. As Carl Kimlinger points out, the anime's simplicity is instantly borne out by its approach to storytelling, where the dispassionate exploration of the most basic — and often most painful — human experiences invariably gains precedence over either dramatic complexity or rhetorical ornamentation: "the tales it tells are simple; tales of loneliness, illness, despair, and sacrifice, ever so human and yet eerily supernatural. Each episode gently insinuates us into the lives and minds of its protagonists, evoking surprisingly strong responses to the tragedy, hope, and quiet triumph they experience" (Kimlinger 2007). According to Theron Martin, one of the main reasons for which *Mushi-Shi*'s drama feels compelling in spite of its yarn's narrative minimalism is the aesthetic quality of its visuals. "Its stories may be too low-key and mellow (some might say boring) to sufficiently entertain some viewers," argues the critic, "as the series works best when a viewer just sits back and allows themselves to be wrapped up in the mood each episode establishes, but the quality of its production ... and how all of its elements work together to craft the whole, is self-evident. Its human character designs may be unglamorous and offer little major variation in appearance beyond Ginko, but that helps emphasize the plain rural settings and keeps attention on the story and the *mushi* rather than the characters' appearances." The story's natural settings work wonders to

bolster *Mushi-Shi*'s overall aesthetic without ever pandering to theatricality, and hence respecting the *kanso* ideal even when they approximate the awe-inspiring splendor of *yūgen*: "its background art sets the story in gorgeous mountain vistas without overplaying them, while its depictions of the *mushi* themselves are endlessly inventive and certain individual scenes ... delight with their stunningly effective beauty" (Martin 2008).

What matters most, in the present context, is the centrality accorded to nature by both *Mushi-Shi*'s narrative terseness and its poignant visuals. Marcello pithily underscores this idea in his assessment of the series' distinctive tone and generic identity: "*Mushi-shi* is the story of nature. The tone of this 26 episode anime series is very quiet and somber, balancing on the edge of being a ghost story.... There are no giant robot battles, and no teenage boys nervous about aggressive girls. The tone is slow and purposeful" (Marcello). Kimlinger emphasizes the anime's imbrication with nature in further detail, arguing that *Mushi-Shi*'s aesthetic distinctiveness ultimately pivots on its unrivaled ability to interweave its "human tales with the world around them, with the boundless universe of nature, with the green growing things, animals, and strange, ethereal *mushi*. It's a relationship evoked by the way human structures — ancient, complex and organic in their own right — melt effortlessly into their surroundings — be they misty emerald forests, rocky seaside pine, or silent snow-swathed mountains — and by the incorporation of traditionally garbed humans, plants, and swirling *mushi* into a single, beautiful organic whole ... the *mushi*'s most prominent trait is the magic they impart to seemingly mundane objects — to mossy rocks, unfurling leaves, aged vault doors and wooden rooms" (Kimlinger 2007). Few anime can be attributed *Mushi-Shi*'s power to yield images of nature that capture so resonantly, and yet so delicately, the spirit of *seijaku* at its purest: namely, a stirring impression of energized stillness, on the one hand, and a soothing sense of serenity amidst swirling activity, on the other. In Hiroshi Nagahama's hands, *seijaku* takes the shape of a comprehensive vision of nature as a silent sea astir with undying energy. Comparable accomplishments, arguably, can be witnessed in Hayao Miyazaki's *Princess Mononoke* (1997) with the rendition of the primeval forest presided over by the formidable Shishigami, and the same director's *Spirited Away* (2001) with the sequence in which the protagonist and her metamorphic companions journey by train through the exquisitely hushed solitude of a water expanse left behind by preternatural rain.

Mushi-Shi is comparable to *Natsume's Book of Friends* in its adoption of an eminently unassuming style redolent of the twin aesthetics of *wabi* and *sabi*. The anime's approach to nature, specifically, recalls the poignant description of that venerable aesthetic pair offered by the article "*Wabi Sabi*, Japanese Philosophy of Authenticity." Accordingly, the anime's interpretation of nature pivots on *wabi* and *sabi* as the embodiment of the "ancient Japanese wisdom of finding beauty in imperfection and simplicity in nature, of accepting the natural cycles of growth, decay, and death. Enjoying the simple, natural, and uncluttered, *Wabi Sabi* reveres authenticity above all. It celebrates cracks, chips, and other marks of time, weather, and use. Once we see the beauty in such 'deficiencies,' we can learn to embrace the flaws — the wrinkles, rust, and frayed edges, and all the imperfections in our lives" ("*Wabi Sabi*, Japanese Philosophy of Authenticity"). While acknowledging the crucial significance of this traditional form of wisdom to *Mushi-Shi*'s presentation of the natural world, it is also necessary to appreciate that the anime is not monolithically governed by the aesthetics of *wabi* and *sabi*. On the contrary, it simultaneously treats us to a tastefully restrained adaptation of the concept of *yūgen* through its subdued colors and inconspicuous forms: visual elements which, upon first inspection, might seem incongruous with *yūgen*'s sublimity but, often enhanced by soulful musical accompaniment, in fact coalesce in the evocation of the pervasive sense of awe which courses the *mushi*-teeming landscape. It is precisely by interspersing its predominantly *wabi-sabi*-oriented aesthetic with judiciously measured doses of *yūgen* that *Mushi-Shi* delivers a unique interpretation both of nature itself and, by implication, of the Shintoist conception of the universe as the repository of inexhaustible energies.

At the same time, the studious attention to detail which has traditionally distinguished Japanese art and aesthetics is consistently honored by the anime's thoughtful portrayal of the *mushi*'s interstitial dimension. This is indeed ideated as a coherent ecological system which, however bizarre its habits may appear to common humans, is nonetheless internally consistent, and therefore quite convincing. As a result, viewers can relate to the *mushi* in spite of the creatures' perplexing shapes, many of which combine fragments of images drawn from nature in its empirically recognizable manifestations, and fantastic elements drawn from the hypothetical interpretations of nature conceived over time by ingenious and playful

artists. Concomitantly, the *mushi*'s designs allude to a variety of visual influences: styles and motifs which, it must be stressed, were not always deliberately or consciously invoked by the anime's creators. At the same time as they persistently echo the preference for stylized decoration typical of traditional Japanese art, several *mushi* recall the ornamental themes favored by the postmodern Japanese movement known as Superflat, while others bring to mind Joan Miró's amoeba-like squiggles. Thus, the *mushi*'s reality cumulatively comes across as an enthralling world-within-a-world which runs counter to common reality, on the one hand, yet continually echoes it through its graphic symbols, on the other. Imaginary characters like the *mushi* demonstrate the relevance to the art of anime of E. H. Gombrich's proposition, put forward vis-à-vis pictures in general, that images can be most successfully "used to work magic" (Gombrich, p. 40). This function, according to the eminent critic, is inherent in the most ancient of images — including "pictures of animals" such as the ones which "primitive peoples" would "scratch" on "rocks" in "the eerie depth of the earth" as a means of figuratively gaining the "power" of the creatures depicted in them (p. 42). The images invoked by Gombrich are so atavistic as to represent appropriate visual correlatives for the designs of the ancestral *mushi* which people the anime.

Mushi-Shi also echoes *Natsume's Book of Friends* by proposing an intimate connection between nature's hidden presences and the domain of textuality. Nagahama's anime gives us both a macrocosmic and a microcosmic interpretation of textuality. The former takes the guise of a library: a sprawling galaxy of august scrolls written by a young woman whose whole line has been afflicted for many generations by a baleful fate. As a result, each generation contains an individual bearing a "charcoal birthmark" which connotes the presence of a *mushi* within his or her body. The curse, it transpires, is the long-term effect of "a forbidden *mushi*" having once been sealed in one of the girl's forebears, and having then been transmitted along the dynasty amid ordinary human genes. The only way of taming a captive *mushi*, and thus relieving the physical torment it induces in its host, is to gather stories about the creature and consign them to writing so as to contain the *mushi* within the margins of a scroll. Should the preternatural entity break loose, the characters written in each scroll would disengage themselves from the paper, and fill the library with an elaborate mesh of intersecting ideographic strings akin to the threads in a

spider web. The cursed heroine's task, in the face of such an eventuality, is to disentangle the jumbled net and return the words to their legitimate scrolls with the assistance of a preternatural adhesive. With this library, which Ginko visits in order to assist the hapless girl, *Mushi-Shi* obliquely alludes to an old and compelling metaphor for the intrinsically textual character of nature in its entirety: namely, the image of the universe at large as a hypothetical library. This idea is tersely captured by the opening words of Jorge Luis Borges' story "The Library of Babel," which state: "the universe (which others call the Library)" (Borges, p. 78). At the same time, the lurking vitality which characterizes all of the scrolls assembled in *Mushi-Shi*'s textual collection echoes Umberto Eco's depiction of the medieval library central to his groundbreaking novel *The Name of the Rose*. This is indeed described as "a living thing" (Eco, p. 185) in which books have the power to interact and communicate with one another, and even spawn more creatures of their ilk. An intriguing reconceptualization of these ideas can also be found, incidentally, in the fantasy anime *Yami to Bōshi to Hon no Tabibito*—a.k.a. Darkness, the Hat, and the Book Travelers—directed by Yuji Yamaguchi and aired in 2003.

Mushi-Shi's microcosmic interpretation of textuality engages with the intrinsic nature of language itself by deploying its imaginary biology as a metaphor for both the materiality and the latent vitality of the written word. In so doing, the anime establishes an intimate connection between human language and the natural world, which echoes the idea, here examined in Chapter 1 vis-à-vis pictographic symbols, that nature supplies the matrix for the metaphoric associations whereby human language operates. One of the series' most memorable episodes articulates the relationship between nature and language in overtly graphic terms by depicting the ideograms drawn by its key character as animate entities comparable to the *mushi* themselves, which are capable of detaching themselves from the page and assuming a tantalizing variety of shapes as they fill the surrounding space. At the same time as it gives the anime scope for exploring the nature-language bond, the proposition that written characters are inherently alive also works as a powerful symbol for the essence of anime itself as an art form able to breathe life into inert matter. Finally, in *Mushi-Shi* as in *Natsume's Book of Friends*, even when textuality is not overtly brought into play on either the thematic or the visual planes, it is still notable as an abiding presence in the sheer care devoted to the elaboration of the

anime's aesthetic as a *text*— a delicate web of *tissues*, or rolls of multicolored *textiles* in which all manner of *textures* are lovingly attended to.

Bakemonogatari (TV series, dir. Tatsuya Oishi, 2009) and *Nisemonogatari* (TV series, dir. Tomoyuki Itamura, 2012)

The Shintoist conception of the cosmos as the abode of a boundless family of spiritual entities finds an unprecedentedly sparkling expression in the TV series *Bakemonogatari* and its sequel *Nisemonogatari*. At the same time as they endeavor to bring to the screen a popular series of light novels, penned by the Japanese author Nisio Isin and illustrated by the Taiwanese artist Vofan, both shows also serve to remind us that in the context of Japanese lore, fantastic creatures are held to pervade the entire fabric of nature. This deeply ingrained belief is pivotal to any adequate understanding not only of Japan's mythological heritage but also of its aesthetic sensibility, insofar as all of those imaginary beings invariably come across as scrupulously detailed, well-defined, and distinctive not only at the visual level but also at the sensory level generally. *Bakemonogatari* and *Nisemonogatari* perpetuate this tradition by imparting their supernatural characters with palpable and sensitively individuated identities. In so doing, they operate as both entertaining and sobering illustrations of the idea, pithily promulgated by Eden Phillpotts, that "the universe is full of magical things, patiently waiting for our wits to grow sharper" (Phillpotts).

Both series resonate with pantheistic motifs, which are explicitly referred to in the dialogue, reminiscent of Shintō's conception of the universe in the image of a symphony of ubiquitous spiritual agencies, as outlined in the previous chapter. All sorts of material objects, and especially natural or semi-natural entities, are assiduously portrayed as the abodes of disparate *kami* capable of affecting human existence in both predictable and surprising ways. It is in the representation of the natural domain, specifically, that *Bakemonogatari* and *Nisemonogatari* alike communicate this message with arresting beauty. At the same time, their portrayal of various types of architecture, of domestic interiors, and even of everyday household items, allude to the presence of spiritual powers in the human-made world, emphasizing that this does not only pertain to venues designed

to accommodate solemn events such as rituals but also the humble settings of humdrum everyday jobs. The spirits of the deceased are concurrently posited as omnipresent and profoundly influential forces. In all of these areas, the two series strive to convey the Shintoist notion, pithily phrased by Michael Ashkenazi, that there is "no effective limit to the number of *kami*," and the related belief that there is "no clear division between the mundane and the *kami* worlds" (Ashkenazi, p. 27). *Bakemonogatari* and *Nisemonogatari* echo Shintō-based traditions in two principal ways. On the one hand, they implicitly hark back to the body of textually encoded myths that have come to be shared and endorsed over the centuries as essential facets of the Japanese nation, most famously the *Kojiki* (a.k.a. *Furukotofumi*, c. 712) and the *Nihonji* (c. 720). On the other hand, they remind us of the ubiquity, in Japanese mythology and lore, of stories centered on ghosts, spirits, demons, goblins, magical patrons, and itinerant deities spawned by the genius loci of each of a galaxy of small communities. The reality portrayed by the two series is redolent of Vilém Flusser's assessment of "the universe of traditional images" as a dimension "as yet unclouded by texts": namely, "a world of magical circumstances; a world of eternal recurrence in which everything lends meaning to everything else and everything signifies everything else: a world full of meanings, full of 'gods'" (Flusser).

Bakemonogatari and *Nisemonogatari* employ as their protagonist the character of Koyomi Araragi — a third-year high-school student who has recently recovered from his metamorphosis into a vampire: a phenomenon triggered by his selfless rescue of a mortally injured member of that breed. In the wake of his recovery, achieved with the assistance of the charismatic mystic Meme Oshino, Koyomi has consistently endeavored to assist anyone who might have likewise fallen prey to a supernatural misfortune. He has done so by seeking Meme's invaluable advice on each occasion but also, no less importantly, by striving to relieve the victims of their emotional distress through his own supportive presence and unaffected humor, in keeping with an inveterately kind-hearted nature. On a number of occasions, in fact, Koyomi's benevolence thrusts him into situations where he feels he has no choice but to put his own life on the line by acting as either a rescuer or a bait. This does not automatically turn the youth into a saint or a martyr, however: on the contrary, the story is careful to emphasize Koyomi's humanity by interspersing his acts of generosity with endearing

reminders of his failings — which occasionally manifest themselves as intolerance toward the casualties of the supernatural ailments he aims to alleviate. In the process, the effects of Koyomi having once been a vampire live on, albeit in a comically muted guise, as though to alert both the youth and his associates to the fact that the supernatural is not a domain to be handled flippantly, and that entering its secret labyrinths is something we inevitably do at our own peril, and with feasibly irreversible repercussions. Thankfully, in the circumstances, Koyomi's post-vampiric peculiarities amount to a lingering fear of sunlight and, more beneficially, the capacity to heal surprisingly fast. The anime's eschewal of cut-and-dried characterization does not only abet the protagonist's portrayal: the mystic's personality likewise comes across as refreshingly devoid of clichés. Meme indeed evinces throughout an elatingly nonchalant stance to even the thorniest of conundra, which works wonders to lighten up the mood of the drama's potentially distressing moments. Concurrently, he is unequivocally presented as someone who can always come up with the right answer without ever being reduced to the cardboard role of a deus ex machina.

Koyomi's female counterpart is Hitagi Senjougahara: an attractive young woman who is instantly distinguished by her trenchant sarcasm and flair for ad hominem invective. As Tim Jones observes, "Hitagi is not your typical heroine in this kind of series. Intelligent, sharp-tongued, calm, and at times remorseless, her character feels more like an *antagonist* than Koyomi's love interest. Her conversational exchanges with Koyomi often play out like an even more mean-spirited version of *The Lockhorns* comic strip. And she's not afraid to threaten Koyomi either when he annoys her, though these threats are seldom carried out." In spite of these potentially offputting attributes, which some fans of more conventional romance anime might deem quite unpalatable, Hitagi does reveal a caring disposition as the drama unfolds, as it becomes more and more obvious that her rhetorical aggressiveness is effectively a defense mechanism constructed in an effort to keep at bay a tangle of insecurity and self-doubt bred by a traumatic past. With their dramatization of the relationship which gradually develops between Koyomi and Hitagi, *Bakemonogatari* and *Nisemonogatari* give us abundant and conclusive confirmation of their psychological subtlety — a quality which may be sometimes obfuscated by the story's emphasis on witty and surreally elaborate dialogue, word play, sparkling repartee, deliberately puzzling nonsequiturs, metanarrative allusions, and occasional con-

cessions to fan service. A viewer would have to be emotionally anesthetized, or at the very least uncommonly blasé, to remain totally unaffected by the sequence in which Hitagi takes Koyomi to a secluded spot whence the night sky can be observed in its full and overwhelming glory, offering the starry vault as her present to the boy she has come to love despite of her deeply ingrained aversion to relationships which might get her uncomfortably close to another human being.

Adopting a multi-arc dramatic structure, the two series dramatize several interconnected adventures centered on various female characters and their respective supernatural afflictions — Hitagi herself, Mayoi Hachikuji, Suruga Kanbaru, Nadeko Sengoku, and Tsubasa Hanekawa in the first anime, and Karen Araragi and Tsukihi Araragi in the second. As Jones points out, "unlike a lot of series that have arcs for its heroines, where the character of the arc is typically abandoned when their arc is over, the girls in *Bakemonogatari* actually make quite a few appearances in the series. This gives the series a more connected feel, making its cast feel more like a whole than a series of somewhat related vignettes like a lot of visual novel / dating sim anime are" (Jones 2012b). From an aesthetic perspective, *Nisemonogatari* departs most significantly from *Bakemonogatari* at the structural level by dramatizing only two arcs, and hence focusing on only two distinct supernatural ailments and their two (related) victims, Karen and Tsukihi, rather than on a varied chain of emotional issues revolving around a varied set of characters. A further aesthetic peculiarity distinctive of the second series lies with its treatment of the young girls themselves: although Karen and Tsukihi are introduced as the supposedly pivotal characters, they actually constitute relatively marginal screen presences. As kevo points out, "Karen and Tsukihi themselves are present enough to barely develop their own stories but absent during the actual climaxes and resolutions of their respective arcs. Both times, Koyomi and one of his allies goes to square off against the bad guy." Unsettling though this strategy might initially seem, it constitutes an effective way of throwing into relief the "family" dimension underlying the series as a whole as one of its implied leading threads. In this particular instance, the anime aims to show unequivocally that "Koyomi is unflinchingly devoted to protecting his sisters and acts as their proxy in dealing with their curses" (kevo). Furthermore, while *Nisemonogatari*'s key girls may often seem peripheral, they are by no means rendered uninteresting by their relative marginality. Kai emphasizes this

166

point in a pointedly jocular fashion: "the two sisters ... are actually quite a fun pair. I especially like Karen due to her passion for Justice, and for a middle schooler, she has an exceedingly good figure too. I can totally relate to Koyomi's doubts in regards to just who is the cuter girl" (Kai).

All in all, it could be argued that *Bakemonogatari*'s structure facilitates the ongoing insertion of disparate characters into the plot, thereby allowing both the drama and the writing to concentrate on different supernatural missions and different psychological ordeals as the series evolves. *Nisemonogatari*, by contrast, focuses on the vicissitudes of its two pivotal personae without allowing the characters from the first series much room for development — with the exception, arguably, of Koyomi himself due to both his preternatural abilities, which remain one of the anime's primary ingredients, and his intimate relationship with both of the afflicted girls. It is also worth stressing that *Nisemonogatari*'s emphasis on simply two key characters, while it provides its director with ample leeway for close analysis, does not swamp either the hearty appetite for witty dialogue or the opportunities for vibrant action in confrontational scenes which distinguished first series. Undeniably, in devoting considerable attention to the dramatization of the protagonist's somewhat peculiar relationship with his female siblings, *Nisemonogatari* repeatedly engages with some problematic facets of human sexuality, incestuous desire included. Even though some viewers might find these aspects of the drama potentially disturbing, it is crucial to appreciate that their import is regularly redeemed by their overall comical handling. No less importantly, they are made to seem quite justifiable as integral components of the anime's psychological dimension. In their lighter moments, they are rendered relevant to the franchise as a whole as opportunities for humor; in their duskier manifestations, conversely, they act as triggers for serious reflection.

In different ways, both *Bakemonogatari*'s and *Nisemonogatari*'s characters are repeatedly required to confront the supernatural at its most impenetrable and undiluted in the guise of myriad uncanny creatures — gods, ghosts, demons, and vampires among them. In so doing, they have no choice but to embark on perilous journeys of quasi-epic proportions even as they remain anchored to their familiar surroundings and the prosaic pursuits of the other humans around them. In the process, the ordinary world fluidly blends with the alternate reality of an interstitial or liminal realm: a region of numinous darkness which may only be perceived through

a commodious disposition to its elusive, and often distressing, whispers — and, even then, in a purely tentative fashion. In order to function in this split reality, the anime's personae must be willing not only to venture into an unknown domain — which would be challenging enough for most regular people — but also to acknowledge its deep shadows with generosity and humility. It is through this act of unconditional acceptance that alterity may come to be understood as an awakening companion or mentor rather than a crippling antagonist. Thus, *Bakemonogatari* and *Nisemonogatari* could be said to deploy the supernatural as a means of dramatizing the often painful rites of passage through darkness and mystery — St. John of the Cross' Dark Night of the Soul, as it were — which are integral to any genuine process of self-discovery and self-development.

By peopling their plots with preternatural entities, the two series convey a distinctive world view predicated on the idea that in order to approximate, if not exactly gain, an honest knowledge of the world, we must be willing to recognize and respect the invisible reality which coexists at all times with the domain of the visible. Concomitantly, both series intimate that while human beings are by and large powerless to interact with those spectral forces, they are also, for this very reason, subliminally drawn to them. As Maurice Blanchot remarks, "what haunts us is something inaccessible from which we cannot extricate ourselves. It is that which cannot be found and therefore cannot be avoided" (Blanchot, p. 11). *Bakemonogatari* and *Nisemonogatari* dramatize these deeply ingrained human preoccupations with implicit reference to the concept of otherness. In so doing, they draw attention to an inveterate human proclivity to demonize the Other as an imponderable, and hence fearful, entity. At the same time, they remind us that in spite of our demonizing attempts, the Other is crucial to the definition of the Self, to the extent that the Self is powerless to declare what it *is* independently of what it is *not*. The two series propose that as long as the Other is excluded as a threatening or polluting force, the Self is doomed to a fate of alienation or self-defacement, insofar as the Self cannot function healthily without the excluded party. Accordingly, *Bakemonogatari* and *Nisemonogatari* lay emphasis on the necessity of embracing the Other as instrumental in the creation and development of both personal and communal versions of identity. Both series intimate that for this strategy to be effective, the Self must not simply affect an ethically expansive attitude toward the demonized Other, while secretly seeking to

168

contain it or tame it for its own convenience. In fact, the Self's accepting gesture must be underpinned by humble and respectful recognition of the essential difference harbored by the Other as a reality in its own right.

While Shintō and several related mystical traditions play prominent roles in both *Bakemonogatari* and *Nisemonogatari*, it is crucial to appreciate that the characters' predicaments are never accounted for exclusively as supernatural phenomena as such — e.g., curses, possessions or hauntings — even though these popular ingredients of Japanese lore are frequently brought into play for dramatic effect. On the contrary, both anime consistently impart those occurrences with remarkable psychological verisimilitude, and a corresponding capacity to engage the mind and touch the heart, by relating them to the victims' emotional problems, traumas, and uncertainties, to the onerous mnemonic baggage produced by their exposure to both physical and psychological abuse, and to their vulnerability to daunting feelings of inadequacy and lack. Relatedly, a variety of unresolved emotional conflicts and identity crises underpin virtually all of the victims' ordeals. The aforementioned concept of the family, in particular, is often thrown into relief in *Bakemonogatari* as either the latent or explicit cause of far-reaching emotional disturbances. The girls' supernatural afflictions can therefore be regarded as metaphors for their human quandaries and grievances. The crab tormenting Hitagi and causing her absurd weightlessness, for instance, is said to be a *kami* by the expert Meme, but also personifies the emotional strife emanating from the girl's subjection to the horrors of parental neglect and sexual violation. Mayoi's status as a haunting ghost, and her subsequent promotion to the supposedly more elevated rank of a wandering ghost, are likewise rooted in an onerous legacy of familial discord. The devil hosted in Suruga's arm, in turn, can be seen as an apposite correlative for unresolved identity issues: an idea reinforced by the creature's power to destroy the girl's soul should the limb be used to fulfill desires motivated by vengeful or resentful urges. The demonic snake squashing Nadeko's life force, similarly, is the outcome of an amateurish attempt to dispel a curse, which can be interpreted as an act of blasphemous arrogance, and hence the sign of a vulnerable ego. Tsubasa's transformation into a *bakeneko*, or monster cat, is primarily the result of unrequited love, though the girl's portrayal also intimates that it might be a physical expression of the instinctive self which her adoption of the persona of the exceptionally efficient student has harmfully repressed.

As we move on to *Nisemonogatari*, the same metaphorical principle remains operational as a pivotal thematic thread. Thus, the fever tormenting Karen after she is stung by a particularly pernicious bee constitutes a simple but dramatically effective metaphor for the girl's ardently quarrelsome disposition. In Tsukihi's case, finally, the revelation that she is in fact a (fake) phoenix can be said not only to reflect the girl's mercurial behavior, but also to encapsulate a major aspect of the series as a whole: its concern with the pervasiveness of the phenomena of fakery, simulation and deception. Indeed, as Verdant observes in a review of *Nisemonogatari*'s finale, "throughout this series, we've been presented with many questions surrounding the idea of fakes and imposters, questions that no physical fight could ever resolve. However, the most important question of all was saved for this final episode: what is the value of a fake? In keeping with the theme of the series, nothing is safe from being revealed as a fake, not even the supernatural and immortal phoenix that resides inside Tsukihi. A fake phoenix, inside a fake sister " (Verdant). In this regard, it is important to understand the implications of the two series having received separate titles, instead of being simply designated as seasons one and two of the same anime, despite their intimate and obvious connection. As Kai explains, in both instances "the latter part of the phrases, '*monogatari*,' means 'tales.' It can then be easily seen that *Bakemonogatari* is a portmanteau of *bakemono* (monster) and *monogatari* (tales), and *Nisemonogatari* is a portmanteau of *nisemono* (a fake, imitation) and *monogatari* (tales)." This difference is instrumental in the achievement of a radical shift in tone, resulting in the second series' more pronounced emphasis on the concept of fakeness: "*Bakemonogatari* focuses more literally on the 'monsters' part of the series and while *Nisemonogatari* dealt with the 'monsters' part ... too," it is on the whole more concerned with the relationship "between real and fake," and with the "quality" of these conflicting concepts. "Needless to say, *Nisemonogatari* will have less monster-y plotlines and ... less action" (Kai).

Bakemonogatari's psychological subtext is tantalizingly intensified by the sequel's thematic and formal reorientations. Indeed, both of *Nisemongari*'s arcs make it incontrovertibly clear that the "fakes and imposters" mentioned in Verdant's review are not to be literally equated to the creatures that take over the heroine's identities, and hence lumber them with fake lives. In fact, the creatures only constitute the drama's surface, the

narrative façade. Far more vital is the extent to which those "creatures," in actually personifying problematic facets of the characters' personalities and experiences, are not so much fake beings in themselves as ways of showing that the characters' own lives are bound to be false — and hence unreal — as long they struggle to stifle or conceal their limitations and anxieties. The ultimate sham, in this perspective, is neither the supernatural entity apparently causing a character's troubles nor the identity she takes on as a result of her enslavement to an external agency. In fact, what triggers the accumulation of phonies and simulacra on which a significant part of the narrative is woven is the bundle of dormant, disavowed, or suppressed emotions which have been poisoning that character's life since infancy (or possibly, at least in one case, even earlier), and thus trapping her into a frustrating maze of misrecognition and self-deception. The "nature" explored by *Bakemonogatari* and *Nisemonogatari* through their personae's emotional ordeals is nature at its most fraught, tortuous and, in a sense, *unnatural*: in other words, it is *human* nature as it manifests itself when people become alienated from their shared roots in the authentic flow of existence, and strive instead to construct synthetic identities meant to protect them from the painful obligation to confront their inadequacies and fears.

It could be argued that from a rhetorical point of view, the idea of *imposture* finds a subtle expression in the dramatic circumstances which surround the genesis of irony: namely, a trope renowned (or perhaps notorious) for its knack of *imposing* an apparent, false, meaning upon an underlying, real, meaning. The word "irony" indeed originates in the Greek comic persona of the Eiron, a self-effacing character type who pretends to be stupid in order to outwit the character of the conceited impostor, known as the Alazon. The concept of Socratic irony which animates Plato's dialogues issues from this theatrical tradition: Socrates feigns ignorance and stupidity by asking apparently inane questions to which his interlocutors assume there to be perfectly obvious commonsensical answer as a means of demonstrating the fallacy of entrenched opinions to which people automatically subscribe out of regimentation, habit, or simply laziness. Irony courses *Nisemongatari* throughout at both the thematic and the stylistic levels. Irony is indeed what enables the series to build on *Bakemonogatari*'s knack of using potentially wacky supernatural events as a means of fathoming what are in fact very human nightmares, and to deploy disturbing

behavioral quirks to ludic ends. Moreover, irony is the animating force behind some of *Nisemonogatari*'s most affecting moments, where Koyomi discovers that he is capable of caring deeply for his sister Tsukihi regardless of whether she is a real girl or a simulacrum. Hence, the supreme irony with which the anime presents us is the proposition that a human being's genuine essence — his or her *quiddity* as it were — ultimately bypasses commonsense human understanding, exploding the laws of both classical logic and physics along the way. The art of anime itself, by suspending these same rules through its distinctive aesthetic, could be regarded as a tantalizing metaphor for that elusive essence.

In all its expressions, space shapes human experience at both the corporeal and the mental levels, at times allowing us to interact directly with its materials, and at others engaging us abstractly by means of emblems and mental images. As artifacts, *Bakemonogatari* and *Nisemonogatari* offer us virtual places which cumulatively encourage the emergence of meanings and experiences in which the actual and the fictional smoothly coalesce. When their everyday worlds intersect with the supernatural, which they do with equal doses of persistence and passion, the scope for constructing hypothetical places in which reality and fantasy meet grows astronomically. Both reality and the self are here approached as incessant work-in-progress: as processes defined by the physical and affective dialogue which human characters conduct with disparate spaces and places as they alternately strive to settle and to move on, to belong and to "ex-ist." *Bakemonogatari* and *Nisemonogatari* exuberantly remind us that where the supernatural is concerned, the urge to voyage is ultimately more vital an attribute of this dimension's denizens than the urge to strike roots. The supernatural, in other words, is the illimitable realm of the perpetual wanderer. Unleashing legion life forms that tease or defy human comprehension, let alone control, *Bakemonogatari* and *Nisemonogatari* also call upon the bond between nature and the supernatural as a means of questioning with gusto the anthropocentric and anthropomorphic leanings inherent in the humanist perspective. By giving life to entities which irreverently escape classification in ordinary scientific terms, the universe articulated in the two series teems not solely with *things* but also with *non-things*: the elusive beings which people the gaps between any two recognized categories, and thus expose the uncertainty of the boundary between presence and absence. While, as Edmund Leach points out, the "taboo inhibits the recognition of those

parts of the continuum which separate the things" (Leach, p. 47), the supernature depicted in *Bakemonogatari* and *Nisemonogatari* asks us to recognize the life that dwells on the borders and in the interstices, and therefore enjoins us to confront the "taboo" as an ironical source of both attraction and aversion.

At the same time as they seek to offer a dispassionate analysis of their characters' actions, motivations, and inner specters, *Bakemonogatari* and *Nisemonogatari* seek to embody these thematic elements in their form. Thus, the stories' introspective import comes to be written on their textual body no less than on the bodies and psyches of their personae. Both series bear eloquent witness to the studio's preference for stylized art: they therefore bear clear affinities, from a formal perspective, with another title also produced by Shaft, and here examined in the previous chapter, *Puella Magi Madoka Magica*. Their palettes and background art tend to complement a scene's prevalent mood, while the settings, though punctiliously detailed, never get so crammed with objects as to impede the eye's journey from frame to frame. In addition, both *Bakemonogatari* and *Nisemonogatari* repeatedly relinquish full animation in favor of monochrome drawings, pictures akin to clippings from an artist's sketchbook or to a child's crayon scrawls, and a heady assortment of scribbles, doodles and squiggles of disparate hues. In addition, certain scenes are almost entirely desaturated, the only touches of color being reserved for symbolic objects meant to stand metonymically for a character's emotional affliction. With the further addition of collages, which combine what looks like clippings from actual photographs and newspaper articles, the two series yield a genuinely intriguing mélange of disparate visual media. Furthermore, Shaft's distinctive proclivity to lay bare the devices deployed in the construction of the visual narrative by means of both conventional and cutting-edge techniques renders the anime a pointedly self-referential exercise. This aspect of both series is further reinforced by the assiduous use of snippets of interior monologue, occasionally invested with a captivating stream-of-consciousness flavor.

Shaft's style indubitably has its critics, as tersely demonstrated by M0rg0th's review of *Bakemonogatari*. "As for this series," states M0rg0th, "I would classify the Shaft-y bits in three categories in terms of what they intend to do: 1. Setting the atmosphere of a scene. 2. Characterizing a character's mood visually. 3. Apparently nothing.... Most of the instances connected to three are the so-called 'Unnumbered cuts' that come in vari-

ations of colour (black and red mostly) and just appear in place of a scene or interrupt a scene hinting at what's supposed to happen on screen. At the start it is still an ... 'interesting' way to dictate a pacing in terms of scene-structure. Later, though, the usage of these 'unnumbered cuts' gets excessive and when a scene is visually interrupted not by one unnumbered cut but by two then it oversteps the boundary of being unique and goes into the territory of 'forgetting what they actually try to do.'" A strictly functionalist approach to the display of technical expertise is bound to regard Shaft's tendency to punctuate the action with scenes which neither advance the plot in any way, nor contribute explicitly to character development, as gratuitous addenda. However justifiable this critical attitude may be, it does not take adequately into account the studio's aesthetic vision. For Shaft — as for traditional Japanese aesthetics — the creative *process* far exceeds in importance the finished *product*: it is therefore entirely logical for its anime to accommodate images which do not aim to ensure the artifact's steady march toward completion, but rather honor at leisure the ethos of "art for art's sake." The scenes bemoaned by M0rg0th are disarmingly autotelic — they aim to give pleasure to both their recipients and their creators as innocent and exuberantly open-ended *ends in themselves*. The argument here pursued takes respectful cognizance of the fact that Shaft's approach is by no means an object of universal acclaim among anime fans. Nevertheless, it proposes that the studio's controversial style never really smacks of self-gratifying or self-indulgent posturing. In fact, its penchant for formal experimentation is consistently channeled into an intelligent assessment of both the powers and the limitations inherent in the art of anime, and attendant explosion of all manner of established formulae. M0rg0th concludes the argument with a rhetorical question which makes it incontrovertibly clear that for this reviewer, Shaft's approach is ultimately more a hindrance than an advantage: "it's nice and all to have an unique animation-style but if it gets in the way of the animation itself?" (M0rg0th). It could be argued, however, that the studio's idiosyncratic strategies doe not actually "get in the way of the animation" but rather throw into relief its status as an art form. They thus deliver a form of metadrama, or metatheater, with the power to remind us that following the laws of nature is a noble pursuit, but following the laws of art is ultimately what turns an anime into a thought-provoking art object rather than a thoughtless attempt at mimetic accuracy.

3. Nature

It is also worth noting, for the sake of contextual accuracy, that Shaft has made use of analogous visual strategies in other anime likewise concerned with the mapping of affective rites of passage and journeys of self-discovery. Most notable, in this regard, are *ef—a tale of memories* and *ef—a tale of melodies*, two TV series directed by Shin Ōnuma, and aired in 2007 and 2008 respectively. In both instances, Shaft posits the art of animation itself as a decisive component of the series' narrative content through assiduous formal play and technical adventurousness, interspersing the regular footage with black-and-white frames, hand-drawn sketches, character silhouettes within which parts of the environment seem to flow unrelentingly, stylized renditions of natural motifs such as snowflakes and raindrops, ingeniously edited photographs, and frequent shots of a sky in constant motion enriched by a variety of tactile textures. Solarization, color separation and desaturation are concurrently utilized in order to enhance the dramatic import of the more suggestive scenes, while many backgrounds and props, by contrast, are executed with photorealistic accuracy. These techniques are accompanied by many daring cinematographical gestures, including unusual framing, the insertion of ostensibly random frames and off-kilter camera angles, as well as strategies which emulate live-action filming, such as frequent rack focuses and jump cuts. In *ef—a tale of memories*, some of the more memorable moments are those offering a stylized record of the heroine's creative struggle in the face of a major neurological impairment. In these scenes, the background fills with swirling fragments of sentences, as well as individual typographical items in disparate fonts, which are by turns superimposed, assembled and disassembled across the screen. In some of the scenes devoted to the story which the girl is striving to write, extensive portions of text scroll over the background, cut through the images or flash intermittently through the frames. Like the first series, *ef—a tale of melodies* announces its technical boldness unequivocally, using all of the strategies already found in *ef—a tale of memories*, alongside collages which integrate full-color frames, monochrome cut-outs and textual components. From an aesthetic point of view, one of the scenes in *Bakemonogatari* where Shaft exhibits its experimental genius most poignantly is the one recording Hitagi's physical violation. The stylized representation of the supine body, which is tastefully portrayed as an anonymous entity rather than the girl's own physique, conveys an unsettling feeling of vulnerability and utter powerlessness. The likewise stylized graphic motifs

175

surrounding the body consolidate this impression with crisp symbolic relevance. This sequence finds an intriguing parallel in an image used recurrently in the series *Shigofumi: Letters from the Departed* (dir. Tatsuo Satō, 2008)—a work produced by a studio renowned, like Shaft, for its stylistic adventurousness: i.e., J. C. Staff. The shot in question is also used to encapsulate the unpalatable topos of a young woman's sexual abuse, and consists of the stylized image of a nude female body inscribed all over with typographic characters to intimate that the palimpsest of traumatic memories left by the girl's ordeal constitutes a physical reality unto itself.

In *Bakemonogatari* and *Nisemonogatari*, colors are employed with explicitly symbolic intent. This is most patently borne out by the use of shots in which the screen is entirely flooded by a uniform expanse of a particular hue, often accompanied by its name. Most prominent throughout are red and black, followed by yellow, green, blue, orange, and pink. Given the prominence granted to red and black throughout the anime— also noted in the M0rg0th review cited earlier—these two hues deserve special consideration in the present context. In the anime's world picture, red retains the symbolic connotations it has held for centuries in the context of traditional Japanese culture. As Cassandra Mathers explains, it is an inherently "powerful colour ... representing strong emotions rather than ideas. As the colour of the sun in Japanese culture and on the Japanese flag, red is the colour of energy, vitality, heat, and power. Red also represents love and intimacy, including sexual desire and the life force and energy in people." The anime's use of black, in turn, reminds us that "traditionally, black has represented death, destruction, doom, fear and sorrow. Especially when used alone, black represents mourning and misfortune." Despite its sinister connotations, however, black has concurrently been accorded a privileged position in Japanese culture by virtue of its association with "formality, and has increasingly come to represent elegance, with the growing popularity of Western conceptions of black tie events" (Mathers). In the anime itself, black is not only exploited to convey a pervasive sense of mystery, which would be quite predictable given the anime's generic affiliations, but also brought into play in subtle ways in order to evoke a sense of solemnity, either in a serious vein or in the service of irony. Above all, it could be argued that black is the most crucial hue in the anime's palette because it encapsulates one of the key philosophical lessons pivotal to both *Bakemonogatari* and *Nisemonogatari* (and examined

earlier in the discussion): namely, the proposition that without a generous disposition toward darkness, no real knowledge of either the self or its natural environment can ever be attained. It is worth recalling, on this point, that in the context of traditional indigenous aesthetics, light — and the related notions of illumination, radiance, and brightness — have no meaning until they are brought into relief by the austere tenebrosity of black. Black is the symbol of the arcane depths which daylight existence must revere if it is to interact harmoniously within its own activities, rhythms and cycles — it is no coincidence, in this regard, that Japanese culture should have elected it as the apposite hue to accompany both traditional funerals and weddings.

Finally, it is worth noting that virtually all of the "shades of beauty" examined earlier in this chapter are embodied in the two series' aesthetic vision. *Kawaii* has a role to play in the depiction of practically all of the heroines pivotal to the various arcs, Mayoi being its most classic embodiment simply by virtue of her age. In addition, and more surprisingly perhaps, some imaginative touches of *kawaii* are also used to enliven the physiognomies of both of the principal male characters, Koyomi and Meme. At the same time, the anime's passion for detail is borne out by the infusion of *kawaii* elements not merely into the actual personae's physiques but also into numerous props, fashion articles, and accessories — e.g., Mayoi's backpack, an item which many young viewers (and perchance a few older ones too!) would undoubtedly be quick to place near the top of a fluffy wish list. Both *Bakemonogatari* and *Nisemonogatari* concurrently pay homage to the time-honored principle of *fūryū*, both as a signifier of stylishness, as tends to be the case in contemporary Japanese culture, and as the embodiment of supreme refinement, as was the case within the aesthetic parameters promulgated by Heian civilization. *Shibui* concomitantly features as an important trait of the franchise's overall aesthetic as a restrained solemnity starkly opposed to ritualized pomp: the ceremonial moments in which Meme endeavors to appease the tormenting spirits, and hence help the affected characters come to terms with their buried conflicts, epitomize this interpretation of *shibui* at its most poignant. Finally, both *yūgen* and *yūdai*, as alternate encapsulations of the concept of sublimity, find original expression in the memorable sequence, referred to earlier in this discussion, in which Hitagi presents Koyomi with a starry sky of breathtaking beauty, thus communicating the anime's underlying ethical

message as one of candor and hope in the face of the world's ubiquitous fakeries.

Children Who Chase Lost Voices from Deep Below (movie, dir. Makoto Shinkai, 2011)

Any viewer familiar with Studio Ghibli's globally acclaimed output, and specifically with the works that have issued from Miyazaki's undisputed genius, will rapidly recognize the inspirational imprint of some of their most eminent titles within the aesthetic vision animating Makoto Shinkai's latest endeavor. Kurt Halfyard highlights this proposition, arguing that "Shinkai seems to have found a lot of inspiration in the collective work of Studio Ghibli," and noting that it is not unusual for "people ... to compare *Hoshi* to *Laputa* [*Castle in the Sky*] (for very obvious reasons)." Halfyard himself adds "*Mononoke Hime* [*Princess Mononoke*] to that equation. When you combine the adventures of a young kid guided by a mysterious crystal with the guardians of the world you get awfully close to the synopsis of Shinkai's latest" (Halfyard). The crystal motif is indeed also central to Miyazaki's *Laputa: Castle in the Sky* (1986), whereas the world guardian topos recalls the same director's *Princess Mononoke* (1997). As the present discussion unfolds, supplementary analogies linking Shinkai's aesthetic to Studio Ghibli will be suggested. Shinkai himself has commented on his debt to Miyazaki's opus in the course of an interview conducted by *activeAnime* following the release of his blockbuster *The Place Promised in Our Early Days*:

> **Active Anime:** You have been referred as the New Miyazaki, what are you thoughts on that?
>
> **Makoto Shinkai:** Its an honor to hear, but I think the comparison is an overestimation. I myself am very influenced by Hayao Miyazaki, but his works have an incomparable richness that is not the same "animation" as my animation. I certainly won't create such wonderful works in my future. However, I would like to deliver works that have a different place with audiences than the place of Hayao Miyazaki's films [Shinkai 2005].

Scott Speziani's comments on the subject of Shinkai's debt to Miyazaki's oeuvre also deserve consideration at this juncture, insofar as

they pose an intriguing question about the director's current place in the ever-shifting galaxy of Japanese animation: "Makoto Shinkai has been called the next Hayao Miyazaki, for good reason. In his newest work he creates an adventure narrative in the vain of the greatest of Miyazaki's films, a departure from his extremely emotional love stories. By making a Ghibli-esuq [*sic*] film he is making a direct challenge to the master of Japanese animation but is it too early for him to be making such bold declarations or is this Shinkai clearly declaring his rightful place in the animation world?" (Speziani).

Whichever stance one might ultimately adopt toward Shinkai's relationship with either Miyazaki himself or Studio Ghibli as a whole, there can be little doubt that in *Children Who Chase Lost Voices from Deep Below*, Shinkai simultaneously elaborates his own independent aesthetic by chronicling the adventures of a solitary girl named Asuna as she strives to trace a mysterious boy known as Shun, who one day materializes out of the blue to rescue her from a portentous creature, and soon after vanishes from Asuna's world. What Shinkai thereby delivers is a multilayered quest which is as much a tale about love and longing as it is a myth-encrusted saga about indigenous lore and its underlying aesthetic values. As Catherine Munroe Hotes observes, this tantalizing blend ensures that *Children Who Chase Lost Voices from Deep Below* is "on the one hand the moving story of a lonely girl's quest to make sense of the world she is living in. On the other hand, for the viewer it is a philosophical journey into the realms of the possible. Although there is some influence of the Orpheus myth, the ideas in this film largely come from Shintō, Buddhist, and even some Sanskrit thought, with the medicine man reminding us that while it is normal to grieve the dead, we should not pity them for the cycle of life and death is a natural one" (Munroe Hotes).

While it indubitably delivers a tantalizing adventure and a fascinating insight into a rich body of lore, *Children Who Chase Lost Voices from Deep Below* is likely to abide in memory first and foremost as a beautifully crafted vision of nature pregnant with both budding hopes and the tenacious phantoms of loneliness and loss. This aesthetic achievement could never have been accomplished without Shinkai's uncommonly sensitive approach to nature, regardless of his technical skills — consummately sophisticated though the movie is at the levels of animation, special effects, and the seamless integration of traditional and cutting-edge technologies of visu-

alization and vision. As the most salient attribute of the film's aesthetic, Shinkai's attitude to the natural environment pervades its entire diegesis. It is indeed immediately evident in the early sequences in which the heroine is seen running through forests and up rocky hills, amid majestic mountains covered in a plethora of typically Japanese trees and shrubs, on her way to the den where she keeps, among a few victuals and books, the precious crystal set which enables her to communicate with worlds unknown. The distinctive mood set up by *Children Who Chase Lost Voices from Deep Below* in the drama's inceptive stages continues to imbue, now with the addition of a generous dose of rapid-fire action, the decisive scenes in which the Arch Angels — a faction which has been seeking out the road to the nether-world (i.e., the land of Agartha) with the intention of appropriating its legendary wealth and wisdom — open up a gateway to that region with the aid of a magical crystal dubbed a "clavis," and the young protagonist decides to follow them driven by her own pure thirst for the unknown. Nature goes on playing a pivotal role in the sequences focusing on the ini-tially fraught interaction between the newcomers and the underworld's native people, reaching its visual apotheosis in the climactic moments dramatizing the heroine's brave return to the ordinary human world as an undoubtedly wiser, and most likely also sadder, girl. It is at this point that one can fully appreciate the movie's aesthetic value, as its drama's affective strands gain unprecedented momentum at the same time as Shinkai's unique vision expresses itself in its outstanding melancholy glory. Shinkai himself has explained that his attraction to the natural environment and its translation into cinematic images is inseparable from his memories of puberty as a time fraught with anxieties and doubts which could only be relieved by meticulous attention to the world around him: "I feel that I was always saved by the beauty of the scenery. I clearly remember that I used to look outside from the train every day not to miss a thing because there was always something to note. So I'm constantly wanting to put such feelings into the movies" (Shinkai 2006).

From an aesthetic point of view, it is also vital to appreciate that Shinkai's attention to detail is not purely confined to his loving depiction of the natural environment in its minutest and most elusive facets. On the contrary, it consistently extends to the representation of the action's inte-riors, as borne out by settings as diverse as the kitchen in the protagonist's family home, with its meticulously rendered shelves and cupboards accom-

modating all manner of cooking equipment and colorful comestibles, the school's traditional classrooms and enticingly musty library, and the treasure house embedded in the private study in which Asuna's mentor cultivates zealously his scholarly pursuits. This particular venue deserves special attention, insofar as the myriad books, antiques and august implements it hosts offer at once a mesmerizing phantasmagoria of crosscultural allusions charged with disparate aesthetic implications, and a palimpsest in which the traces of the old stories erased to make room for new theories and beliefs remain forever perceptible, albeit subliminally, as enduring and awe-inspiring influences. The mood surrounding these images is at times redolent of the atmosphere found in some of Studio Ghibli's most inspiring interiors — e.g., the dreamlike shopping arcade in Yoshifumi Kondo's *Whisper of the Heart* (1995), and the magician's chamber in Miyazaki's *Howl's Moving Castle* (2004). Likewise notable are the interiors devoted to the civilization of Agartha: a tantalizing mélange of echoes from Miyazaki's *Nausicaä of the Valley of the Wind* (1984), especially in the architectural and vestimentary domains, and legion Pre-Columbian influences. The latter are corroborated by the film's explicit references to Quetzalcoatl — the feathered serpent of mesoamerican tradition symbolically associated with death and resurrection, as well as both fertility and warfare depending on the specific cultural context in which the deity occurs; in the film itself, "Quetzalcoatls" are keepers of the dead.

Shinkai's approach to the portrayal of nature — and, by extension, also to the representation of human-made locales — pivots on the director's seemingly intuitive flair for oneiric landscapes. This is most palpably borne out by the film's breathtaking sunsets and sunrises, sublime storms and angry oceans, gently rolling hills and forbidding mountain ranges, as metamorphic locales in which each image seems constantly in the process of spawning a new image as the light shifts across the landscape, and colors alter accordingly in its wake. With such images, Shinkai effectively allows nature itself to take over the role of narrator: a wordless and immortal storyteller whose narrative effectiveness could never be matched by even the most proficient of human chroniclers or thespians. Moreover, Shinkai punctuates his unique vistas with painstakingly designed edifices and legion accessories, at times allowing the natural and artificial portions of the habitat to coalesce harmoniously, and at others capitalizing on chromatic and textural divergences as a means of contrasting them with economical non-

chalance. With his vision of space as a metamorphic dimension which intersects continually with the temporal axis along which its transformations take place, Shinkai conceives of the demarcations imposed by both nature and architecture as no more than provisional margins —fluid boundaries which do not contain space so much as accommodate its transmutations in the way a multipurpose experimental stage would feasibly accommodate a play's diverse settings within its scope. The metamorphoses undergone by Shinkai's space are themselves impermanent, ambiguous, and wholly conditional on each individual viewer's personal perception of that space: a perception which may well alter over time, even for one and the same spectator, as different viewing experiences yield variable impressions, and hence trigger disparate chains of metaphorical associations. The aesthetic of Shinkai's dreamlike sceneries does not simply bear witness to specific stylistic and formal predilections: on the contrary, it also — and, ultimately, far more crucially — acquaints us with an ethical attitude to the so-called real world which proposes that *all* forms are inexorably implicated in an relentless and irreversible process of change.

It is once again worth stressing that the director's care for details is everywhere palpable: whether the focus is on a falling raindrop, on a shred of fleecy cloud, on a lush tapestry, on a boiling pot, on a rusty pipe, or else on gigantic structures and towering preternatural creatures, Shinkai's appetite for delicate minutiae never abates. This invests *Children Who Chase Lost Voices from Deep Below* with almost photorealistic density without, however, pandering to documentary verisimilitude for its own sake, and thus sacrificing creativity to credibility: a temptation to which much photorealistic cinematography of the purely reportorial ilk is often vulnerable. Accuracy never becomes an end in itself for the reason that Shinkai's agenda is incessantly sustained by an unflinching desire to throw into relief the emotional and psychological connotations of his palpably pictorial tableaux. This aesthetic propensity, in fact, is sometimes so marked as to lead to the impression that the director's camera is more eager to shoot in the service of atmosphere than in that of plotting. This impression is reinforced by the assiduous deployment of lighting effects on a par with live-action cinematography at its most proficient as a means of bolstering the realism of the visuals. At the same time, as Speziani aptly points out, the director's "subtle use of visual narrative gives the audience a ton of information through quick visuals or background noise" (Speziani). The

minute details with which Shinkai's regales the eye in virtually every scene often seem to glow with a melancholy inner flame, and thus contribute vitally, though silently, to the film's evocation of a pervasive sense of irretrievable loss. While their flimsiness points to the ephemeral nature of human reality at large, their radiance imbues that feeling of transience with a lyrical nostalgia redolent of *mono no aware* at its subtlest. The spirit of *mono no aware* informs the story more personal dimension by instilling its vicissitudes with an intimate and poignant feel of all-pervasive yearning, and thus elevates Asuna's private quest to the level of a sustained meditation on human impermanence at large. At the same time, *mono no aware* also infuses the plot's cosmic strands by couching the journey as a panoramic glance across an imaginary gallery of forgotten artifacts, mementoes and relics evocative of the genius of archaeology at its most wistfully romantic. In addition, in following the exploits of Asuna and her companions as they explore Agartha, *Children Who Chase Lost Voices from Deep Below* offers an original interpretation of *yūgen* as the very essence of that magical Beyond which seems to transcend human reality, on the one hand, and yet is incessantly at work just below its manifest surface, on the other.

With its distinctive version of the aesthetics of both *mono no aware* and *yūgen*, Shinkai's latest movie yields a thoughtful treatment of the related themes of separation, loss and insatiable longing. Already tackled by Shinkai in the OVA *Voices of a Distant Star* (2002), further utilized as the fulcrum of a concurrently personal and sociopolitical saga in feature-length production *The Place Promised in Our Early Days* (2004), and finally employed as the very essence of the three interconnected stories which form the film *5 Centimeters Per Second* (2007), those themes gain fresh resonance with *Children Who Chase Lost Voices from Deep Below*. As intimated, the film delivers a fantasy tale of epic proportions, weaving a mesmerizingly allusive tapestry in which the anguish attendant on irretrievable loss is at all times intertwined with a bittersweet recognition of waning youth, on the one hand, and a brave search for love, hope and purpose, on the other. At the same time, the film's philosophical dimension provides an original interpretation of nature in which the director's established cachet intersects consistently with both traditional Japanese aesthetics and a vast body of indigenous legends. This aspect of the movie revolves around two distinct attitudes to nature: the child's and the adult's. With its preteen heroine, *Children Who Chase Lost Voices from Deep Below* portrays the

child's ability to experience nature with eyes unclouded, highlighting the value of innocence and spontaneous curiosity in a fashion which elliptically evokes the lessons of Zen. With the character of Asuna's teacher, Morisaki, the movie examines the typical adult's perception of nature through eyes veiled by experience and sorrow, which inevitably results in calculated and biased conduct. Even though some viewers would argue that by comparison with his settings and background art, Shinkai's personae tend to come across as somewhat plain and impersonal, characterization is actually a key aspect of film's overall aesthetic. Its effectiveness, however, does not depend so much on conventional criteria — such as appealing looks, outlandish garb, or endearing quirks — as on the director's knack of defining his actors in relational terms, allowing their distinctive personalities to emerge from the action's interpersonal dynamics, and from ethical contrasts like the one just outlined.

An exceptionally knowledgeable and versatile scholar, Morisaki could no doubt have found ways of channeling his expertise into a salutary — though no longer innocent — study of nature, had he not been driven to fathom the netherworld of Agartha by an insane desire to resurrect his late wife. As things stand, Morisaki's manic single-mindedness is so absorbing and soul-consuming as to turn him into a callous exploiter. As Speziani points out, the teacher, whose "obsession" can effectively be regarded as "the driving force of the film," is so starkly and monolithically presented as to come across as "a flat obsessive villain," even though his predicament could potentially have paved the way to his portrayal as "a rich, sympathetic character." This cumulative impression owes much to Shinkai's unsentimental presentation of Morisaki's unquestioning preparedness to "endanger a young girl, recruit a group of commandos, and recklessly journey across a dying world on foot" to accomplish his personal goal. This aspect of Shinkai's approach to characterization contributes vitally to the communication of the film's ethical message, positing *Children Who Chase Lost Voices from Deep Below* as "an extended metaphor for grief, the process of overcoming the death of a love one and what happens when someone isn't able to let go" (Speziani). According to Munroe Hotes, in its engagement with ancient indigenous lore, *Children Who Chase Lost Voices from Deep Below* harks back to "Japanese creation mythology." As the critic reminds us, in this venerable corpus of cosmogonic tale, "it is said that the female deity Izanami dies and goes to Yomi — the 'shadowy land of the dead.'

The male deity Izanagi goes after her and tries to bring her back to the land of the living." Readers familiar with the West's classical heritage will be quick to recognize that this foundational Japanese myth bears several affinities with one of the most popular Greek legends: the story, already alluded to earlier in this analysis, of "Orpheus and his wife Eurydice" (Munroe Hotes). In its treatment of legendary allusions, no less than in its magisterial handling of details, *Children Who Chase Lost Voices from Deep Below* finally reverberates with the crystalline purity of the traditional *haiku* at its best, and thus attests incontrovertibly to Shinkai's aesthetic preference for a mindful and non-proprietorial assessment of the natural world. In so doing, it pays homage to the principle of *karumi* as a proclivity to glide innocently over the surfaces of the visible in pursuit of a clarity of vision untainted by judgmental bias.

MASAO WATANABE ON THE CONCEPTION OF NATURE IN JAPANESE CULTURE

This love of nature has resulted in a refined appreciation of the beauty of nature in, for example, landscapes, miniature gardens (hakoniwa), miniature trees (bonsai), flower arrangement (ikebana), the tea ceremony (chanoyu), short poems called haiku, and even the art of cookery. Nature for the Japanese has not traditionally been an object of man's investigation or of exploitation for human benefit, as it has been for Westerners. For the Japanese and for other Oriental peoples, man was considered a part of nature, and the art of living in harmony with nature was their wisdom of life.... To a Chinese or a Japanese, drinking tea and eating food are not merely matters of nourishment or of meaningful companionship, they are also considered occasions for artistic appreciation of nature. Therefore, the landscape you look at while eating, the room in which you serve your meal, as well as the tableware you use and the food itself, must suit your attitude. This appreciative attitude toward nature has been a central theme of people's lives in Japan. — Watanabe, Masao, p. 279

Filmography

Primary Titles

Another (TV series, dir. Tsutomu Mizushima, 2012)
Bakemonogatari (TV series, dir. Tatsuya Oishi, 2009)
Bokurano (TV series, dir. Hiroyuki Morita, 2007)
Children Who Chase Lost Voices from Deep Below (movie, dir. Makoto Shinkai, 2011)
Guilty Crown (TV series, dir. Tetsuro Araki, 2011)
Millennium Actress (movie, dir. Satoshi Kon, 2001)
Mushi-Shi (TV series, dir. Hiroshi Nagahama, 2005)
Natsume's Book of Friends (TV series, dir. Takahiro Omori, 2008, 2009, 2011, 2012)
Nisemonogatari (TV series, dir. Tomoyuki Itamura, 2012)
Ouran High School Host Club (TV series, dir. Takuya Igarashi, 2006)
Puella Magi Madoka Magica (TV series, dir. Akiyuki Shinbō, 2011)

Additional Titles

Clannad (TV series, dir. Tatsuya Ishihara, 2007)
D. C.— Da Capo (TV series, dir. Nagisa Miyazaki, 2003)
ef—a tale of melodies (TV series, dir. Shin Ōnuma, 2008)
ef—a tale of memories (TV series, dir. Shin Ōnuma, 2007)
Fafner (TV series, dir. Nobuyoshi Habara, 2004)
The Familiar of Zero (TV series, dir. Yoshiaki Iwasaki, 2006)
Familiar of Zero F (TV series, dir. Yoshiaki Iwasaki, 2012)
The Familiar of Zero 2: The Knight of the Twin Moons (TV series, dir. Yuu Kou, 2007)
The Familiar of Zero 3: The Princess's Rondo (TV series, dir. Yuu Kou, 2008)
Five Centimeters Per Second (movie, dir. Makoto Shinkai, 2007)
Ghost in the Shell 2—Innocence (movie, dir. Mamoru Oshii, 2004)
Gunbuster (OVA, dir. Hideaki Anno, 1988)
Howl's Moving Castle (movie, dir. Hayao Miyazaki, 2004)
Laputa: Castle in the Sky (movie, dir. Hayao Miyazaki, 1986)
Lum the Forever (movie, dir. Kazuo Yamazaki, 1986)

Magic Knight Rayearth (TV series, dir. Masami Obari, 1994–1995)
Magic Knight Rayearth 2 (TV series, dir. Toshihiro Hirano, 1995)
My Neighbor Totoro (movie, dir. Hayao Miyazaki, 1988)
Nausicaä of the Valley of the Wind (movie, dir. Hayao Miyazaki, 1984)
Neon Genesis Evangelion (TV series, dir. Hideaki Anno, 1995–1996)
Only Yesterday (movie, dir. Isao Takahata, 1991)
Petite Cossette (OVA series, dir. Akiyuki Shinbō, 2004)
The Place Promised in Our Early Days (movie, dir. Makoto Shinkai, 2004)
Princess Mononoke (movie, dir. Hayao Miyazaki, 1997)
Princess Tutu (TV series, dir. Junich Satō, 2002)
RahXephon (TV series, dir. Yutaka Izubuki, 2002)
Sailor Moon (TV series, dir. Junichi Satō, 1992–1993)
Shigofumi: Letters from the Departed (dir. Tatsuo Satō, 2008)
Spirited Away (movie, dir. Hayao Miyazaki, 2001)
The Tale of Genji (TV series, dir. Osamu Dezaki, 2009)
Tsubasa: Spring Thunder (OVA, dir. Shunsuke Tada, 2009)
Voices of a Distant Star (OVA, dir. Makoto Shnkai, 2002)
Whisper of the Heart (movie, dir. Yoshifumi Kondo, 1995)
X (movie, dir. Rintaro, 1996)
xxxHOLiC (TV series, dir. Tsutomu Mizushima, 2006)
xxxHOLiC: Kei (TV series, dir. Tsutomu Mizushima, 2008)
xxxHOLiC Rou (OVA, dir. Tsutomu Mizushima, 2010)
xxxHOLiC Rou Adayume (OVA, dir. Tsutomu Mizushima, 2011)
xxxHOLiC: Shunmuki (OVA, dir. Tsutomu Mizushima, 2009)
xxxHOLiC the Movie: A Midsummer Night's Dream (movie, dir. Tsutomu Mizushima, 2005)
Yami to Bōshi to Hon no Tabibito (TV series, dir. Yuji Yamaguchi, 2003)

Bibliography

"Aesthetics in Japanese Art." 2003. *Things Asian*. http://www.thingsas ian.com/stories-photos/2351.

Ames, R. T. 1995, "*Bushidō*: Mode or Ethic?" In *Japanese Aesthetics and Culture: A Reader*," edited by N. G. Hume. Albany: State University of New York Press.

Ando, T. 2000. "What is *Wabi-Sabi*?" http://nobleharbor.com/tea/chado/ WhatIsWabi-Sabi.htm.

Ando, T. 2007. "The Conflict Between Abstraction and Representation." In A. Isozaki, T. Ando and T. Fujimori, *The Contemporary Tea House: Japan's Top Architects Redefine a Tradition*. Tokyo: Kodansha.

Antariksa. 2000. "Space in Japanese Zen Buddhist Architecture." *DIMENSI TEKNIK ARSITEKTUR*, vol. 29, no. 1, July, pp. 75–84. Jurusan Teknik Arsitektur, Fakultas Teknik Sipil dan Perencanaan — Universitas Kristen Petra.

Ashkenazi, M. 2003. *Handbook of Japanese Mythology*. Oxford: Oxford University Press.

"Asymmetry and Emptiness: Lessons from the Tearoom." 2010. http:// www.presentationzen.com/presenta tionzen/2010/06/ephemerality-vaca ncy-asymmetry-lessons-from-the-tearoom.html.

Avella, N. 2004. *From Woodblock and Zen to Manga and Kawaii*. Hove, East Sussex: RotoVision.

Bamboo Dong. 2012. "The Stream — The Killing Fields." Anime News Network. http://www.animenewsne twork.co.uk/the-stream/2012-03-20.

Baroni, H. J. 2001. *The Illustrated Encyclopedia of Zen Buddhism*. New York: Rosen.

Bashō, M. 1994. From *Anthology of Japanese Literature: From the Earliest Era to the Mid-Nineteenth Century*, edited by D. Keene. New York: Grove.

Bazzano, M. 2002. *Zen Poems*. Illustrated by André Sollier. London: MQP.

Bertschy, Z. 2012a. "*Puella Magi Madoka Magica—*_Limited Edition Blu-ray Volume 1." *Anime News Network*. http://www.animenewsne twork.co.uk/review/puella-magi-madoka-magica.

Bertschy, Z. 2012b. "*Puella Magi Madoka Magica—*_Limited Edition Blu-ray Volume 2." *Anime News Network*. http://www.animenewsnet work.co.uk/review/puella-magi-madoka-magica/limited-edition-blu-ray-vol-2.

Bertschy, Z. 2012c. "*Puella Magi*

Madoka Magica—_Limited Edition Blu-ray Volume 3." *Anime News Network*. http://www.animenewsnetwork.co.uk/review/puella-magi-madoka-magica/vol-3.

Blanchot, M. 1982. "The Two Versions of the Imaginary." In *The Space of Literature*. Trans. A. Smock. Lincoln: Nebraska University Press.

Blocker, H. G., and Starling, C. L. 2001. *Japanese Philosophy*. Albany: State University of New York Press.

Borges, J. L. 1970. *Labyrinths*. Harmondsworth: Penguin Books.

Calza, G. C. 2007. *Japan Style*. London: Phaidon.

Carver, N. F., Jr. 1984. *Japanese Folkhouses*. Kalamazoo, MI: Document.

Cavallaro, D. 2009a. *The Art of Studio Gainax: Experimentation, Style and Innovation at the Leading Edge of Anime*. Jefferson, NC, and London: McFarland.

Cavallaro, D. 2009b. *Anime and Memory: Aesthetic, Cultural and Thematic Perspectives*. Jefferson, NC, and London: McFarland.

Cavallaro, D. 2011. *The Fairy Tale and Anime: Traditional Themes, Images and Symbols at Play on Screen*. Jefferson, NC, and London: McFarland.

Cavallaro, D. 2012. *CLAMP in Context: A Critical Study of the Manga and Anime*. Jefferson, NC, and London: McFarland.

Conan Doyle, Sir A. "Quotes about Aesthetics." *goodreads*. http://www.goodreads.com/quotes/tag/aesthetics.

Cooper, J. C. 1983. *Fairy Tales: Allegories of the Inner Life: Archetypal Patterns and Symbols in Classic Fairy Stories*. Wellingborough, Northamptonshire: Aquarian.

Coulmas, F. "The Quest for Happiness in Japan: Working Paper 09/1." *German Institute for Japanese Studies*. http://www.dijtokyo.org/publications/WP0901_Coulmas.pdf.

Cox, R. A. 2003. *The Zen Arts: An Anthrolological Study of the Culture of Aesthetic Form in Japan*. Abingdon, Oxon and New York: Routledge-Curzon.

DarkKanti. 2006. *"Ouran High Scool Host Club." The Nihon Review*. http://www.nihonreview.com/anime/ouran-high-school-host-club/.

Douglas, M. 2011. *"Puella Magi Madoka Magica*— Review." *Sugoi*. http://www.isugoi.com/puella-magi-madoka-magica-review/.

De Bary, W. T. 1995. "The Vocabulary of Japanese Aesthetics, I, II, III." In *Japanese Aesthetics and Culture: A Reader*," edited by N. G. Hume. Albany: State University of New York Press.

De Mente, B. L. 2006. *Elements of Japanese Design*. Tokyo, Rutland, VT, and Singapore: Tuttle.

Eco, U. 1984. *The Name of the Rose*. Trans. W. Weaver. London: Picador.

Einstein, A. "Quotes About Imagination." *goodreads*. http://www.goodreads.com/quotes/tag/imagination.

Ekuan, K. 2000. *The Aesthetics of the Japanese Lunchbox*. Trans. D. Kenny. Cambridge, MA: MIT Press.

"Elements of a Traditional Japanese Interior." *The Yoshino Newsletter*. http://www.yoshinoantiques.com/Interior-article.html.

Engel, H. 1964. *The Japanese House a Tradition for Contemporary Architecture*. Tokyo: Charles E. Tuttle.

Eternal. *"Puella Magi Madoka Magica." The Nihon Review*. http://www.ni

honreview.com/anime/puella-magi-madoka-magica/.

"Ferdinand de Saussure." 2008. *New World Encyclopedia*. http://www.new worldencyclopedia.org/entry/Ferdi nand_de_Saussure.

Flusser, V. 1992. "Key Words," edited by A. Müller-Pohle and B. Neubauer. http://www.equivalence.com/labor/lab_vf_glo_e.shtml.

Frampton, K. 1995. "Essay — Thoughts on Tadao Ando." *The Pritzer Architecture Prize*. http://www.pritzkerp rize.com/laureates/1995/essay.html.

Fujiwara, I. Poem cited in D. T. Suzuki, 2010.

Fukai, A. 2010. "Future Beauty: 30 Years of Japanese Fashion." In *Future Beauty: 30 Years of Japanese Fashion*, edited by A. Fukai, B. Vinken, S. Frankel, H. Kurino. London: Merrell.

Fukuda, K., and Hibi, S. 2000. *The Colors of Japan*. Translated by J. Bester. Tokyo, New York and London: Kodansha International.

Gombrich, E. H. 2006. *The Story of Art*, 16th ed. London: Phaidon.

Gonzalez, E. 2003. "Film Review: *Millennium Actress*." *Slant Magazine*. http://www.slantmagazine.com/film /film_review.asp?ID=795.

Gordon, A. F. 2007. *Ghostly Matters: Haunting and the Sociological Imagination*. Minneapolis and London: University of Minnesota Press. Kindle Edition.

Haga, T. 1982. "Color and Design in Tokugawa Japan." In *Japan Color*, edited by I. Tanaka and K. Koike (unnumbered pages). San Francisco: Chronicle.

Halfyard, K. 2012. "Fantasia 2012 Review: *Children Who Chase Lost Voices from Deep Below*." *twitch*. http://twitchfilm.com/2012/07/fantasia-2 012-children-who-chase-lost-vo ices-from-deep-below.html.

"History of the Japanese Tea Ceremony." *The Japanese Tea Ceremony*. http://japanese-tea-ceremony. net/history.html.

Høgset, S. 2009. "*Natsume Yuujin-chou*." *T.H.E.M. Anime Reviews*. http://www.themanime.org/viewre view.php?id=1167.

Holmes, S. W. 1990. *Zen Art for Meditation*. Tokyo: Charles E. Tuttle.

Hoover, T. 1978. *Zen Culture*. London: Routledge.

Hume, N. 1995. *Japanese Aesthetics and Culture: A Reader*. Albany: State University of New York Press.

Isozaki, A. 1996. *Island Nation Aesthetic*. London: Academy Editions.

Isozaki, A. 2007. "The Teahouse as a Manifestation of Manmade Anti-Nature." In A. Isozaki, T. Ando and T. Fujimori, *The Contemporary Tea House: Japan's Top Architects Redefine a Tradition*. Tokyo: Kodansha.

Isphording, D. 2008. "A Rose by Any Other Name: Euphemisms, Descriptions, Titles, & Epithets for the Fae." http://www.desireeisphording. com/faerynames.html.

Itō, T., Noguchi, I., and Futagawa, Y. 1963. *The Roots of Japanese Architecture*. New York and London: Harper and Row/Evanston.

"Japan Smitten by Love of Cute." 2006. http://www.theage.com.au/news/people/cool-or-infantile/ 2006/06/18/1150569208424.html.

"Japanese Aesthetics." 2005. *Stanford Encyclopedia of Philosophy*. http:// plato.stanford.edu/entries/japanese-aesthetics/.

"Japanese Traditional and Ceremonial Colors." 2001. *TemariKai.com*. http://www.temarikai.com/meaningoftraditionalcolors.htm.

Jones, T. 2012a. *"Puella Magi Madoka Magica." T.H.E.M. Anime Reviews*. http://www.themanime.org/viewreview.php?id=1243.

Jones, T. 2012b. *"Bakemonogatari." T.H.E.M. Anime Reviews*. http://www.themanime.org/viewreview.php?id=1170.

Juniper, A. 2003. *Wabi Sabi: The Japanese Art of Impermanence*. Tokyo, Rutland, and Singapore: Tuttle.

Kai. 2012. *"Nisemonogatari* Review." *deluscar—The otaku wonderland*. http://deluscar.wordpress.com/2012/03/20/nisemonogatari-review/.

Katzumie, M. 1980. "Japan Style — Yesterday, Today and Tomorrow." In *Japan Style*." Tokyo: Kodansha International.

Kawai, H. 1988. *The Japanese Psyche, Major Motifs in the Fairy Tales of Japan*. Dallas: Spring.

Kawana, K. 2008. "In the Traditional Japanese Garden — An Introduction by Dr. Koichi Kawana (Sumi-E Ink Painting by Haruko)." *The Garden: Symbolism and Esthetics*. In *The Japanese Garden*. http://www.thejapanesegarden.com/esthetics.html.

Keats, J. 1977. *John Keats: The Complete Poems*, edited by J. Barnard. London: Penguin.

Keene, D. 1995. "Japanese Aesthetics." In *Japanese Aesthetics and Culture: A Reader*," edited by N. G. Hume. Albany: State University of New York Press.

kevo. 2012. *"Nisemonogatari." The Nihon Review*. http://www.nihonreview.com/anime/nisemonogatari/.

Kimlinger, C. 2007. *"Mushishi—*DVD 1." *Anime News Network*. http://www.animenewsnetwork.co.uk/review/mushishi/dvd-1.

Kimlinger, C. 2012. *"Guilty Crown—*Episodes 13–22 Streaming." *Anime News Network*. http://www.animenewsnetwork.co.uk/review/guilty-crown/episodes-13.

King, W. L. 1994. *Zen and the Way of the Sword: Arming the Samurai Psyche*. Oxford and New York: Oxford University Press.

Kinsella, S. 1996. "Cuties in Japan." In *Women, Media and Consumption in Japan*, edited by L. Skov and B. Moeran. Honolulu: University of Hawaii Press.

Kishida, H. 1936. *Japanese Architecture*. Tokyo: Japan Travel Bureau.

Kodansha Encyclopedia of Japan. 1983. Tokyo: Kodansha.

Kon, S. 2004. "A Conversation with the Filmmakers." http:www.millenniumactress-themovie.com/.

Kōshirō, H. 1995, "The *Wabi* Aesthetic through the Ages." In *Japanese Aesthetics and Culture: A Reader*," edited by N. G. Hume. Albany: State University of New York Press.

Koyama-Richard, B. 2010. *Japanese Animation From Painted Scrolls to Pokémon*. Paris: Flammarion.

Kuma, K. 2010. "Architectural Truth." In M. Locher, *Traditional Japanese Architecture*. Tokyo, Rutland, VT, and Singapore: Tuttle.

Larsen, J. L. 2001. "The Inspiration of Japanese Design." In *Traditional Japanese Design: Five Tastes*. New York: Japan Society.

Leach, E. 1972. "Anthropological Aspects of Language: Animal Categories and Verbal Abuse." In *Mythol-*

ogy: Selected Readings, edited by P. Maranda. Harmondsworth: Penguin.

Leary, B. 2009. *"Natsume Yujincho Episode # 9."* Mania. http://www. mania.com/natsume-yujincho-epis ode-09_article_116152.html.

Lee, D. 2005. "Inside Look at Japanese Cute Culture." *Uniorb.* http://uniorb. com/ATREND/Japanwatch/cute.htm.

Leon. "Japanese Aesthetics in Design." http://vehicle4change.wordpress.co m/japanese-aesthetics-in-design/.

Light, S. 1987. *Shūzō Kuki and Jean-Paul Sartre: Influence and Counter-Influence in the Early History of Existential Phenomenology.* Carbondale: Southern Illiois University Press.

Lim, S. 2007. *Japanese Style: Designing with Nature's Beauty.* Layton, UT: Gibbs Smith.

Locher, M. 2010. *Traditional Japanese Architecture: An Exploration of Elements and Forms.* Tokyo, Rutland, VT, and Singapore: Tuttle.

Lonsdale, S. 2008. *Japanese Style.* London: Carlton.

Lowell, P. 2005. [1894.] *Occult Japan or The Way of the Gods.* Boston: Elibron Classics.

MacWilliams, M. W. 2008. "Introduction." In *Japanese Visual Culture: Explorations in the World of Manga and Anime*, edited by M. W. Williams. Armonk, NY, and London: M. E. Sharpe.

Mannering, D. 1995. *Great Works of Japanese Graphic Art.* Bristol, UK: Parragon.

Mansfield, S. 2001. "Japanese Aesthetics and High-Tech Design." *J@pan. Inc.* November. http://www.japan inc.com/article.php?articleID=515.

Marcello. 2010. *"Mushi-Shi—* Review."

Japan Cinema. http://japancinema. net/2010/07/01/mushi-shi-review/.

Marra, M. 2002. "The Space of Poetry: The Kyoto Scool and Nishitani Keiji." In *Modern Japanese Aesthetics: A Reader*, edited by M. Marra. Honolulu: University of Hawaʻi Press.

Martin, T. 2005. *"Petite Cossette—* DVD 1." *Anime News Network.* http://www.animenewsnetwork.co. uk/review/petite-cossette/dvd-1.

Martin, T. 2008. *"Mushi-Shi—* DVD 6." *Anime News Network.* http:// www.animenewsnetwork.co.uk/re view/mushi-shi/dvd-6.

Martin, T. 2009. *"Ouran High School Host Club* DVD — Season 1 Part 2." *Anime News Network.* http://www. animenewsnetwork.co.uk/review/ ouran-high-school-host-club/dvd-season-1.

Martin, T. 2012. *"Another—* Streaming Episodes 1–6." *Anime News Network.* http://www.animenewsnetwork.co. uk/review/another/streaming-epis odes-1.

Mathers, C. "What Is the Meaning of Color in Japanese Culture?" Translated by Ehow Contributor. *eHow. co.uk.* http://www.ehow.co.uk/abo ut_6658499_meaning-color-jap anese-culture_.html.

McLane, D. 2008. *Japan Style*, edited by A. Taschen. Hong Kong, Köln, London, Los Angeles, Madrid, Paris, Tokyo: Taschen.

Mingus, C. "15 Famous Quotes on Creativity." *Twisted Sifter.* http:// twistedsifter.com/2012/03/15-fam ous-quotes-on-creativity/.

Mizuno, K. 2005. *Styles and Motifs of Japanese Gardens.* Tokyo: Japan Publications Trading.

M0rg0th. 2011. *"Bakemonogatari—* Re-

view." *Otakuness — Anime Reviews.* http://otakuness.wordpress.com/2011/12/05/bakemonogatari-review/.

Munroe Hotes, C. 2012. "*Children Who Chase Lost Voices from Deep Below.*" *Nishikata Film Review.* http://nishikataeiga.blogspot.co.uk/2012/06/children-who-chase-lost-voices-from.html.

Natsume, S. 1984. *The Three Cornered World.* Trans. E. McClellen. London: Arrow.

Nishi, K., and Hozomi, K. 1983. *What is Japanese Architecture?* Tokyo and New York: Kodansha.

Odin, S. 2001. *Artistic Detachment in Japan and the West.* Honolulu: University of Hawai'i Press.

Okakura, K. 1964. *The Book of Tea.* New York: Dover.

Parkes, G. 1995. "Ways of Japanese Thinking." In *Japanese Aesthetics and Culture: A Reader,*" edited by N. G. Hume. Albany: State University of New York Press.

Pascal, D. "Japanese Aesthetics and the Nature of Anime." *Unreal City: Literature of the Twenty-First Century.*" http://www.davidpascal.com/unrealcity/reviews/anime.html.

Phillpotts, E. "Eden Phillpotts Quotes." *ThinkExist.com.* http://thinkexist.com/quotes/eden_phillpotts/.

Pound, E. 1919. "The Chinese Written Character as a Medium for Poetry." Adapted from Ernest Fenollosa. http://www.pileface.com/sollers/IMG/pdf/The_Chinese_Written_Character_As_A_Medium_For_Poetry_Ernest_Fenollosa-Ezra_Pound_.pdf.

Redjuice. 2011. *Animation Notebooks.* Tokyo: Production I.G.

Richie, D. 2007. *A Tractate on Japanese Aesthetics.* Berkeley, CA: Stone Bridge Press.

Richie, D. 2011. *Viewed Sideways: Writings on Culture and Style in Contemporary Japan.* Berkeley, CA: Stone Bridge.

Rimer, J. T. 1995. "Japanese Literature: Four Polarities." In *Japanese Aesthetics and Culture: A Reader,*" edited by N. G. Hume. Albany: State University of New York.

Rossman. 2008. "*Bokurano.*" *Rossman Reviews and Ratings.* http://www.therossman.com/rrr/anime/bokurano.html.

Sadao, T. S., and Wada, S. 2009. *Discovering the Arts of Japan.* New York: Abbeville.

Saito, Y. 2007. "The Moral Dimension of Japanese Aesthetics." *Journal of Aesthetics and Art Criticism* 65 (1), 85–97.

Shadowmage. "*Bokurano.*" *The Nihon Review.* http://www.nihonreview.com/anime/bokurano/.

Shinkai, M. 2005. "Makoto Shinkai: *The Place Promised in Our Early Days* Director." *activeAnime.* http://activeanime.com/html/2005/09/27/makoto-shinkai-the-place-promised-in-our-early-days-director/.

Shinkai, M. 2006. "Interview." *The Place Promised in Our Early Days* DVD. ADV Films.

"Shintō." *Answers.* http://www.answers.com/topic/shinto#ixzz1xQBwPQSO.

"The Shintō Tradition." *Street Magic.* http://www.shadowrun4.com/resources/downloads/catalyst_streetmagic_preview2.pdf.

Shirane, H. 2005. "Performance, Visuality, and Textuality: The Case of Japanese Poetry." *Oral Tradition*

20/2. http://journal.oraltradition.
org/files/articles/20ii/Shirane.pdf.

"*Shōjo* Manga: A Unique Genre." 1998.
A History of Manga. http://www.
dnp.co.jp/museum/nmp/nmp_i/ar
ticles/manga/manga6-1.html.

Slawson, D. A. 1987. *Secret Teachings
in the Art of Japanese Gardens: Design
Principles, Aesthetic Values*. Tokyo,
New York and London: Kodansha
International.

Speziani, S. 2011. "Review: *Children
Who Chase Lost Voices from Deep
Below*." *Otaku in Review—An Ex-
amination of Japanese Influence on
American Culture*. http://otakuinre
view.com/blog/2011/12/15/review-
children-who-chase-lost-voices-
from-deep-below.html.

"The Spirit of *Sumi-e*: An Introduction
to East Asian Brush Painting." 2009.
Prairiewoods. http://prairiewoods.
org/the-spirit-of-sumi-e-an-introdu
ction-to-east-asian-brush-painting-
091911.

Stanley-Baker, J. 2000. *Japanese Art*.
London and New York: Thames and
Hudson.

Sternenberg, M. 2006. "*Ouran High
Scool Host Club*." *T.H.E.M. Anime
Reviews*. http://www.themanime.org/
viewreview.php?id=970.

Stryk, L. 1985. "Introduction." *Of Love
and Barley: Haiku of Bashō*, edited
by L. Stryk. London: Penguin.

Suzuki, D. T. 2000. *The Awakening of
Zen*. Boston, MA: Shambhala.

Suzuki, D. T. 2010. *Zen and Japanese
Culture*. Princeton and Oxford:
Princeton University Press.

Tanaka, I. 1982. "Beauty Beyond Har-
mony." In *Japan Color*, edited by I.
Tanaka and K. Koike (unnumbered
pages). San Francisco: Chronicle.

Tange, K., Kawazoe, N., and Watan-
abe, Y. 1965. *Ise: Prototype of Japanese
Architecture*. Cambridge, MA: MIT
Press.

Tanizaki, J. 2001. [1933.] *In Praise of
Shadows*. Trans. T. J. Harper and E.
G. Seidensticker. London: Vintage.

Tierney, P. L. "The Nature of Japanese
Garden Art: *Seijaku*." *Kyyriolexy*.
http://kyriolexy.wordpress.com/
gemme-di-talento-larte-ed-il-bo
nsai/il-giardino-in-10-semplici-reg
ole/the-nature-of-japanese-garden-
art-seijaku-l-tierney/.

Tuan, Y. 2004. *Place, Art, and Self*.
Center for American Arts and Co-
lumbia College Chicago.

Turan, K. 2003. "Movie Review: *Mil-
lennium Actress*." *Los Angeles Times*.
http://www.calendarlive.com/movie
s/reviews/cl-et-kenny12sep12,2,511
8759.story?coll=cl-mreview.

Ueda, A. 1990. *The Inner Harmony of
the Japanese House*. Tokyo, New York
and London: Kodansha International.

Ueda, M. 1967. *Literary and Art Theories
in Japan*. Ann Arbor: Center for Japa-
nese Studies, University of Michigan.

Varley, H. P. 2000. *Japanese Culture*, 4th
ed. Honolulu: University of Hawaii
Press.

Verdant. 2012. "*Nisemonogatari*—11
(END)." Random *Curiosity*. http://
randomc.net/2012/03/18/nisemono
gatari-11-end/.

VivisQueen. 2008. "*Natsume Yuujin-
chou* Review." *Anime-Planet*. http://
www.anime-planet.com/reviews/
a536.html.

VivisQueen. 2010. "*Bokurano* review."
anime-planet. http://www.anime-
planet.com/reviews/a776.html.

"*Wabi Sabi*, Japanese Philosophy of
Authenticity." *HubPages*. http://js

parker.hubpages.com/hub/Wabi-Sa
bi-Japanese-Philosophy-of-Authe
nticity-Be-Happy.

Watanabe, Masako. 2011. *Storytelling in Japanese Art*. The Metropolitan Museum of Art, New York. New Haven and London: Yale University Press.

Watanabe, Masao. 1974. "The Conception of Nature in Japanese Culture." *Science* 25 (January) vol. 183, no. 4122, pp. 279–282.

Yoshida, M. 1980. "Japanese Aesthetic Ideals." In *Japan Style*. Tokyo: Kodansha International.

Yoshida, M. 1985. *The Culture of Anima: Supernature in Japanese Life*. Hiroshima: Mazda.

Index

Index

199